20 LANDSCAPE PAINTERS AND HOW THEY WORK

20 LANDSCAPE PAINTERS
AND HOW THEY WORK

FROM THE PAGES OF *AMERICAN ARTIST* EDITED BY SUSAN E. MEYER

WATSON-GUPTILL PUBLICATIONS, NEW YORK
PITMAN PUBLISHING, LONDON

First published 1977 in the United States and Canada
by Watson-Guptill Publications,
a division of Billboard Publications, Inc.,
1515 Broadway, New York, N.Y. 10036

Library of Congress Cataloging in Publication Data
Main entry under title:
20 landscape painters and how they work.
 1. Landscape painting—Technique. I. Meyer, Susan E.
II. American artist.
ND1342.T93 751.4 77-10008
ISBN 0-8230-5490-X

Published in Great Britain by Pitman Publishing Ltd.,
39 Parker Street, London WC2B 5PB
ISBN 0-273-00153-7

Manufactured in Japan

First Printing, 1977

INTRODUCTION

LANDSCAPE HAS BEEN a major source of inspiration to artists for several hundred years and continues to be a favorite subject to even the most contemporary 20th century painters. By placing a number of landscapists side-by-side, as we have done here, one cannot but marvel at the range of expressive possibilities that can derive from a familiar subject. Artists bring to the land a diverse set of artistic traditions and personal experiences, making their particular impressions on an objective subject: landscape appeals to artists who come from the most traditional backgrounds; it appeals to those figurative artists emerging from the period of Abstract Expressionism; it can even act as a motif for artists who are totally abstract. The gamut of these experiences is shown here.

We have Emile Gruppe and Ken Gore, for example—New England painters greatly influenced by the American Impressionists and by other 19th and early 20th century landscape painters—whose vigorous and brilliant oils are reminiscent of their American predecessors. Nell Blaine and Wolf Kahn come from a very different tradition. Having studied with Hans Hofmann in New York, their work reveals unusual attitudes toward space and color—more reminiscent of the Abstract Expressionists inspiring them. In this vein, moreover, Robert Dash, a painter from Long Island, sees the opportunity to display the wondrous qualities of acrylic paint in his landscapes—its texture and luminosity—while Karl Schrag explores the full potential of color orchestration in all media. At the full opposite extreme we have Robert Singleton—very different from all the others—who employs the *memory* of landscape as a motif for his totally abstract paintings.

If the expressive potential of landscape is varied, so are the methods by which the paintings are created. Artists like Ted Christensen will paint only on location, even if it means traveling miles to the scene and waiting days for the correct climate and light for his painting. Conversely, Diane Burko has never yet seen the mountains she paints; she works from photographs alone, regarding her landscapes simply as a vehicle for setting color relationships into deep space.

Some landscape painters were lucky enough to be born into the environment that continues to intrigue them today. Charles Berninghaus, for example, has lived in New Mexico all his life and brings to his work the traditions passed onto him from his father, Oscar Berninghaus, one of the earliest founders of the Taos art colony. Others have had to migrate to their favorite environment, perhaps bringing with them the traditions of another region. Jean Parrish—although she's been living in New Mexico for many years—still depicts her southwestern landscape with a New England palette. Clark Hulings has traveled widely before settling in the southwest, and Wilson Hurley also moved to New Mexico, taking very different aspects of the same environment for his inspiration. Robert Maione traveled still further for inspiration—all the way to Italy—where he has adopted many of the traditions from the great masters who lived there centuries before. Peter Homitzky, on the other hand, paints modern America, the industrial sites of New Jersey.

Unlike Homitzky, many landscape painters prefer a land that is untouched by the hand of man. In New England, Walter Bollendonk and Marshall Joyce take full advantage of the nearby North Atlantic coast, painting rich and dramatic seascapes. Another New England painter, Eric Sloane, views his landscape as an opportunity to record history by documenting the barns and bridges built by our forefathers. And Michael Coleman, from a very different part of this country (Utah), records the Indians and animals residing in the open. If these artists find in the land an important aspect of our heritage, at least one artist has devoted much of his time to its preservation: Alan Gussow.

For all these differences, the artists in this volume have one very basic ingredient in common: the land is their inspiration and they are all dedicated to celebrating its virtues.

The chapters of this book derive from feature articles appearing in *American Artist* magazine between the years 1973 and 1977. As Editor of the magazine, I am proud to introduce these talented and dedicated artists, hoping their diverse approaches to landscape will be its own source of inspiration for years to come.

SUSAN E. MEYER

CONTENTS

20 LANDSCAPE PAINTERS AND HOW THEY WORK

CHARLES BERNINGHAUS

BY BARBARA WHIPPLE

THE HAND HOLDING the charcoal flickers over the canvas board and with quick, loose strokes establishes the lines of the composition. In his other hand, Charles Berninghaus holds a small cardboard frame, or "finder," of the same proportion as the canvas. Looking through the finder is an aid to finding the essential lines and forms in the composition. After a glance through it, the artist's eye shifts to the canvas, and a few more lines are made. Soon the sketch is completed and painting can begin.

"I have different sized finders for different sized canvases," he says. "They are always in my car, with my easel and paints, ready to use."

This morning in Taos the scene was especially breathtaking. In the background were the mountains and cloudless sky; in the middle distance, back-lit and sparkling in the morning sun, were fields and cottonwoods and willow hedges, with here and there an adobe dwelling. Closer in was the fresh, green grass of his sister's garden, then the warm brick of the

Hollyhocks at Ranchos Mission, 1972, oil, 12 x 16. Private collection. The whole state of New Mexico is Berninghaus's studio. Here he's selected the ever-present hollyhock as the feature of an entire series of paintings.

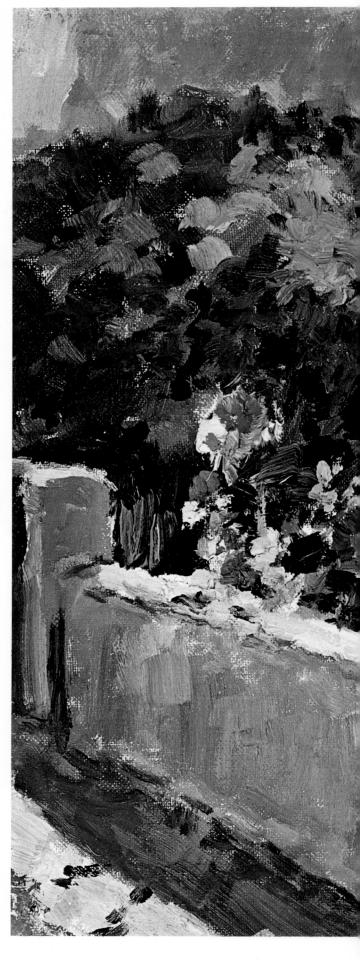

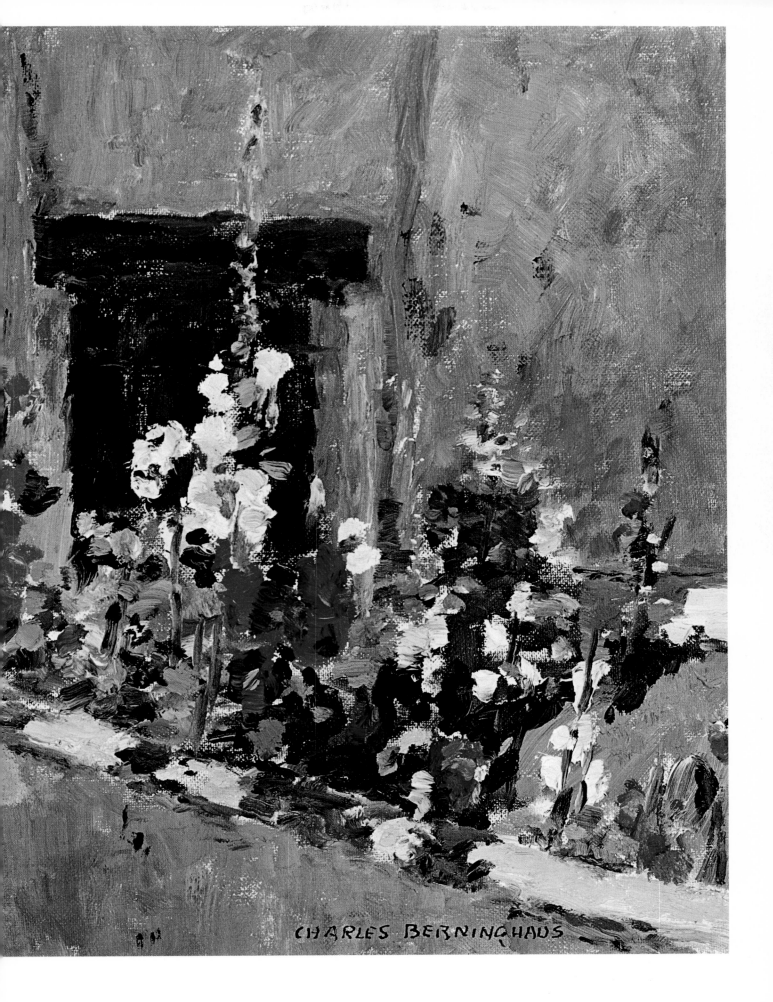

patio, two giant redwood tubs of red and white geraniums, some lawn furniture, and the blessed shade of the veranda roof. The artist had selected the location for this particular painting with courtesy and consideration: he could endure the brilliant midsummer sun, with his visored white hat and his painting umbrella, but an observer might be less than comfortable. Seated in the cool shade of the veranda, with the sound of meadowlarks in the distance and hummingbirds darting in and out, one could turn one's entire attention to the painting as it developed under Berninghaus's hand.

The canvas was held in a portable wooden easel of conventional design, but it was stabilized against the sudden and violent winds of New Mexico by a heavy rock weight, which hung suspended by a thong from the top center of the easel to within a foot of the ground. "Even if it isn't windy, the rock makes the whole easel more secure," Berninghaus commented.

He sat perched on the arm of a redwood chair, facing his canvas and the brilliant scene beyond. His palette and paint rags were in his left hand, his brush in his right. No turpentine or medium was in sight, and the palette knife was left in his box of paints.

"When you're working out of doors, direct from the subject (and he always works this way), you have to work fast," he advised. "Sometimes I don't bother to set up my umbrella; it takes too much time. You see something you like, and you want to get right to work."

Turpentine or medium? "No, I don't use them. But I use lots of paint rags to clean my brushes." Watching him work, using only one brush, one sees how the brush is thoroughly wiped clean between colors: a paint rag, about ten inches square, is held firmly with thumb and finger through the palette grip hole.

Berninghaus's palette is unique and personal, one that has evolved out of a lifetime of painting experience. Reading from right to left, you find the following colors: zinc white, colbalt blue, yellow ochre, zinc yellow, alizarin crimson, permanent green light, viridian, permanent blue, and occasionally cadmium red. He seldom uses umbers, siennas, or blacks. He likes a good grade of medium-rough, commercially primed linen canvas and does the stretching himself. Usually his largest canvas is about 35 x 40, and for smaller sizes, such as the one he was using this morning, he uses prepared canvas boards.

"A lot of people think I use a palette knife for painting, but I only use a brush," he said, as he mixed a blue tone, wielding the ¾-inch bristle flat like a weapon. And, working directly over the unfixed charcoal drawing, he established the forms of the mountains. Wiping his brush, he quickly mixed ochre, alizarin and white together on the palette, and laid in the tone of the sunlit patio brick. A wipe of the brush again, a blend of paint from the palette, and the shadowed side of the redwood containers was built up with quick, nervous strokes. Periodically, he checked his composition with his finder, commenting, "It's important not to lose your sense of drawing:

the feeling that everything is fitting into place."

Work continued over the entire canvas. Seemingly at random, but with unerring color sense, pigments were mixed and applied, and soon the forms of the sketch could be seen in the staccato strokes of paint: the pale blue of the sky, the shaded edge of the willow hedge in the foreground, and the grove of cottonwoods in the middle distance.

"It's very important to establish your values right from the start. You have to get your darks and lights down just as fast as you can." Light changes outdoors within an hour and a half. This means that rapid execution is a necessity; it also means returning to the same site at the same hour for several days to continue work. Sometimes he completes his canvases at home. And occasionally, if the values are firmly established and the painting is developing well, he will stay on location as long as four or five hours without stopping, referring to the scene in front of him for the forms themselves rather than for the light and shadow.

Berninghaus stopped painting and went to a nearby table to scrape the paint from the center of the palette, add some fresh pigment, and get a clean supply of paint rags. "I like to keep a clean palette," he said, and returned to work.

To paint like this, with an unerring touch and an unfaltering color sense, can only be done after years of experience. As the son of Oscar Berninghaus, one of the ten original members of the Taos Society of Artists, Charles Berninghaus had been associated with art and artists since childhood. He had had access to paints, paper, brushes, canvas, and the stimulation and encouragement afforded him by his father and his father's friends. As a boy he went on sketching trips. ("I used to get around on a burro; then I had a bike.") He remembers selling his first sketch for a dollar, and a small watercolor still in the artist's collection attests to his skill at the age of 13.

While he was growing up, summers were spent in Taos, and during the winters the family lived in St. Louis, where Oscar Berninghaus did free-lance commercial work, much of it for the Anheuser-Busch brewing company. Later on, Charles helped his father with murals commissioned for the State Capitol and other locations. Charles did the squaring-up and blocking-in for his father, an athletic undertaking the elder Berninghaus was doubtless happy to turn over to his son. Other interesting assignments that Charles helped his father with were the floats and costumes for the annual Veiled Prophet parade in St. Louis. The designs for these floats were rendered in color before being turned over to the builders who did the actual construction. Charles made meticulous traced copies of these designs for safekeeping in the studio against the event that something should happen to the original drawings during the process of building the actual float.

Up until 1928, when the family moved permanently to Taos, they had traveled by train every summer to and from St. Louis. "This was quite an or-

deal," Berninghaus reminisces. "First it was overnight from St. Louis to Kansas City. Change trains in Kansas City and go on to Lamy, New Mexico. Change trains at Lamy and go on north to Santa Fe. We'd spend the night in Santa Fe. The next morning we'd get the narrow gauge up to Taos Junction and the driver would meet us there with the stage and drive us into town."

There never was any question but that he would be an artist; he was written up in high school as the "Future Famous Artist," and while attending high school he was able to take the art classes given there. A painting of his was exhibited in the Santa Fe museum when he was only 17.

But also, as he had the ability, and his family had the means, it was always expected that he would go away to finish his education, either in college or in an art school. So it was that in 1926 he went to the Art Institute of Chicago. In spite of all the opportunities of drawing and painting that were available to him at home, he remembers with pleasure the demands of a traditional art-school curriculum. He remembers drawing classes using plaster casts, calligraphy courses and, best of all, drawing from all the riches at the Chicago Museum of Natural History—bones, rings from an Egyptian princess, rocks, mounted animals in life-like settings—anything you wanted.

After a year in Chicago he tried the Art Students League in New York. Even though he had grown up in a city as large as St. Louis and had spent a year in Chicago, New York City overwhelmed him with its noise, dirt, and crowds. Besides, he found the League dark and over-crowded at that time. "You couldn't find space to set up your easel when you had a model to work from." So, early in the spring of 1927, he and a friend set off on a painting trip through New England and the Cape and on up to Maine. The artist still has a few of the paintings done on this trip; they show his love of the sea and ships and the coastal towns, but he never went back.

His family never could understand why he had taken off in this way, but it has been quite characteristic of Berninghaus throughout his life to go his own way and to do things on his own. During these early years he was never caught up with enthusiasm for any other painter's style or way of painting, nor was there any particular teacher he desired to emulate. He says of these training years that maybe even more important than going to school—which "was the thing to do, sort of expected of me"—was all the peripheral activity, going to art shows, meeting new people, being on his own—that really made the school experience matter.

When he returned to St. Louis after his New England trip, Berninghaus found his family had decided to locate permanently in Taos. Although he had mixed feelings about the move at first, after another semester at the Art Institute of Chicago, he, too, settled in Taos, and, except for trips to Arizona, Texas, and other parts of the Southwest, has been there ever since.

At about this time one winter he was driving alone across New Mexico, his car loaded with paintings to take to an exhibition in St. Louis. Anyone familiar with desert roads of the 1920s knows they were not only hard on tires, but also that tires were not of the caliber they are today. At one point the car needed new tires, but Berninghaus refused to part with even one of his sketches to pay for them. At another point in the journey, when the car had to be abandoned entirely, he carried huge packages of canvases three miles through the snow rather than entrust them to a village doctor who volunteered to send them on to St. Louis by Railway Express.

While a student in New York, he had turned down the opportunity to go into commercial art, and he knew his father was somewhat disappointed at his decision. He early made up his mind to devote himself to painting, and he had ample opportunity to exhibit in Santa Fe, Taos, St. Louis, and other cities. He received much favorable attention for his work. Some of his early paintings were of Indians, and others were portraits, but for the most part they were then, as they are today, the landscapes and flowers of the Southwest. "Why paint anything unpleasant?" he asks.

Such a decision does not always make for an easy life. "You make sacrifices," he says, "in order not to work in some other line—like a night clerk. I've been through several depressions, and you learn you mustn't think too much of yourself . . . you must not price yourself out of the market. You must take what you can get for your work . . . because you're still able to produce, you see, and money is absolutely necessary." His father helped him considerably over hard times, and there was a period when survival depended on a hundred dollar a month insurance payment. One day he was down to $1.59, and someone dropped by and saw a painting which had just been returned from Kansas City. They offered him $150 for it. "This seemed like a mountain to me. . . . It has happened so often, being bailed out at the last minute."

Today, most of the pressures and disappointments of those early years have faded away. He is very much his own man. He lives by himself in a small house just outside Taos. For recreation he enjoys tennis, and fishing in the surrounding mountain streams gives him another opportunity to spot good painting locations. His painting gear is always with him in his car, so he can work whenever and wherever he chooses. Sometimes a whole week will go by without painting; other days he will paint straight through without a break.

As mentioned earlier, when the light goes, he may either finish the work at home or return to the same spot during ensuing days. This latter method occasionally involves a certain risk. Once he was working on a large canvas in the neighborhood of Mabel Dodge Luhan's house. The sunlight faded, and, rather than try to load the big, wet canvas into his compact car, he simply leaned it against a partly hidden tree some distance off the road. Actually, this was the

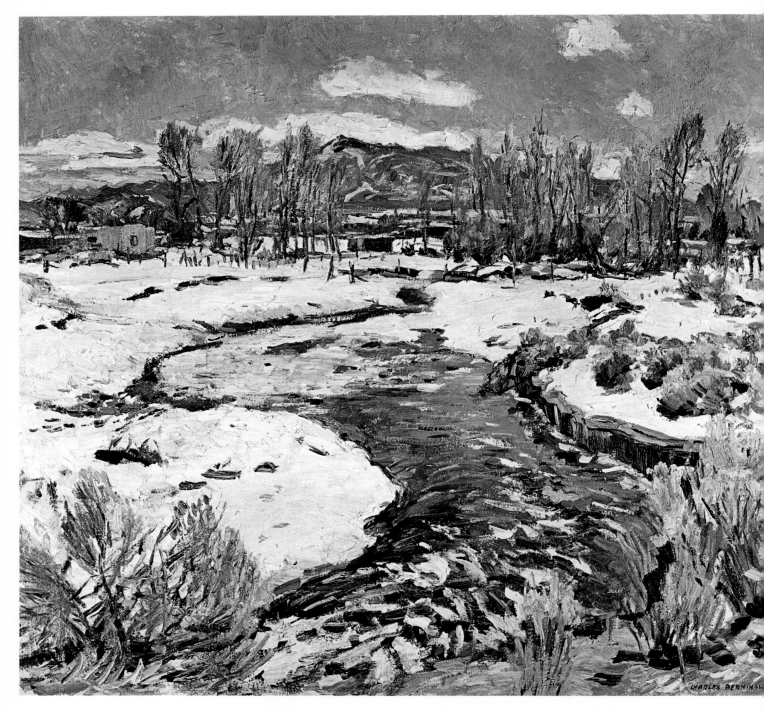

Taos Pueblo River, oil, 35 x 40. Collection Mr. and Mrs. William D. Harmsen. Since light changes quickly outdoors, Berninghaus works quickly to establish his darks and lights first.

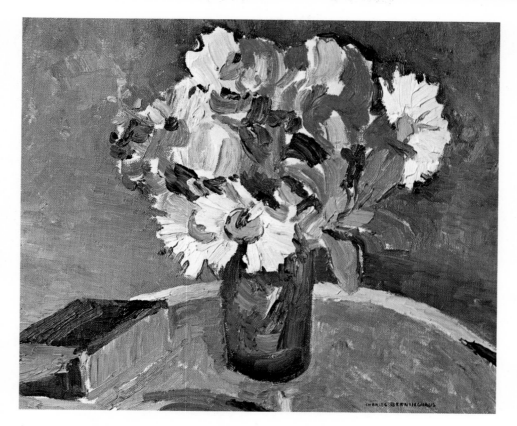

Still Life with Flowers, oil, 12 x 16. Collection Mr. and Mrs. William D. Harmsen. The artist's palette is unique and personal; he seldom uses umbers, siennas, or blacks.

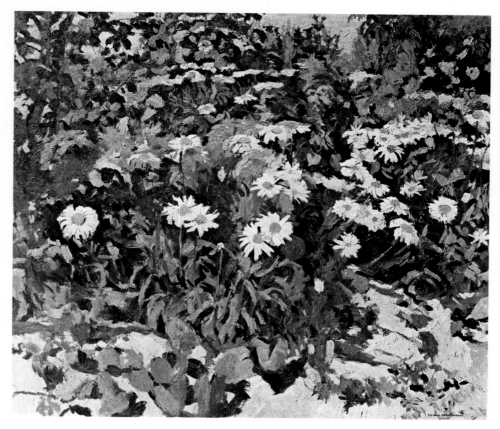

Shasta Daisies, oil, 35 x 40. Collection Mr. and Mrs. Jack Brandenburg. Working with just one brush, cleaned thoroughly between each application of color, Berninghaus creates illusion of lushness and detail.

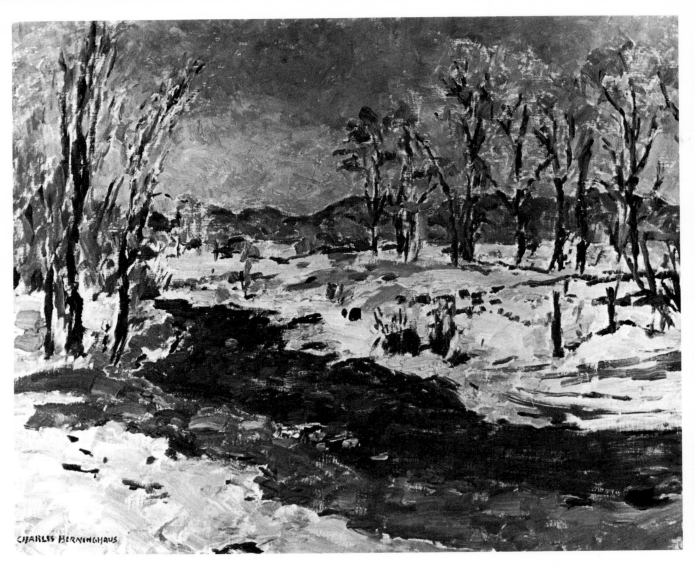

Ranchitos Winter, oil, 12 x 16. Collection Sandra Wilson. Berninghaus uses a ''finder'' to locate the essential lines and forms in a composition. Then he keeps it handy so as not to lose a sense of drawing.

road going to the town dump. He intended to come back at the same time the following day, but personal affairs took him downtown the next morning. As he was walking past a sheltered hallway leading into what is now a local restaurant, he spied his painting hanging on the wall. Surprised and curious, he looked up the owner. As it turned out, the owner, having made a necessary trip to the town dump the day before, had spotted the painting leaning against a tree, surmised that it had been abandoned there by its former owner, found the painting attractive, and appropriated it for himself. Of course, upon learning the circumstances, he was glad to relinquish it to its rightful owner. Taos has always been noted for its understanding tolerance of artists, their lives, and their personal eccentricities.

In the wintertime, when it gets too cold to do much outdoor painting, Berninghaus loads his car with paintings and heads for Texas or California. He has many friends and former purchasers there, people who have told him to drop in if he is passing through, and he sells many paintings in this fashion. There is also another method familiar in Texas but almost unknown in the more conventional East: A couple will display the work of an artist, or several artists, in their home. In some cases the work has been bought for resale; in other cases it is still the property of the artist. Invitations are sent out to come to the house to have wine and cheese or some other simple repast and in the process see the art and perhaps meet the artist. All the work is for sale and exhibited in the home surroundings. The success or failure of such a venture depends largely on the skill of the host and hostess at keeping the attention of the guests focused on the artwork. Berninghaus has had several such exhibitions.

Back home in Taos, with his canvases, paints, and easel in his car and his time at his command, the whole state of New Mexico is his studio. Everywhere he has subjects to choose from: mountains, desert, glorious skies, aspen, evergreens, and flowers. Currently he is doing a whole series of paintings of hollyhocks. Hollyhocks manage to grow everywhere in Taos, tucking their roots down into the cracks in the cement-like earth at the shaded corners of adobe walls and blooming with unmatched radiance in the hot and brilliant sunlight.

Charles Berninghaus is a free spirit, painting what he wishes, when he wishes. He lives as he pleases, and he is obligated to no one. There are many who would envy his life.

NELL BLAINE

BY DIANE COCHRANE

WHEN NELL BLAINE begins a painting, she experiences the same tension and excitement, the same fear and agony as a performer stepping out on a high wire. Will she make it, or will the wire slip out from under her, plunging her to earth? The same question worries her every time she picks up her brush, despite countless of her paintings hanging in museums and fine art collections throughout the world. Most painters suffer similar doubts but her tensions are special—special to an "action painter."

"Action painting" is a term usually associated with the Abstract Expressionist painters of the '40s and '50s. Each encounter with the canvas represents a spontaneous response to the painter's medium, which must be sustained from start to finish. The non-stop process roars ahead, fueled by heady excitement, sheer joy—and agony, because it's a risky business, this bravura display of skill, speed and im-

peccable responses. Sometimes it falls flat. The brilliance, the clarity of conception can cloud over, go sour. And there's no going back; reworking usually means a loss of spontaneity. Says Blaine, "The greatest strength of this method is its honesty; its greatest difficulty is sustaining the high intensity for a great length of time."

On the surface, Blaine is an unlikely "action" painter because of her figurative style. Her paintings are poetic visions of landscapes and flowers, a far cry from the swirling violence of a purely abstract action-painted picture. But not when you consider her background. After studying with Hans Hofmann in the '40s, she was a purist abstract painter, creative geometric abstractions influenced in part by Mondrian, Arp, Léger, and Hélion.

During her geometric period the act of painting had become a physical thing; she felt she could be-

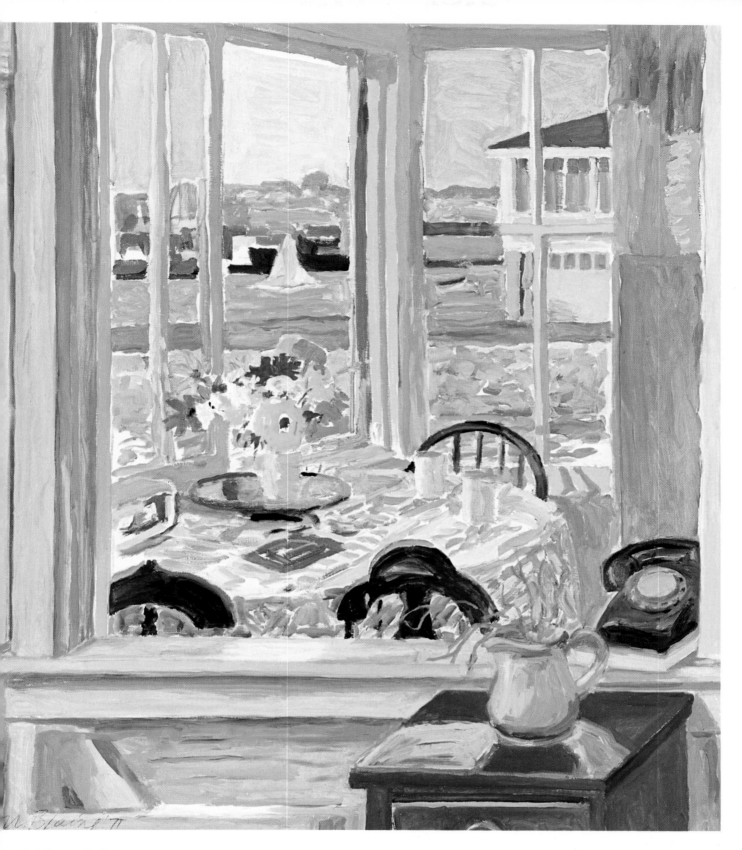

Left: *Pasture II*. 1972, oil, 18 x 30. Impasto application gives greater intensity to the color rhythms. Although Blaine's abstract experience is still apparent in her work, it is no longer the subject.

Above: *Summer Interior, by Gloucester Harbor II*, 1971, oil on canvas, 39 x 34. Collection Mrs. Norman C. Stone. Views from an interior allow the artist to visualize landscape in more than one level of space.

come one with the brush or paint. Then she began her gradual shift to figurative art in the late '40s and began to take more pleasure in the sensuous feel of the paint, unlike the flat paint application of her abstract art. Although not particularly interested in Eastern religions, she can only describe her feelings as something akin to a Zen experience, or, as she said in Alan Gussow's *A Sense of Place:*

"At one point when I was studying, I felt that I had made some sort of contact with something in myself—something like a physical force that would come out through my fingertips. Some years ago I read that painting is like a spider's web. It comes out of the body of the artist, is pulled out of the body. From that point, I felt I could judge whether it was true or contrived, synthetic or really felt. You know when your whole person is coming together to do this act. You learn to make it come, how to spring open the door."

Once the door is opened, Blaine enters a world of pure feeling. The initial excitement is produced by an abstract idea about the relationships between forms or colors: the way the tops of trees meet the sky or a color may set off the reaction. For example, because she was thinking "red" one day, she got out a checkered cloth and painted *The Red Table Cloth.*

Only, it isn't quite that simple. Blaine's approach to painting is a curious synthesis of intuitiveness and extreme order. The initial idea for a picture may come in a flash, but arranging the composition is a lengthy process that may demand two or three hours of strict concentration. Since many of her paintings are still lifes and interiors ("I like to paint the furniture of my daily life."), she positions and repositions the objects—vases with flowers, cups, plates, chairs, etc.—until their relationships satisfy her: "I think out the balances of things and how I will respond to them in an intuitive, not an analytical way."

Blaine also lavishes great care and considerable time on setting up her palette. And here again intuition and order go hand in hand. Around the edge of a large sheet of plate glass backed with white paint she lays out 48 to 50 colors and many little blobs of white in the middle (another hour's work). But the colors aren't arranged in an order most artists would follow, such as light and dark hues or warm and cool colors. The Blaine system is unscientific, yet exact: unscientific in that no system seems to prevail; exact in that each color returns to the same spot on the palette for each painting so that in the heat of painting she can always hit the right color with her brush.

Once the ritual is performed, she picks up one of her brushes (Nos. 8, 10, 12, or 14 flat sable brights). She uses four or five during the creation of one painting, usually wearing out two or three before she finishes a simple painting. The first strokes are usually nothing more than fluid "writing." Indeed, for the first hour or so the whole canvas may look like nothing more than colorful calligraphy.

Color is also used intuitively. She has no preconceived ideas or color theories, because she feels such ideas are restrictive. She does not, for example, think in terms of blues receding while reds jump forward. Instead, she may simply streak a color around on her palette to see if she likes it. But if the choice of colors is random, the way they are applied is not. "I use color rhythmically. The whole canvas must be broken up by color so that there are intervals of color, like intervals in music."

Finally, forms begin to emerge. She works fast, rarely stopping because she is so excited. And she maintains this "high" until the painting is complete and she, exhausted.

The result is usually a joyous celebration of unbelievably beautiful colors in impeccably organized shapes, unless the painting falls flat because the excitement wasn't there, and this can be the shortcoming of the so-called action painting: "If I wasn't really with it, if I didn't get really involved so it was a complete blend of feeling and facility, the painting won't work. I am merely a vehicle for the paint."

Blaines' career has been marked by several watershed events. Before coming to New York from Richmond, Virginia, to study with Hofmann in 1942, she painted rather academically ("with no idea of "organic" composition"); loved Matisse, Rouault, and Bonnard; and reveled in the music of Prokofiev and Beethoven.

New York changed all that. Nell Blaine emerged from Hofmann's school an avid abstractionist and became involved with jazz. Mondrian and Lester Young were among her idols. Days and nights were spent with new friends—Robert Bass, Leland Bell, Louisa Matthiasdotir, Larry Rivers, Elaine and Willem de Kooning, Robert deNiro, Jane and Jack Freilicher—discussing art theories and listening to jazz. She even took up the drums herself: "Music was a release for me from painting, a relaxation." But the combination of the two art forms also had a more philosophical meaning. Both represent a desire to strip down or simplify forms, and both are based on rhythm.

"In jazz I saw the ever-freshening, always spontaneous, renewing spirit and high regard for pure form which I felt to be at the heart of creativity and the excitement I felt keenly in being a part of modern art. Mondrian's 'The new spirit is on the way, and nothing can stop it!' was my battle cry. Like each improvisation in jazz, each color in abstract painting was to have a life of its own in the picture. Color relationships were to be more keenly felt and weighed. So it was with the roles of the players in a jazz ensemble. Each part was a clear voice, and when together, the oppositions were also clear. Equilibrium came when the rhythms balanced."

Such ideas complemented those she learned at Hofmann's school. Hofmann, in Blaine's opinion and many others, was one of the great painting teachers in history. Yet, despite his vast reputation, she feels many people didn't understand him, nor could they make the distinction between Hofmann the painter and Hofmann the teacher. "Of course, he was many

things to many people, but some people—art critics, even students—felt that if you were a true Hans Hofmann student you must paint abstractly." But that's not what he was all about.

Composition was everything to him, and his aim was to teach artists how to build an organic composition. To demonstrate this he devised a diagrammatic method designed to divide up space into geometric forms, but not in a purely abstract way: "He always worked from nature. An arrangement of plates and teacups, for example, would demonstrate how a pictorial space should be structured."

Hofmann's theories were based on "a sensing of the duality of the two-dimensional surface of the canvas versus the three-dimensional," says Blaine. He believed space could be felt physically. He wanted his students to see the palpitating space around objects. The plastic qualities and the life of a picture stemmed from the movement of planes and clearly sensed space. What he was teaching was so basic that a painter could work in any style he wanted once he had learned to "see."

Today many young people have never even heard of this teaching approach. "In the '60s it became fashionable to think that structure, or a sense of form, was restricting. But learning to 'see' the relationship of forms liberates you and makes your painting more fluid."

Jazz and abstract art took on an almost religious significance for Blaine and her friends. And with this religion came intolerance. Approximately ten artists belonged to the Jane Street Group—the first serious and successful cooperative in New York—and they gradually excluded figurative artists, except for one or two members. Blaine laughs when she thinks of this period: "We thought we were missionaries for abstract art. We really had blinders on—just like young people today who are so sure of themselves."

By the end of the '40s, her passion for abstract dogmas began to pale. She felt restricted by the limitations of purist abstraction and slowly moved away from it. Then a trip in 1950 to France and Italy dealt the final blow to any lingering attachments to abstraction as her direction. The landscapes of the two countries, and museums, filled with the throbbing paintings of the Impressionists as well as the work of Courbet, David, Delacroix, Veronese, and Poussin, influenced her immensely. "When I saw those paintings I became tremendously excited. It took guts to forsake my earlier love—it was like admitting I might have been wrong—but I know that working directly from nature for me became much freer."

Abstract art had a profound influence on Blaine's later work. "I didn't turn my back on abstraction; it's just that it went underground in my paintings. I don't make it the *subject* anymore. I think you look at things totally differently after having the abstract experience. It forces you to always look for rhythms, whether you're painting trees, a landscape, a flower—or whatever." So Blaine considers the experience invaluable and her work with Hofmann the two most

Shaded Garden with Live Oaks, 1972, ink stick and wash, 14 x 20. Collection Norman and Karen Stone. The swirling rhythms of trees are an intriguing subject for the artist.

Trees Near Studio Late Afternoon I, 1972, ink and wash, 11 x 14. Collection Mr. and Mrs. Norman C. Stone. Photo courtesy Poindexter Gallery. Shadows and structure are given equal solidity.

Bryant Park #1, 1956, india ink and brush on paper, 16 x 23. Collection Mr. and Mrs. Harry Jason. The suggestion of detail—not its actual rendition—is made bolder with the brush.

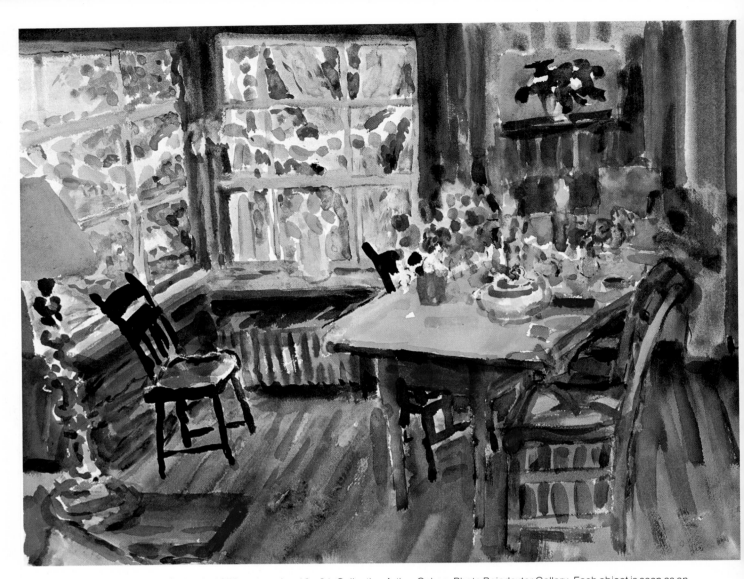

Country Room with Paper Garlands, 1973, watercolor, 18 x 24. Collection Arthur Cohen. Photo Poindexter Gallery. Each object is seen as an object in a total environment. Here Blaine uses the window as a view beyond the interior space of the room, yet her treatment of windowpane area brings the viewer's eye back into the interior space. The window also permits her to work with the contrast between inside light and outside light.

Landscape, Woodside, California, 1972, watercolor, 20¾ x 26½. Collection Norman and Karen Stone. The artist uses watercolor washes with the same gusto she applies to other media.

important formative years of her life.

The change to figurative art gradually resulted in heating up of her visual responses. After trips to Mexico and Greece, where she was struck by the brilliant light and the vividness of color found in the flowers and folk art of the regions, her canvases began to vibrate with oranges, violets, yellows, and vivid blues. Now these bright hues are her trademark.

If the first two major events in Blaine's life—the discovery of abstraction and the return to figurative art—were exciting, the third was tragic. In 1959 Blaine was stricken with bulbar and spinal polio, which left her almost completely paralyzed. With surgery, therapy, and the help of an extraordinary nurse, Dilys Evans, she regained use of her right hand (but cannot lift the right arm) and more complete control of the left, although she is still confined to a wheelchair. Her disability, of course, presented many technical problems. Naturally right-handed, she now draws and paints in watercolor with this hand, but she must paint in oils with her left hand because of the need for greater reach on a vertical surface.

But the redoubtable Blaine thinks this may not be a handicap: "I was told I was very skillful with my right hand; now my style seems broader because this kind of facility no longer exists." Technical virtuosity, she thinks, is not the essential part of a painting and, in fact, may overwhelm it. To reinforce this idea, she says that other painters, such as Arshile Gorky, have felt the same way: "Gorky was extremely facile with his right hand, so he deliberately painted with his left to provide a challenge." In any case, she goes on, "When I have a clear idea of color and form, and I am excited, the physical obstacles slip away. I don't seem to need the greater facility."

Blaine, a friendly, articulate woman, lives in an apartment overlooking Manhattan's Riverside Drive. The walls of her workroom are covered with her own paintings and drawings as well as those of others. The room itself is highly organized with neat files, shelves of paints, and rows of blue and white daylight bulbs. Yet it achieves a look of comfortable

Pages from Gloucester Sketchbook, 1971, ink and stick drawing. Recently Blaine has made painting excursions to Gloucester, Massachusetts, and California. Sketchbooks provide material for work later in the studio.

disarray.

In this room Blaine often spends her nights painting light-drenched still lifes and floral arrangements. She has always liked working at night, when she can totally shut out distractions and noise. And once she achieves utter quiet, she may work until morning. "I stayed up all night, for example, to complete a floral still life recently because I wanted to capture the flowers as I had arranged them. If I had waited until the next day, the flowers would have changed. They often shift radically, and it wouldn't have been the same."

Landscapes bring Blaine out into the sunlight. She is stimulated by both ends of the day: early morning and late afternoon. And, since she can't work at both times, she opts for the afternoon. "The moment of the dying of the light is my favorite moment to paint landscape. For me this time is a great flaring up of life and illumination and excitement and revelation. I become more alive, too."

So she begins to set up her equipment at 2:30; by 4:00 p.m. she's ready to go, and she works until dark.

If the canvas is large, she may have to return for several afternoons, a procedure she dislikes. "It is often difficult to get right back into it, because the flow of the painting has been broken or the light may be different." When it hasn't broken, and all goes well, this is how Blaine has described the act of painting in the periodical *Women and Art*:

"When I dip a brush into paint, a state which has built up inside me is suddenly set in motion. With the release, a state of joy comes like a strange enchantment, and a pure absorption in the adventure on the canvas has begun. The experience is a physical oneness with paint, a hedonist delight on one hand, but an anguish near the end of the journey builds . . . for completeness is the absolute demand, queen with hatchet raised: 'If you don't pull it together, off comes your head!' It is a life and death affair. What began and continues as joy and adventure becomes a duel to the death, and the shore ever recedes from the swimmer. I become more and more tired, yet I swim on and finally in a surpreme effort not to drown . . . I seem to make the shore as in a dream."

WALTER W. BOLLENDONK

BY CHARLES MOVALLI

GLOUCESTER AND ROCKPORT share an island, one port at each end, and the road that connects artist colony to artist colony twists and turns. White houses line the way, with a yard here and there full of fishnets, lobster pots, and bait for tourists. "Things pick up in July," residents tell you. But motels and inns are hidden discreetly among the elms, and the area keeps up a somnolent look despite disconcertingly sharp glances at strangers by the local tradesmen.

After you've made what seems your hundredth turn and begin to enter the outskirts of Rockport proper, you sight a large, Victorian-style house, taller than it is broad, which rests at a fork in the road. This is your destination. After parking nearby, you enter the house to find that the downstairs rooms are small but filled with large paintings, large in size and large in conception. Here you see Walter Bollendonk's work, hanging on the walls and on the pegboard that blocks a back window, resting four or five deep against the wainscot.

"I've been keeping busy," he says, as he rests his hand on a frame. He's tall and angular and many-faceted and looks as if he were carved out of wood and left unsanded. His eyes twinkle, but it's a twinkle that's honed and has a shiny-sharp edge to it. He talks for a minute about an exhibition he plans to enter—he needs to submit some slides, and he's worried about the dangers of color reproduction. Having worked in publishing all his life, he's wary of most commercial printers. "In New York," he says, "I knew only one decent one. He used to do reproductions of Frederick Waugh's work. He tried to match the quality of the original, but getting it right took him eight or nine plates and almost $5000! You don't find many people like that." A sharp glance: "Wait a minute, I want to show you something."

Now Bollendonk walks with a slight limp, but that doesn't hold him back, He disappears up the hall stairs and comes back with a collection of Waugh prints: "I came across this awhile back. Look at the color." He squeezes his eyebrows together in a look that mixes pain, amazement, and worldly cynicism. It's as if he were saying, "This is outrageous! But what can you expect?" He flips through the collection:

"Terrible stuff!" He snuffs. "If Waugh were alive today, he'd shoot these characters. How can anyone who *loves* Waugh have anything to do with this? He points to a blood-red sunset: "The printer couldn't have used more than three colors here. The cleverest engraver can't do much with that." He almost chuckles. "Now an amateur will get his hands on this and copy it, thinking it's really Waugh's work. And he'll do the gaudiest ones, of course, because that's what he thinks being a 'colorist' means. Throwing color on raw. He doesn't know yet that color is a matter of subtleties. And with prints like this to guide him, he'll *never* know."

He puts down the prints and sits on a wooden bench at one end of the gallery. The place is Spartanly furnished. "I had a great opportunity," he continues. "When I was in New York, the galleries were full of good color work. Waugh was at Grand Central Galleries, selling everything he brought in. There were great still life men around and first-class landscapists. And, better still, magazines and newspapers covered them. The *avant garde* hadn't taken over. You could read about them—and about yourself. So you didn't feel you were working in a vacuum. You knew you were part of something: we had our clubs, talked to each other, criticized each other, praised each other, learned from each other. And, as I say, there were the galleries, I'd go see Waugh. I wouldn't copy him, of course—even though his influence was strong in those days. He was on top, and only a fool would enter a surf in the same show with him. He made everything else look like student work." He almost winks, then looks at his hands. "So nowadays people call me a hard judge—and I *am* tough at shows. But that's because I've been lucky enough to see the best. That's what I use as my criteria.

The artist runs one hand over his eyes as he rests a forearm on his knee. "As a kid, I lived near The Metropolitan in New York; it was my second home. I'd go there after school, and they'd kick me out at five. This is when the place was a museum. Now it's a 'gallery.' Then the pictures were hung three high, almost frame to frame—not one high and a yard apart. Of course, you couldn't see them all as well as you

The Final Plunge, 1970, oil, 30 x 36. Collection the artist. When asked how one becomes a marine painter, Bollendonk's response was "Paint anything but marines. Especially do a lot of still lifes. Learn to paint first, then specialize."

wanted. But at least you could *see* them. And that's what I was interested in. Now half of the stuff is in the cellar—discoloring. Pictures don't like dark places, you know. Once back in the light, some of the color comes back. But plenty's lost. I saw a James H. Dougherty hung in a gallery a while back, and all the foam had turned yellow. It probably had been pulled out of storage. You don't help an artist by hanging something like that."

He leans forward and starts to talk about his student days: "So I finally went to study at the National Academy. The only problem was getting a decent studio. The rich boys had rented most of them—not to paint in, of course, but to use as backdrops for their chic studio parties." He squints, as if to get a better view of a New York 50 years in the past. "I can't say I got all that much from my instructors. They'd breeze in once a week and poke at your picture with their brush"—he imitates the teacher, throwing his head back and looking down his nose—"Change this! Change that! No: I learned as much from the other students. You see a man who's been there eight years

and knows what he's doing, and you watch him. The teacher you see once a week; you can watch that student every day. And, you know, it always takes at least two to make an artist."

Bollendonk, the artist, straightens up and looks out of the corner of his eye: "Even if you didn't get much formal instruction, you had a good chance to train your hand and eye. You got a full year's drawing with charcoal. And in the meantime you worked with still life. Still life gave you a chance to experiment with your materials so you'd be able to handle yourself when you finally got to the life class. It was wonderful exercise. If someone asked me how best to become a marine painter, I'd tell him to do anything *but* marines—especially do a lot of still lifes. Learn to *paint* first; then specialize if you want. I never got marine or landscape training in New York, but those still lifes taught me all about values, color, and composition. So I had the fundamentals; I had what I needed to begin to study nature."

I went to work for the newspapers, doing layouts. And I also did some scene painting, both at the

Strand—a big, popular theater—and the Lexington Opera House. I remember working on the big curtain for the opening of Grauman's Chinese theater. A picture of a galleon, done to imitate mosaic. Silver and gold that glistened when the light played over it. Not much up close," he admits, "but what an effect from a distance! That big effect is what you should always be after. At the Lexington, I'd get an eight by eleven inch sketch of a backdrop; then I'd have to blow it up—at a scale of about a half inch to three feet! These weren't the tight backdrop designs you usually see. They were free-flowing things, very decorative. So, in the long run, the business taught me how to use a brush—a big one—and loosened me up. Working on that scale, you learn not to niggle." He makes flowing motions with his hands in an attempt to suggest the nature of these huge backdrops.

"Whenever I got some time off, I'd take a trip on one of the old steamers that ran out of New York—both up and down the Coast and into the Caribbean. I always liked boats and the ocean. Those were great trips, and reasonable. The war and German submarines finally put an end to them. I'd enjoy those cruises: just studying the ocean, sketching a little. Later on I got a chance to work with the navy, painted the submarine Abraham Lincoln and the Polaris missile project and toured the Portsmouth Naval Yards looking for material. Everything's gigantic down there, with scaffolding everywhere. You have to pick and choose when faced with that kind of subject. Some of the final work is hanging in Washington." The artist pulls some material out of a drawer: Navy publications that make good use of his paintings. Prominently hung in the gallery is a picture of one of the ships he sailed in while on assignment. Thinking about this work obviously makes him feel very good.

The conversation slowly turns to his methods. "Well," he says, putting the clippings away, "when I'm outdoors, I like to start with a toned canvas. If you start with a plain white one, you can't gauge the strengths of your highlights: you don't know where you stand. So I just rub some umber over the canvas with a rag and some turpentine. If it's a sea picture, I may add a little cobalt blue. That gives it a greenish tinge. The ocean has that, anyway. This should give you a nice middle tone, halfway between black and white. It's like starting on the middle rung of a stepladder; I can go up or down, as I choose." He looks sharply to see if his point is understood.

"I never bother to do any drawing outdoors," he continues. "I want to approach the subject with paint and brush. If you start with charcoal, you'll stiffen up—you'll end up painting between the lines. So I begin with the brush, going at it with force and enthusiasm. That's pretty much the approach Hawthorne used. I remember him going after the big shape of a nude: just this long, sinuous line defining her silhouette. Then he worked into it." Bollendonk imitates the line with his hand. "Louis Betts was the same way. He was an old friend of mine at the Salmagundi Club and a real painter: plenty of impasto, ev-

Morning Surf, 1973, oil, 24 x 36. Collection William E. Brown. The artist begins by toning the canvas, rubbing some umber over the canvas with a rag and some turpentine for a nice middletone. If it's a sea picture, he may add a little cobalt blue to give it a greenish tinge.

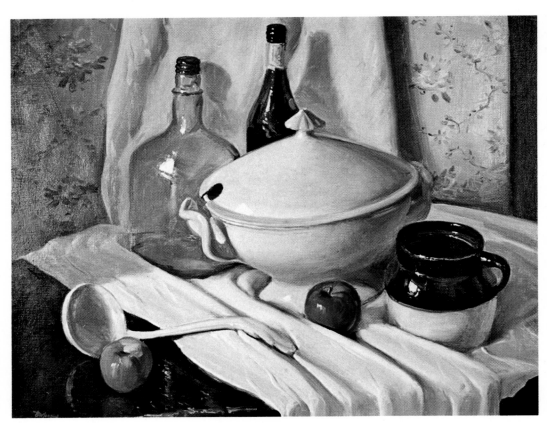

Left: *Still Life with Old Soup Tureen*, 1972, oil, 24 x 30. Collection the artist. "Still lifes teach you about values, color, and composition," says the artist.

Opposite page: *Winter Shadows*, 1974, oil 30 x 36. Collection the artist. Bollendonk works for a broad effect seen best from a distance.

erything strong. He used to do a lot of society women. Now, you'd think that kind of subject would have to be done delicately. But not Betts! You'd look at a hand that, from a distance, seemed all delicate bones and veining; up close, it was just a series of slashes, full of a strong paint texture. That was something," he exclaims, his eyes brightening at the thought of his old friend.

"So," he says, "instead of drawing, I block in my darks and roughly indicate the direction of the ocean. Then I jump right to the sky. That's the important thing. The sky, reflecting down on everything, determines the color scheme. What bothers me about some painters is that they don't make any effort to paint *the day*. They work by formula. I was out once on a day that had the most beautiful silvery water. Down on the rocks in front of me, someone was painting the ocean a bright greenish-blue. Now, his canvas was directly next to the ocean. If he'd stepped back, he could have compared them, side by side; he'd have seen that they didn't match. But he'd gotten into a bad habit." Bollendonk shrugs. "The point is that on a gray day, you're not going to get blue-green water. You have to learn to relate the parts of your picture. Look at that one," he says, pointing to a small study. "The foreground water is very green—but that's all right: it happens when the foam churns up sand, kelp, and seaweed. On the other hand, the background swell is too green for the sky overhead. Here I've been criticizing others—if I saw that picture in a show, I'd say the painter didn't know what he was doing! I'd give him hell!" He laughs noiselessly.

"I've seen pictures—award winners!—where the painter's knowledge of the sea was nonexistent. You feel as if the artist has never gone down to the shore and *looked*. We get mannerisms rather than observation. There's the man with the blue-green water. Another fellow paints every sky just alike—dark, maybe, in an attempt to be 'dramatic.' Another does all his rocks with the same, monotonous, up-and-down strokes, as if they were masonry walls." Bollendonk imitates the stroke with his hand, then continues: "Another is interested in impact; he ignores values and exaggerates everything. His water is too bright, and his rocks too dark. Structure and anatomy are sacrificed to the 'effect,' but the result is too much like a poster. Whistler was simple—but he was also subtle. There's a difference between simplicity and crudeness." His eyes again twinkle sharply.

"The subtlety of your work depends largely on your sensitivity to values. They give solidity to your forms and atmosphere to your picture. Values! Values! Values!" He insists on this as he gets up and pulls out a picture. "Here's a study in values," he says, leaning the painting against the wall: an urn, a ladle, a few apples. "Now, that white urn *looks* strongly lit. But if you hold a white card against it, you'll see it isn't white at all." He gets an envelope and places it near the canvas. "See? It's low in value. I've even played down the highlight—something amateurs almost always make much too bright. So, why didn't I use my purest white; wouldn't that have given the picture some snap? Maybe—but I'd have sacrificed all sense of atmosphere. You know about atmospheric perspective; air dulls things a mile away. But the atmosphere also has an effect on things four feet in front of you. I want the subject, even though it's nearby, to stay back; I want you to feel that the

drapery goes beyond the plane of the frame and that you'd have to reach into the picture to touch it. The only way I can do that is to keep everything in a controlled key. Otherwise it all stays right on the surface of the canvas."

He points to a picture on a side wall. "Look at those poppies. That pot was a devil of a thing to draw; but you see how it goes round?" He illustrates by making a circular motion with his cupped hand. "It's all values. The window and the sea shell are there to give a sense of locale. It's sort of an answer to all those flower painters who arrange their subject against a perfectly flat, dark background. Again, there's no atmosphere; the viewer doesn't get *into* the picture. That's a decorator's picture, if you know what I mean." His questioning glance must be one of the most penetrating on the Cape.

"Values are, of course, just as important in a marine. You have to sense how things become lighter in value as they recede. I'm not saying there aren't days when the distance is crystal clear. But you don't want to paint it that way. You sometimes have to exaggerate in order to make a point. A strong horizon line attracts too much attention. Lighten it up, break it with

small waves or breakers. You can have some sharp edges in the foreground, but keep them out of the distance and the sky. Remember that clouds don't have edges; they blend into the sky around them." He illustrates his point by pulling out another picture, It falls out of its frame, and he grumbles as he tries to get it back in again. "Speaking of clouds," he continues, carefully leaning the framed picture against the wall, "you should try to keep your skies simple and not too dramatic. You don't want to detract from the surf. You can't make *everything* interesting!"

Standing in the middle of the room, he gives a sharp, critical look to the pictures that surround him. "As I work on the preliminary lay-in, I try to get a balance. The canvas is like a scale, and you want to hit equilibrium. You can *feel* when one side is heavier than another," he says, illustrating his point by shifting his weight from one foot to another. "The picture seems to tip to the right or the left. Of course, you also have to avoid the obvious things: cutting a picture in two, getting repetitive forms. Look at that," he says, pointing. "The one-two-three rhythm's too strong in that picture. I know better than that; but when you're at work, things creep in." He shrugs, indicating that

31

the phenomenon is inexplicable but not incomprehensible. "You see errors like that after you've left the picture alone for ahwile. I'll do some more work on it." He makes a mental note.

Then he begins to run his finger along a foreground swell. "See the movement of the water? A feel for that comes with experience. You can't get it by just making a lot of choppy strokes. You have to get the sense of one thing leading to another. You know: like the human body. Once you've studied long enough, one thing *does* lead to another.

"I stick to a fairly limited palette," he says, taking his seat again on the hard gallery bench. "Now, some painters use a whole paint store on their palettes, but the result is a picture that has a paint-by-numbers look. You see the dabs of different paint before you see the subject.

"To begin with," he continues, talking about his palette is more detail, "I use two blues. Ultramarine is a good, strong, *straight* blue. It's the color of the Gulf Stream. Cobalt, on the other hand, has a greenish tinge. You don't want to use either raw, naturally. You want to get warmth into your cools, and vice versa. For example, I use the siennas to tone the distant sea. Out there, beyond the main breakers, the sun warms things up. Just a touch of this sienna does the trick. Use too much, and your picture will turn brown. You want to get a sense of warmth in the water without that warmth taking over. As for the umbers, I use them everywhere. Raw umber cuts down blue's blueness, making it less strident. And both the umbers and siennas can be mixed with the blues to give you deep shadow colors. Here," he says, pointing to some foreground rocks, "the mixture has more light in it than a black. You get some atmosphere depth even in the shadow." He again rubs his eyes.

"I think that some painters are mistaken in their dislike of black. There's nothing wrong with that color. You can use it to make fine grays, and it's invaluable as a toner. A red in the foreground isn't the same as a red in the middle distance: a touch of black can make the difference. If you don't use black, you'll have to substitute purples, all of which tend to attract too much attention to themselves. Or put up with raw color. Uncut. Of course, you're not going to use the black straight—except for a sharp foreground accent. You can't see any black, as such, in any of these pictures. So when you hear people attacking black, just remember Hals and Velasquez. Black was good enough for them!"

He thinks for a second. "You can use Payne's gray, too, if you like. It's more transparent than black—I've used it a lot lately. Cobalt violet is another nice toner—but expensive! The distance tends to go violet anyway." He indicates the effect on a nearby picture. "I also use the cadmiums: red, yellow, and orange. But not too much of them! Reds and yellows are powerful; they call attention to themselves and can destroy atmospheric effects. As a general rule, I'd say

that the nearer you get to the source of light in your picture, the more cadmium you'd use in your highlights. In a mass of foam in full light, a touch of orange gives real snap. Just a touch, though. Use some discretion. It's like the sky over there. It's in the middle distance, so it's green. It takes its place in the gradation from the blue-red zenith to the warmth of the distant horizon. A beginner takes the atmosphere rule too literally and makes it much too green. In fact," he says, squinting, "I may have it too green myself!" The critical glance continues for a second or two. "Another problem, you know, is artificial light. It's yellow and gives all your blues a green cast. Under natural light, all those pictures would look different. I didn't take it enough into account; after all, most of these pictures will end up in private, artificially-lit homes." He makes another mental note.

"Alizarin crimson is a good color to use in the distance. Put a touch out there, near the horizon, and it really makes the sky go back. It's important to get that warmth in the distance, a warmth felt through a veil of cool color. That's why I especially like to use vermilion—the best I can get. But very sparingly. In the deepest foreground shadows, a touch of vermilion breaks up the cool darks and makes you feel as if there's some light in them. Putting a few specks here and there under the foam of the turning wave is effective. Just a few specks—you *sense* them first and can find them later if you go searching. I run it over the surfaces of the foreground foam and over the surfaces of the distant water, just enough to make you feel the sun's warmth."

He gets up slowly and begins to put his paintings back into some kind of order. Bollendonk rests on a frame for a second and considers the tendency of his career. "I've always tried to paint in a manner that combined the best of Winslow Homer and Frederick Waugh. Homer was the poet of the sea. He had great feeling in his work. His structure—well, that was another thing. It's easy to find pictures where his ocean behaves as it never has—or ever will. Waugh, on the other hand, was the great technician. His powers of observation were very sharp—in fact, almost too sharp. He showed *too much* knowledge of the subject. I think that's one reason he's never been given the recognition he deserves; people don't find much emotion in his work. He also tended to overproduce late in life, and when you do that you can't develop your abilities to the full." He hesitates for a minute.

"The important thing is to keep the stance of a student. I've been at this for 50 years, and I feel as if I'm just starting out. One thing all painters have to watch out for is overconfidence. Nowadays, you see one of them get a one-man show. Everyone pats him on the back; he begins to think he's good—and ends up painting the same picture for the rest of his life. What he needs isn't a pat on the back," he says, with a glance that could pin you to the wall: "he needs a kick in the pants!"

Incoming Tide, Cape Ann, 1974, oil, 25 x 40. Bollendonk begins by blocking in his darks, roughly indicating the direction of the ocean.

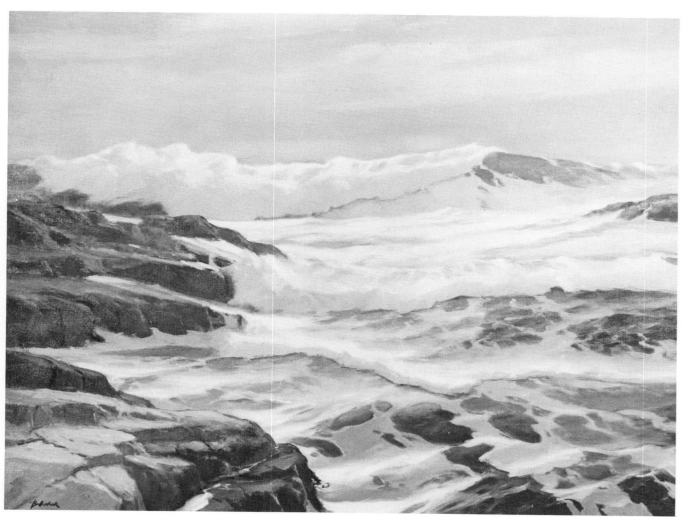

The Big Comber, 1971, oil, 30 x 40. Collection the artist. Bollendonk paints on location without any preliminary drawing.

DIANE BURKO

BY DIANE COCHRANE

Superficially, the development of Diane Burko's art resembles that of many young painters who turned to modern or new realism in the '60s and early '70s. Her development began in college: a brief flirtation with abstraction, followed by a stint devoted to conventional realism in graduate school; both failed to satisfy her. Next Burko's attention was focused on the reality of such banal subjects as cars and motorcycles and the painting of metal and glass surfaces, with their glittery reflections. The camera was added as a tool. Then the trendy idea of incorporating works of other artists into her own was explored. In other words, her personal art history seems to parallel the art history of the whole school of modern realism.

But things are never what they seem. No serious painter having as strong convictions as this tiny, vivacious woman holds would be content to imitate. Although she does use a camera, she does not use it as the Photorealist does. Nor, except for her early obsession with modes of transportation, have her subjects been banal. On the contrary, they have been downright awesome. And this sets her apart from today's landscapists as well. As critic David Bourbon put it in a recent review, "Today's landscapists have narrowed their horizons. They settle for less sweeping vistas and present them with so little sense of exaltation that one wants to ask, 'Where has the awe gone?'"

If Burko's paintings are grand, they are also unique. I know of no one today painting the pristine wastelands of the Himalayas or the Rockies. But novelty would never be a valid reason for Burko to choose a subject. Indeed, her objective is to look very hard at a rather limited subject in order to discover a new way of painting. And she succeeds. By translating the value range of a projected photographic image into patches of color on canvas, her subject shifts back and forth between the recognizable and a complex organization. An illusion of reality is created rather than a photographic illusion. Result: her crisp, austere painting transcends the labels of Photorealism and landscape painting.

Cochrane: What is your conception of realism?

Burko: Realism is the beginning of my process, not what I ultimately want to achieve. I am not so interested in reproducing the exact image I refer to, but in approaching it in a personal way that evolves as I paint. Therefore, realism serves not only as the start of my painting but as a continual force of tension throughout the process. I am fascinated with the ambiguity that occurs between that starting point—the reality of a landscape and its recognizable forms—and the reality of the paint, the surface, and the purely abstract forms that appear. So what I am really playing with is my interaction with a photograph of reality, or an image, and paint.

Cochrane: Before discussing your current mountain series, tell me about your previous images that led up to it.

Burko: For years I painted my studio environment—still lifes, self-portraits, etc.—but finally, they got very boring. It was always the same light, the same studio, the same kind of objects. The color started going dead on me. The obvious solution was to go outside, and when I did, a whole new world opened up to me. We owned a station wagon at that time, and I used to sit in the back of the car painting dozens of small pictures—all pretty conventional stuff. Then one day, while I was sitting in the front seat waiting for someone, I glanced out of the window and saw a fantastic scene in the rear-view mirror. What interested me was the way one landscape, which was surrounded by an edge, was superimposed on another. I made a sketch of it, and it started my car and motorcycle series. (Motorcycles were doubly satisfying because they had two mirrors.)

I spent about a year or so painting in the car, making one hundred or so small studies and enlarging them later in my studio into five by five foot paintings. Then I added another element. At that time I was teaching, and my students were studying the rich color of Van Gogh and Gauguin. All of a sudden, it

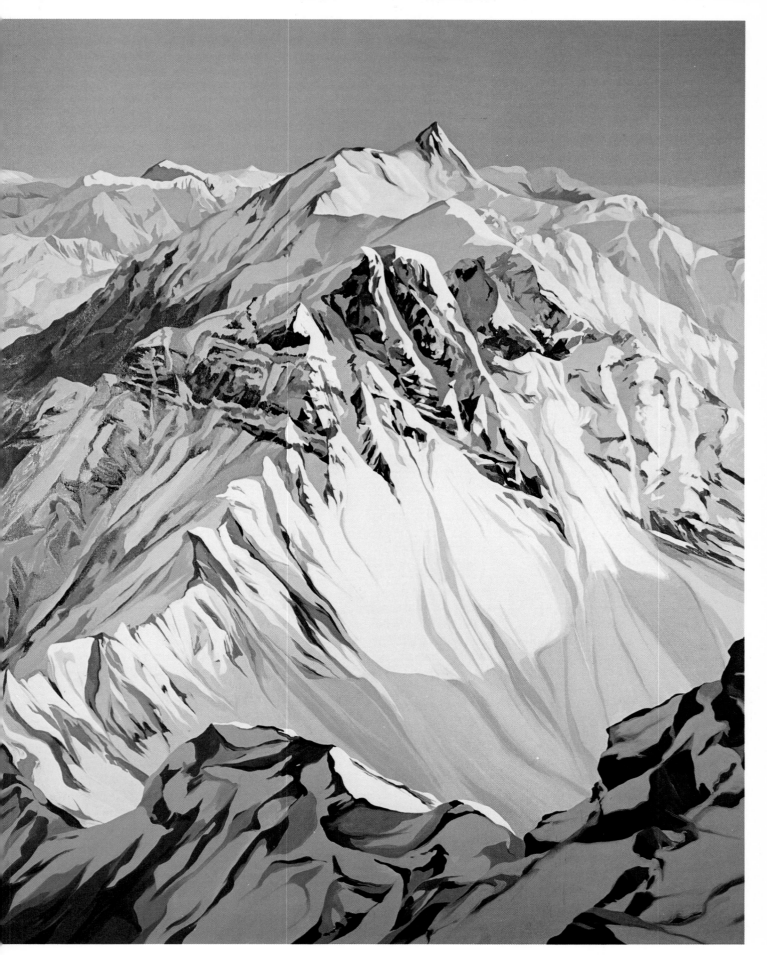

Grissom Alpine, 1973, oil, 84 x 72. Collection Mr. William L. Sharp, Jr. The artist places the viewer out in space, perhaps on another mountain peak.

struck me that I could use the old masters as a jumping off point for my own painting. Instead of putting a Burko landscape in the mirror, I painted landscapes à la Van Gogh or Seurat. Of course, I could do only so many takeoffs on them before I reverted to my own images, this time doing away with superimposed images and painting single landscapes edged by such mechanical devices as plane windows or circular shapes. Finally, I eliminated the edges completely; the landscape stood by itself.

Cochrane: Were you still painting out-of-doors?

Burko: No. Those paintings were based on composite drawings made from aerial views of contour farming, photographs I got from the Department of Agriculture. These serial photographs suited me perfectly, because they were far away from the subject. The landscape became abstract. There were no limbs of trees or rocks to be painted. Such details are not my interest. My interest was then, as it is now, abstract shapes of color on canvas.

Cochrane: What made you stop painting these aerial landscapes?

Burko: My painting became too facile, the color too automatic. I think one builds a color vocabulary over the years just the way one builds a word vocabulary, and it stays with you. Color can be terribly exciting, but it can get stale. That's what happened when I was doing the contour farm paintings. I knew just which orange to put next to which beige; what purples to use with what grays: it became a bore.

Cochrane: Why did you choose mountains as your next image?

Burko: I decided I needed a new challenge based on my interest in the landscape, and I had been looking at pictures of mountains for a long time. A mountain, I felt, would be a whole other experience for me. My previous work was based on painting color to color, shape to shape, with a little overlay of paint in between. There were always some wet-on-wet brushstrokes, but, basically, my painting produced a flat, almost woven, two-dimensional image. Mountains, on the other hand, are three-dimensional; they involve a sculptured concept. To translate my old way of painting into another so that mountains were also formed by shapes was a challenge.

Cochrane: I've heard it said that you selected mountains as a means to keep an emotional distance between you and your subject and that you are expressing a detachment that reflects the times in which we live. Is this true?

Burko: I've heard that said, but I don't agree with this kind of psychological analysis. I admit that my work appears to be devoid of personal presence or intimate space. I suppose this is because—while I am not involved with the photograph as something to be reproduced in terms of focus or depth of field as many contemporary realists are—I always retain a photographic distance, an attitude of observing through a lens. I do this to place you out there in space—maybe across on another mountain peak, maybe in a parachute or a plane—so that I can show you mountains plus shapes and colors. I like to think that the subjective presence of the viewer is implied. In other words, mountains are only a tool that enables my art to be seen on many levels.

On the other side of the coin, I've also been asked if I'm romantically involved with the vista, the mountain, the panorama. Well, I do like the Hudson River School and enjoy learning about the panoramas of Frederick Church and the rest of them. And because I'm so far removed from mountains, especially the Himalayas, I find them exciting to paint. It's been said that some of the greatest American-scene painters have been foreigners who marveled at vistas so different from those of their native countries. The same thing is true in a way with me and mountains: I am a city person. I stand in awe of something unfamiliar. So maybe there is a certain amount of romanticism in my work.

But my real romantic involvement has to do with what this image can do for me in terms of paint. When I look at a mountain, I get excited about its abstract qualities—the large areas of black and white, for example. I am not interested in the mountains per se. You knew that one of my paintings depicted the Snake River and the Tetons. I didn't. Maybe I should know what mountains I paint, but in the end it isn't important. It's what the mountain can do for me in terms of exploring painting and making pictures.

Cochrane: If your imagery isn't a reflection of the times, the photo-image you use is. Were you influenced by the Photorealists' employment of the camera and the projector?

Burko: I suppose so. Photorealists were getting a lot of attention when I started to think about adapting photography to my routine, and, like everyone else, I am influenced by what goes on around me. Ten years ago I might have thought it unethical, although Vermeer and many early artists used the camera obscura as a tool. And I won't let a student use it in my classes today. I feel drawing is part of one's training, one's tradition. But because my training was over and I knew how to draw, I had a choice. So, I reasoned, why spend a week or two transferring a small drawing onto a 6 x 8 canvas when my primary interests are color and painting, not drawing?

Cochrane: Have you been criticized for using the camera?

Burko: Oh, yes. One time, when I was speaking on a panel regarding contemporary approaches to realism

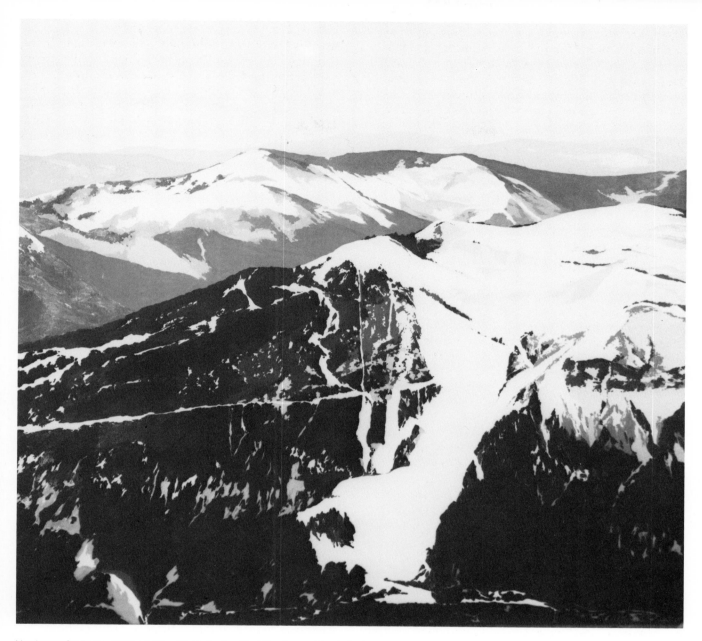

Northwest Ski Trails, 1973, oil, 60 x 66. Collection First Continental Bank, Philadelphia. The closer the viewer looks, the more Burko's paintings become a play of abstract shapes and colors. The values are often close, but the colors are different—a cool blue next to a warm green—as in the foreground here.

at the Figurative Alliance in New York, people in the audience really began to attack me. I tried to say as tactfully as possible that photography is simply a tool and that it's difficult, if not insane, to carry a canvas up the side of a mountain to paint. So someone shouted out, "I know a painter who *does* climb mountains!" It's hard to reason with that kind of thinking, but Alice Neel, who was also in the audience, saved the day. In a very sweet voice she said, "Well, you know Smithson (the environmental sculptor) came to a very bad end that way."

Cochrane: Your use of photography differs significantly from the methods most Photorealists use. What are your rules for photographing and projecting subject matter?

Burko: First of all, I don't use the opaque projector. I take 35mm slides of photographs or parts of photographs. My sources are *National Geographic, Arizona Highways,* calendars people send me, and I recently treated myself to a very large, very lavish book on the Himalayas, photographed by Yhosikazu

Shirakaw. But many of these pictures are too photographic to use. A very fine photograph is a statement in itself, and I can't do much with it—nor would I want to. So I just look through the book, which is about 20 by 15 inches, hoping to find a section, maybe a five by five inch square that strikes me. This process is not much different from the method I used to make drawings for a painting. If I drew ten not-very-good sketches, I would cut out the best parts of each and incorporate them into a new drawing.

Cochrane: Then what do you do?

Burko: For each painting, I project hundreds of slides on a canvas, changing lenses from time to time. Aside from the standard 4″ lens on the projector, I have a close-up 2.5 lens that enlarges the image. Alternating these lenses gives me an instantaneous scale variation. The projector allows me to manipulate the image around the canvas until I find an area of the photograph I want to use. A lot of time goes into this cropping and selecting process. I can spend night after night in my studio, relaxing with a bit of sherry

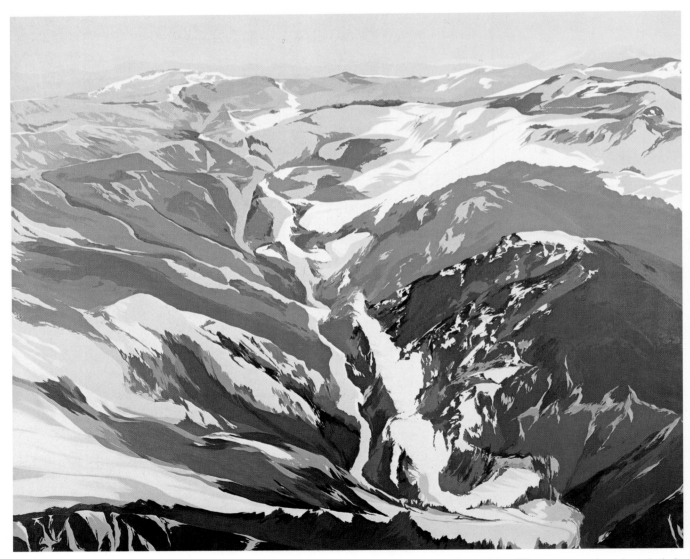

P.J.'s Ridge, 1973, oil, 60 x 72. Courtesy Marian Locks Gallery. With this work the artist expanded her palette of blues, grays, and purples to include greens: shrubbery that Burko defines as patches of color.

and looking and looking until something excites me.

I said that this process eliminates sketching and the transferral of sketches; it has another advantage, too. Projecting the image gives you an idea if it's going to work on a six by eight foot canvas, something you can't take for granted with small drawings.

Cochrane: After you've found what you're looking for, what's next?

Burko: I make a preliminary line drawing in pencil on canvas from the projected image, turn off the projector, and begin to paint. Many people use an opaque projector and keep it on while painting so that the colors are true to the photograph. But for me the photograph is only a diagram that helps me to see if *forms* are coming out correctly. In other words, in a black and white photograph, three-dimensional space and shapes are reduced to values or grades of white, gray, and black. This value system allows me to bring my own color and ideas about space and light to the image. And this is where the real magic lies.

Cochrane: What do you mean?

Burko: First of all, I have never seen the mountains I paint. This means I don't know what they really look like, and I can paint them whatever color I want. And I've been doing just that. As I said before, my color vocabulary in the aerial paintings had gone stale. When I changed my image, I decided to limit my palette. I wanted to narrow down the range of colors to see what I could discover. Initially, the mountains were basically monochromatic—a few different values of blue. As I became involved, I discovered every blue under the sky. I thought I knew everything about blues, but there was so much more to know! Then I slowly worked into greens again, and violets. Grays have come back into my work. And white. White can be a very exciting color; the range of whites one can use is phenomenal. So my color keeps changing. If you look quickly at one of my paintings right now, you might still say, "that's a blue mountain." But, hopefully, if you keep looking, you'll see much more than blue paint.

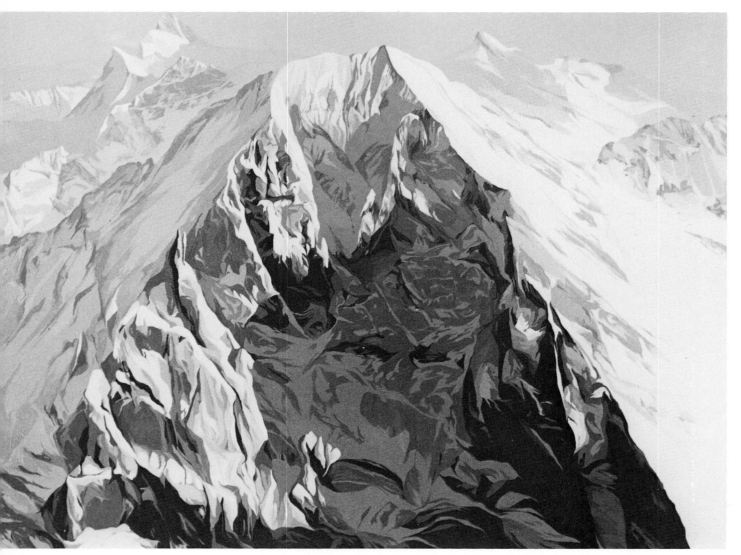

Ama Dablam Peak, 1974, oil, 74 x 86. Courtesy Marian Locks Gallery, Philadelphia. Burko creates the illusion of an awesome landscape.

Cochrane: What else are you trying to achieve?

Burko: Since paintings change, depending on the distance from which they are seen, I want my work to be interesting no matter where the viewer stands. If you are 20 feet away, you see a mountain. As you get closer, you should start seeing other things. When your nose is touching it, the painting should offer a completely different experience. A painting is richer when it isn't all there immediately—when you have to study it to discover new things, like how little shapes come together to make bigger ones.

Recently I switched from oils to acrylics, and acrylics seem to help me achieve this effect. Not that I planned it that way—I changed because I like a very matte surface, which is not always possible with such oil colors as thalo blue or alizarin crimson—and I was surprised to find that acrylics altered my forms. With oil paint, I would put in a form and there was

the shape. Now I put the form down and then put white around it and it's almost like a negative kind of form. Since acrylics are so immediate and dry so quickly, I can continue to apply paint and change the forms any way I want, keeping the paint much more alive for me. And because of acrylics, I can build up forms with tiny brushes like No. 1's. They help to sculpt even the smallest shapes. The end result is that my painting looks less and less like a photograph.

Cochrane: Besides the camera, what else do you share with Photorealists?

Burko: A return to figuration, of course. I don't think I'm a Photorealist. I'm not trying to make a painting that looks like a photograph. But I do feel good about working from nature in general, as opposed to abstraction. Years ago, I did a great many abstract pastels on the order of Arshile Gorky's painting. I was

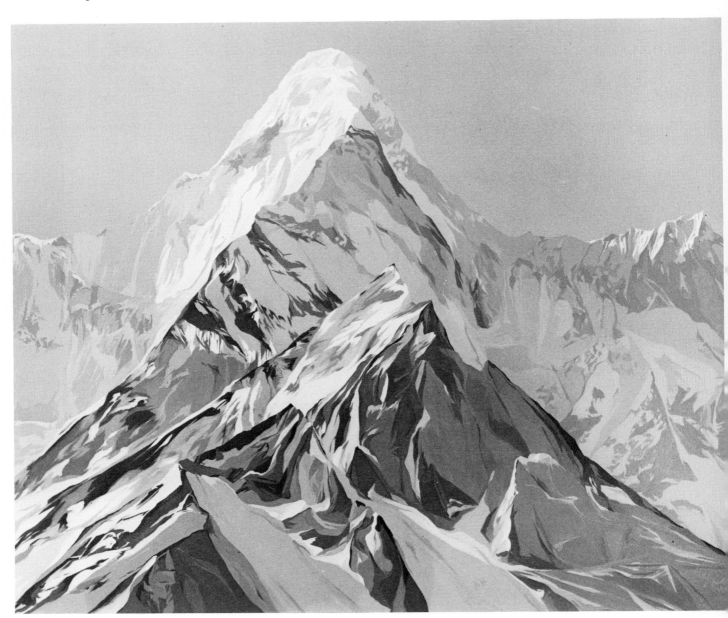

Mountain Range No. 2, Bernese Alps, 1974, oil, 86 x 100. Collection AT&T. Recently Burko has become more involved in the push and pull between shapes. She feels the ethereal quality of this work shows that she was influenced by the American painter Augusta Tack.

going to be another Gorky, but I realized that abstraction wasn't enough for me. Pushing color around, working with surface, working with spatial illusions are all important. But I find that there's an extra tension when one also has to deal with a recognizable object. What I mean is that an area of color can be both a clump of trees and an abstract clump of green paint; or it can be light shining on a snow covered mountain and lush Permalba white still wet with a broad blue area painted through it. This ambiguous experience adds another dimension to the work.

One of the problems with a lot of art I see now—both in classrooms and in galleries—is that so many people are intent on reducing art to a minimum. They are committed to a narrow path. The only place I get inspired today is the museum. You can see the old masters working to solve enormous problems, but in the galleries you see artists working only to perfect a surface or a column of stripes or whatever. Don't get me wrong. I appreciate abstraction. Gorky was one of my heroes; de Kooning, too. But I question when art relates to a tradition that only begins in the 1940s.

Cochrane: you seem to take an extraordinary interest in art history. Why is that?

Burko: I think any serious artist has to know where he or she comes from. I've never thought of myself as being a conservative person, but I'm very conservative about my art. I believe that we have to relate to a tradition. We can go away from it, to create new things, but to be concerned only with newness can be very destructive. Too many young painters think it's more important to have a new image or something that's a bit different, in terms of material or what have you, than it is to worry about what they are really doing.

For instance, once when we were interviewing candidates to teach a basic drawing course at the Community College of Philadelphia, where I taught, a man came in with slides of conceptual art. I really like that kind of stuff—Claes Oldenburg, Christo, Eleanor Antin—they're wildly inventive. But it would be difficult to teach a freshman with only those concepts. So we asked him, "What would you do in a drawing class?" He said, "I do things with surface. I would teach the sensuous feeling of paper and things like that." Of course the line, the pencil, the paper . . . all are sensuous; these are what an artist is really involved with. But when you're teaching a student who knows absolutely nothing and starting there, it's like beginning with Z instead of A. We asked, "What

about the basics?" His reply was, "I don't think one has to worry about the basics. This is the '70s. As far as art history goes, you can look at a book, if you want to go back, but art starts now." My point is that it started with cave painting. I believe in the collective consciousness. You carry that baggage with you wherever you go; you discard, throw away, and begin anew. But you must have a sense of what went on before; otherwise you're in trouble.

Cochrane: What sort of baggage will you discard or carry with you in the future?

Burko: An obsession with colors—which comes from the Postimpressionists and what I learned from Arnold Bittleman and Arthur Anderson, teachers at Skidmore, who were both students of Joseph Albers—will continue to dominate. But it will probably be modified by my recent discovery at the Phillips Collection in Washington of Augustus Tack, who painted nature in what can be truly described as celestial color.

But I'm as curious as you about what I'll be doing in, say, five years. I do know one thing, however. Although I don't want to be a mountain painter the rest of my life, I'd like to go across the country to the places I've been painting—the Sierras, the Rockies. Since my color is completely fabricated, I'd like to see the mountains and rivers as they really are, in different kinds of light, and paint them that way. Think how that might change my work!

If Burko deviates from the aesthetic direction many of her contemporaries have taken, she also runs counter to their geographic course. While they migrated to New York to be in the mainstream, Burko, who was born and raised there, chose to live in Philadelphia after receiving an MFA from the University of Pennsylvania. Philadelphia has been good to her, she says. The less frantic, less competitive atmosphere allows her to develop at her own pace, not at someone else's. She gets good exposure; her work has been shown in many museums and universities both throughout the state and along the eastern seaboard. And her work has found its way into numerous fine collections, thanks to her dealer, Marian Locks.

Burko's friends urge her to move to New York, enticing her with stories of how her career will benefit. Some day she probably will. But when she goes, she'll be traveling with a solid reputation as her companion.

TED CHRISTENSEN

BY MARY CARROLL NELSON

Storm over Napa Valley, 1971, acrylic on canvas, 32 x 34. Private collection. Light rules everything for Christensen, who feels that a day overcast with clouds is essential to a painting of flat country: it enhances the light and sky.

Above: *Mt. Storm,* 1972, acrylic on hardboard, 24 x 30. Collection the artist. Because acrylics tend to flatten out, Christensen textures the surface before beginning to paint.

Left: *View from Twining,* 1968, 30 x 40. Collection the artist. Christensen tones his colors in accordance with the reflection of light, always conscious of five values: light, middle light, middle, middle dark, and dark.

TED CHRISTENSEN spends almost half of every year traveling the roads in his van, ready to paint. He travels far, up and down the West Coast, with frequent trips to New Mexico, across the United States, and beyond: he's been to Hawaii, Canada, Mexico, and Europe. The rest of the time he's home in Sonoma, California, about 40 miles north of the Golden Gate Bridge.

Each trip nets a new group of fresh, vital landscapes, painted vigorously in bold but subtly harmonious colors. Every painting is a separate response to a limited aspect of nature.

What Christensen looks for, as he drives along, is a combination of light, mass, and color that will trigger his artist's eye and emotion. He says the success of the trip depends entirely on the weather, and it doesn't always work out; for example, he wouldn't go out in flat country unless the day was overcast with clouds to enhance the light and sky.

He says, "A subject may look right one day at a certain hour, but on another day would not. Once, on a return trip from Taos, I came over Ebbett's Pass in the Sierras, and the whole scene looked so beautiful that I rushed on home and hitched up my trailer and came back—but by then it just looked blah. I did one painting and went home again.

"I've gone to Mendocino or Monterey and waited out a whole week of blahness when the light wasn't right. Light rules everything."

For Christensen to celebrate nature, the condition he is searching for must be there. Photographs cannot adequately provide subject matter for him, as they lack the sensual completeness of being out in the landscape. However, the recent energy crisis was threatening to his ability to find gasoline for his van, so he bought a single-frame action Super-8mm Nizo movie camera and has now made himself a ten-reel stockpile—each holding 5000 frames of landscape material in color—just in case his on-location painting is permanently curtailed. Meanwhile, he finds little use for photographs except as an aid to painting ultra-large studio pieces.

Most of Christensen's subjects have something to do with water: streams, coasts, frozen water—as in his snowscapes and icy streams—or mist and vaporous clouds. He likes the contrast of rough masses against the softness implied in water, snow, or clouds. Nature strikes him in its large areas of light and dark. "I never think, 'That's a tree.' I see it as a light mass, and I think of design. Without design, you wouldn't have anything," he explains.

If conditions are right, Christensen begins his painting in a style that has been amazingly consistent for over 30 years. He describes himself as a "rough painter," and he knew it so early that, as a beginning student, he changed schools in order to hang onto his own approach—to resist being "smoothed out," as he says.

His first requirement is a place to park the van and lightweight twelve-foot trailer. Made in Canada of fiberglass with only ½-inch thick walls, including the insulation, his trailer is his motel on wheels for trips up to 1000 miles. His Volkswagen van is his studio. He parks so that he can see his subject from the back of the van. This is his third van; at three years old, it already has nearly 100,000 miles on it. He ordered this van empty of interior installations so that he can set up to paint or haul paintings with equal ease. He puts his easel and a stool at the back door and sits down to paint. With this system, he can handle up to a 40-inch square canvas or board on location.

On a painting trip, Christensen carries along a good supply of acrylics, prepared canvas or Masonite, and brushes. "I'm a brush nut," he says. "I have about 400 at the house. Every time I go into a store, I buy three or four new ones. I don't bother to pay too much for brushes: if one wears out, I toss it away."

Although he takes plenty of paint on his trip, Christensen doesn't try to take all the boards he needs. He likes to stop at art stores along the way, and he knows the proprietors of many: "I go to mostly local places because I'm friends with the people who own the store, and it gives me a chance to talk."

He buys the paint he uses—about 20 colors in all—in pint jars. Some of the colors he prefers are produced by an Oakland, California, firm, Polyart, and are meant to be used by school systems. He especially likes their burnt umber for its reddish brilliance, and he always makes sure to bring it with him.

Christensen likes texture. Because acrylics flatten out, building texture with them is difficult. He compensates for this by texturing the surface and may also use additives in his paint. He prepares the ground by applying acrylic gesso directly to raw canvas or sanded Masonite. In addition, he sometimes puts gauze on the wet gesso, or he might glue canvas to the Masonite. Then to add bulk to the acrylic paint, he might use pumice or sand.

"I don't use knives much; it makes it too much of a stucco job," he says. Christensen is a brush painter: regardless of the size of his painting, he prefers relatively small bristle brushes—one inch wide or so on most work, with narrow brushes for detail, and maybe a two-inch-wide brush for painting his nine-foot work back in the studio.

For Christensen, Step One on a new painting is to paint in the lights and darks in large masses, using only the Polyart burnt umber on the textured board. He tones the whole board with a thin layer of the burnt umber, diluted in light areas and denser for the darks. He tries to capture the bold contrasts of form that triggered the painting in the first place. No preliminary drawing, as such, is done but Christensen believes that drawing is happening all the time. "Lines occur wherever masses coincide," he says.

His Step Two is the major part of the effort—painting in color. He limits his palette to five or six colors per painting. If the color is not quite right in the initial layers, it doesn't bother Christensen. He simply continues to add layers. "I will paint four skies into a painting and each sky will be slightly different so the color will break through," he says. It is this method of

layering thinly that enhances the color in his work. Because of his interest in texture, his work seems to be heavily covered with paint, but that is deceptive; the color is actually veiled, not plastered on.

"I search first for the major values of light and dark," he explains. He is always conscious of five values: light, middle light, middle, middle dark, and dark. He tones colors in accordance with the reflection of light. To describe his approach to color, Christensen says, "Everything is controlled by light from above and reflections. The backside of a hill facing you would reflect its color in the front side of a hill behind it, like the facets of a gem. A tree reflects both the sky and the ground. To get to the nitty gritty, the leaves, each facing a different direction, pick up the reflections around them—making the color not so green after all."

His way of painting is to apply a patchwork of brushstrokes in harmonious colors of one value on an area. He directs his strokes in a drawing manner to shape forms.

"I never think of time when I'm painting. All at once, it's as though something says, 'Stop! That's enough.'" At the very end, he puts the "icing on the cake": last-minute strokes of delicious colors that are beautiful in themselves—perhaps a soft pastel turquoise swish on a dull gray boulder, or a pinkish mauve blotch on a snowbank.

"When time dwindles and I keep working on, that usually means I'm getting a dog. If so, I paint a coat of gesso over it and begin again," he says with a smile. If the painting goes well, his last step is to varnish it with acrylic medium mixed in a percentage of 30 per cent matte to about 70 per cent gloss.

With either oils or acrylics, he averages about two and a half hours on a painting. The time passes in a state Christensen has defined as a form of self-hypnosis. He says painting is for him like a release of a pressure valve; it's something he has to do.

From a trip lasting a month, Christensen might return with 30 paintings. He doesn't paint every day, though, but takes an occasional break to look at museums or galleries. He strongly recommends the custom of looking at paintings: "Study them—try to analyze. I've gone back to see one painting many times. I've even taken a magnifying glass along. (Keep an eye out for guards. If they see you, they get very nervous.)"

Over the years Christensen has developed his own methods of handling the practical aspects of painting on the road and at home. His paint box, for example, is the invention of his longtime friend, Richard Yip, who makes and sells it. The device is a wooden box housing a plastic ice cube tray. It has a hinged lid, lined with poly-foam. Christensen fills the cubes with his colors, which stay fresh and pliable for weeks.

While painting, Christensen sprays his paints repeatedly with water from a plastic spray bottle to keep the paint moist.

For mixing, Christensen uses an enamel tray such as watercolorists use. He keeps a small jar of clean water on the tray for quick dips and a big bucket of water for cleaning brushes on the floor by his stool.

Acrylics were not Christensen's favorite medium when he started his travels. He had painted oils for years—and takes oil equipment with him because he still occasionally paints in oil—but hauling wet oils in the van is very difficult.

For two years he carried a set of acrylics in his van, but he never tried them until one hot day in Death Valley, of all places. They worked well for him there, and he now uses them almost exclusively.

But acrylics are not oils. Whites muddy colors, Christensen finds, and make them go dull like a tempera. To compensate for this tendency he developed his layered approach. Rather than always mixing white and red to make a muddy pink, he finds it more satisfying sometimes to paint white and cover it with a thin layer of red. This makes a fresh, glowing pink. Christensen uses a lot of white and buys it by the gallon.

Darks dull out, too, in acrylics. To bring them back he automatically covers them with a swipe of medium, using the mixture of matte and gloss described earlier. For color mixtures that he feels are too matte, he also adds an overlay of medium.

Black, which some artists avoid, is a staple of Christensen's palette. He finds it saves money. To tone a green, he does not use its complement—the expensive crimsons and cadmiums—but a touch of black. He also adds black to that burnt umber he likes. Although black is useful as a toner for all the major colors, he doesn't use it alone. He always cuts it with other colors.

The rest of his palette of 20 colors includes the raw and burnt earth colors, the ochres, red-orange, magenta, lemon yellow, a little medium yellow, ultramarine, and Thalo blue. He mixes his own oranges and greens. "Once in a while," he says, "I use a little goodie on the side, such as a mauve. I have six or eight reds I experiment with, mainly just touches."

When Christensen goes on a painting trip he adapts his palette to the destination and the season; for example, "In the spring," he explains, with a chuckle, "I'll mix a big jar of 'spring color' (a light yellow green), and in the fall I mix a jar of 'fall color' (ochres and burnt umber)."

Although Christensen doesn't enjoy teaching, he empathizes with other artists and readily shares the lessons his life has taught him. To be a professional artist, he believes, it is helpful for the artist to:

1. Learn to draw. Every brush stroke is drawing.
2. Do things himself to keep costs down, such as crating and hauling.
3. Keep records. Christensen does this by taking slides of his paintings. He owns several cameras: a Yashica, a Hasselblad, and a Pentax.
4. Buy in quantity. He recently bought a 100 yard (200 square yard) roll of cotton canvas, which he feels will last him for years. (Christensen prefers linen, but he's allergic to grass: linen is grass.)

Headlands, Mendocino, acrylic, 20 x 30. Collection Jean Caroline Harlow.

Christensen likes contrast. Here the solid, somewhat dark shape of the land contrasts with the light and softness implied by the water and sky.

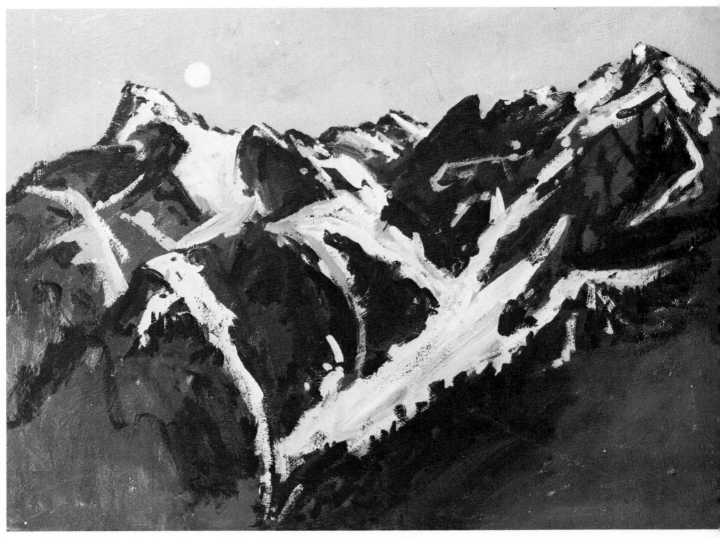

Nocturne—Canadian Cascades, 1975, acrylic on Masonite, 24 x 32. Collection the artist. Christensen works without a preliminary drawing as such. "Lines occur wherever masses coincide," he says, so that drawing is happening all the time.

5. Produce. Christensen paints about 100 paintings a year.

6. Set prices at modest levels so that you can get wider exposure.

For each of his nine galleries—three in New Mexico and six in California—Christensen paints local scenes. Despite the apparently insurmountable effort it would take to handle the painting, framing, hauling and record keeping necessary to supply so many dealers, he says, "I never seem to have demands made on me. I paint what I like for myself. I try to pick a good range of paintings for a show. Portraits would be awful, as you'd have to paint just to please the customer."

As a wry sidelight, Christensen taught Life Drawing at the College of Marin, Kentfield, California, for eight years—yet the only figure one is usually aware of in a Christensen painting is the artist himself.

Christensen is so involved in his art that it took a disaster to stop him even temporarily. In 1971 he was in a head-on collision while at Taos, New Mexico, and was "out of commission" for several months. This enforced period away from painting made him

so gloomy it confirmed for him that he must paint in order to be cheerful.

The next year he was back in Taos living in a rented adobe next door to the Governor Bent Museum and painting out near the Taos Ski Basin in the mountains. The weather was so cold he suffered frostbitten toes three times while painting snowscapes, and he thus can no longer tell if his toes are freezing. "It was so cold I had to take the paints to bed to keep them from freezing; that's a term I use to mean I had to take the paint indoors at night. I left the acrylics in the car one night, and the next morning they were the texture of sherbet while the paint water was frozen solid. The paint seemed okay when it thawed out, though," Christensen remembers. On that trip of about a month, he painted 28 acrylics.

He tells these anecdotes of other painting trips: "While painting in Tucson one winter I was nearly demolished by a dune buggy that came flying over the top of a mound. I was sketching in the Hollywood Hills when I found myself amidst a running gun battle on horseback followed by a jeep with a camera crew. Now I paint in a van because of weather and to

keep the sun off the canvas. People pass by with only a sidewise glance, and the only ones who stop to talk are other artists."

Ted Christensen is a gregarious fellow who enjoys entertaining and is a friend to a wide assortment of artists, many of whom he has known since student days in Los Angeles at the Art Center School and Otis Institute, from which he graduated in 1948.

Though he grew up in the damp coastal area near Vancouver, Washington, not far from the mouth of the Columbia River, a term at Portland (Oregon) Museum School, spent entirely in the rain and fog, discouraged him from settling in his homeland. Instead, since 1949 he has lived within an hour's drive of the Golden Gate Bridge.

He lived four years on an old wooden lumber schooner, the S.S. Lassen, which was resting in the mud by a dock in Sausalito. He rented the forward half of the ship, painted, partied, and fished right through a hatch in the deck. From 1953 until 1970 he owned a home on Mt. Tamalpais, 1000 feet above the upper San Francisco Bay.

Headquarters for Christensen is now a smaller house, in Sonoma, California, 125 feet back from the road, encircled by other people's sizable estates so that he has a park-like setting. He has planted a screen of oleanders on the streetside: they don't require trimming. Inside he has done considerable amounts of work, especially in his indoor-outdoor studio.

His garage, now housing his professional carpentry equipment, is where he does his frame building. Framing a painting may take him three times longer than painting it.

Christensen removed the low ceiling of the garage and now has a 15 foot high studio with a skylight. The room is 12 x 24 feet. At one end is a glass wall, and beyond it is his outdoor studio. He's installed a retractible nylon roof with tracks under the eaves. In sunny weather he can pull the roof overhead and enjoy painting in the open air. This is where he paints his big pieces, up to nine feet, the only ones he does not paint on location. Most of his work is 24 x 30, 24 x 36, or 30 x 40. There are exceptions. For example, he does narrower panels for subjects that seem to require them; his Mendocino gallery likes 8 x 10 and 9 x 12 paintings, and one of his San Francisco galleries specializes in office and commercial sales so they prefer his largest work. Otherwise, he sticks to his preference for medium-large pieces.

Christensen believes in living only for the day and feels he inherited a somewhat mystical view of life, that is, he trusts that what he needs will be forthcoming. (But his own enormous effort must surely help bring this about.)

He suffered a broken neck in a training accident in the Army during World War II, and this has affected his sleep habits. He tells people, "I don't need much sleep. I don't dare spend more than six hours at a time asleep, or my arms will paralyze from spinal nerve pressure, and I'm not very coherent the next day. Usually I sleep about three hours at a time and then I get up and read. I have an art library of five or six hundred books and ten years of bound copies of *American Artist* and all the old ones back to the late '30s when the magazine was called *Art Instruction*."

A confirmed bachelor, he tends to all his needs rapidly and believes a house should be cleanable in 45 minutes—he hopes. His handiness was probably an outgrowth of his life as a child on a ranch, where he learned that anything he wanted he'd have to make. His father was a fine craftsman and provided a model of one who did things with his hands. Another model who has affected Christensen's sense of devotion to his tasks was Anders Aldrin, uncle of astronaut Buzz Aldrin. The continuous work of this relatively obscure but serious painter and his application of rich pigment and generous brushwork have remained imbedded in Christensen's mind. He admired Aldrin's zeal.

One gets a definite sense of leisure from Christensen. Ever since 1967, when he accepted a year's grant from the Wurlitzer Foundation to paint in Taos, Christensen has been simplifying his life and increasing his opportunity for adventure. He can support himself by his painting and has a large number of patrons, including clients in many foreign countries. Successful real estate deals and his years of hard work outside of painting helped him to achieve this time of relative freedom. Christensen's painting now takes precedence over other art forms he used to work at more often: printmaking and pottery.

Such a priority must be satisfying to him, because there is a real feeling of happiness in the man. A moment of rapture in which, all alone, one can be transported by the beauty of nature is, for most of us, a singular event. For Christensen, a moment of visual delight; unconfined, directly before a landscape—or a rock, a rivulet, a clump of daisies, a seacoast, or a mountain—is a constantly recurring cause for celebration.

MICHAEL COLEMAN

BY DIANE COCHRANE

WHEN MICHAEL COLEMAN was a young boy growing up in Provo, Utah, he began to prepare for a career as a landscape painter. He didn't do it consciously; he didn't even paint. He spent his time fishing and trapping—and looking. What he saw from his trout streams and river banks were not the overpowering geological monuments generally associated with Utah, like those found in Bryce Canyon or Monument National Park. To be sure, the magnificent Rockies were always in the background, but a more intimate countryside made up of swamps, meadows, and small waterfalls dominated the foreground. And it was seen at sunrise and sunset, in stormy weather and after the rain. It is a soft, gentle landscape, and the moody tonal paintings that result from these memories bear a striking similarity to 19th century English landscape painters, such as Constable. (Constable, too, preferred the flat river valleys of his native countryside to the drama of the mountains.)

But romantic 19th century landscape painting isn't fashionable these days. At least, that's the impression Coleman received when he studied art at Brigham Young University: "It seemed that both teachers and students would wait for the big art magazines to come out from New York, and two months later you would see everyone copying the style touted in the latest issue. They worked mostly abstractly and moved from one movement to another, but nobody really seemed to know what he wanted to do."

But Coleman did know: "I wanted to paint what was around me, the things that I knew and that meant the most to me." So he left school in his junior year because, "I felt so strongly about the landscape and the animals in it that I had to do more than just look at them."

If Coleman was intensely motivated to paint, his parents felt just as strongly that he would be doomed to failure if he pursued a career in the fine arts. But he persisted. At first many of his paintings were of animals: "Some of the best times I can remember were just standing in the bitter cold watching a moose or a buffalo all by myself in the complete silence." Later, landscapes began to dominate his work, and recently he has added Indian-related objects, such as teepees or burial structures. "I never thought I'd get into cowboys and Indian painting, and I don't paint cowboys," he says. "But Indians seem so much more pure; they really relate to the land."

Now, still under 40 years old, Coleman, far from the failure envisioned by his parents, is an impressive success. He shows at several galleries throughout the West and is represented in New York City. One of his shows sold out before opening. His paintings hang in such collections as those of Phillips 66, Pabst Blue Ribbon, and the White House.

The secret of his success is, in his own words, "Work, work, and more work. I get nervous if I am away from my studio, and can't wait to get back to it." His work ethic is based on two considerations. First, he has a hard time keeping up with his galleries' demands for more paintings, and second, he feels this is the right approach to painting. "Many painters sit around waiting for inspiration to hit," he says. "I used to do this in college. I would finish a certain section of a painting and decide to let it dry before continuing. I thought this would give me time to think about what would come next. Actually, this was just laziness. Inspiration comes while I work, so there's no excuse not to start." Now he paints steadily six days a week from nine to five and hasn't taken the time for a vacation. Sunday is supposed to be his day of rest, but, to make sure he doesn't become restless, he carries a small sketchbook (resembling a hymnbook) to church so he can make quick sketches if he is inspired.

Such total dedication has altered the painting process for him. Instead of letting paint dry, as he did in his college days, Coleman now works wet-into-wet: "Fortunately, I can handle my brush so that I keep colors clear and clean, not muddy." And by sharpening his skills through constant work, he has stopped taking photographs as part of his work routine. "I did this mostly to learn about colors, especially the colors of sunsets. Now I don't need them any more," he says. He also photographed animals until he was nearly run down by a charging buffalo a few years ago and decided that he already knew enough about their anatomy.

Coleman has also largely abandoned glazing in fa-

Summer Pastoral, 1973, oil, 24 x 36. Private collection. To insure smooth, subtle gradations, no visible brush strokes, and no reflected light, Coleman stipples the entire sky with a bristle brush.

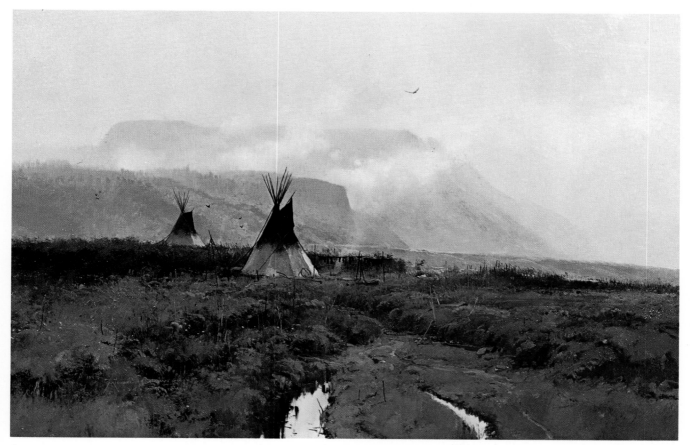

Crow Hunting Camp in the Rockies, 1974, oil, 20 x 30. Private collection. The artist prefers to paint the intimate countryside of Utah—meadows, marshes, and streams. Here in the background, however, he hints at more monumental elements.

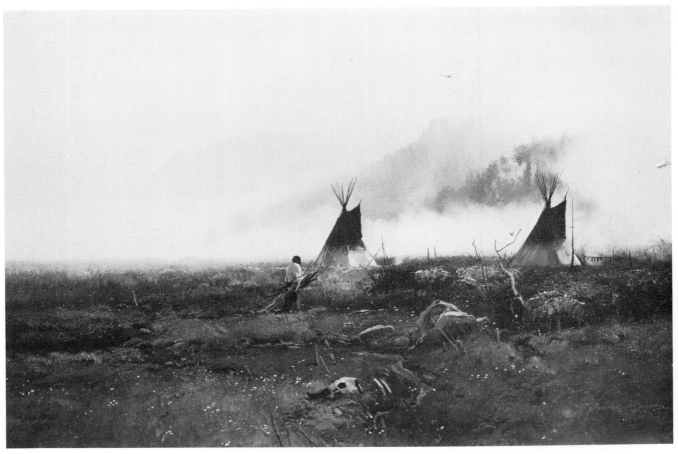

Wolf Creek, 1974, oil, 18 x 24. Private collection. Coleman's main interest is landscape. His recent paintings include Indians and Indian related subject matter, because he feels they have a close relationship to the land.

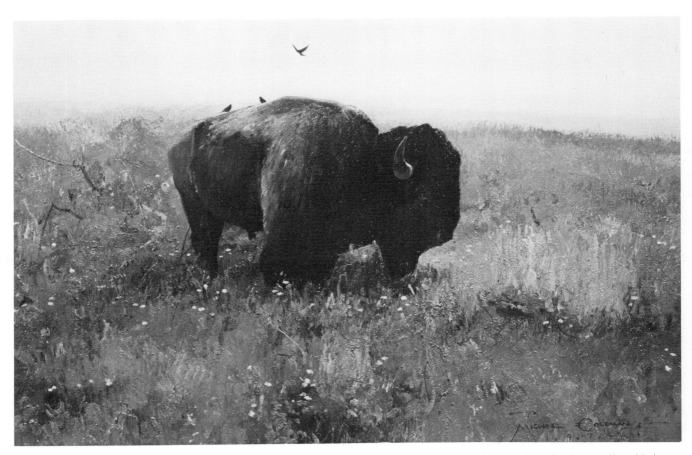

Buffalo Bull in Spring, 1973, oil, 14 x 20. Private collection. Coleman adds certain objects, animals or structures, last, after the panel has dried, so they will have a different texture from the rest of the panel.

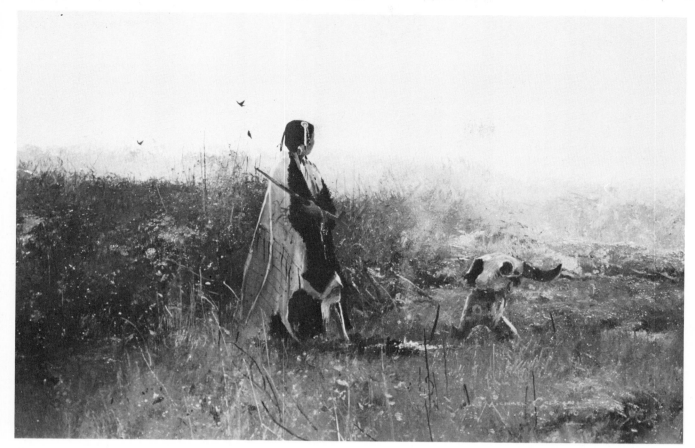

Cheyenne, 1974, oil, 14 x 20. Private collection.

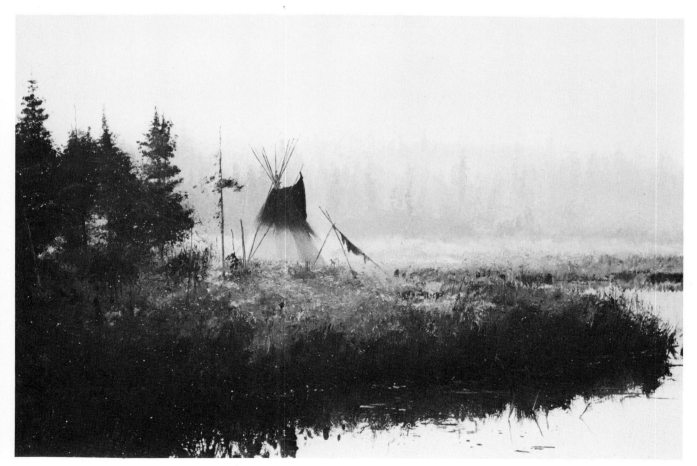

Rising Mist Bitterroot Valley, 1974, oil, 24 x 36. Private collection.

vor of a more direct and more tonal approach to painting: "People have told me my paintings look like they have been glazed, even though I've only been working for maybe five hours," he says. "This is because of the tonal quality. Say I want to make the sky rosy; then everything within the picture will have some rose tones. I don't have to unify different areas of a painting by glazing; the overall tonality does this and at the same time creates a mood."

Eliminating unnecessary procedures is a must for this young man in a hurry, and it's doubtful that any time-and-motion expert could do a better job of whittling down the painting process to its basics. Fortunately Coleman's efficiency is aided by a good memory and source availability. His ideas spring, as mentioned above, from his memories of what he calls "the good old days," and since he has spent so much more time painting than looking recently, these memories seem to grow better and better. The result is that he likes to paint even more, a striking example of the past serving the present, for his ability to retain images counteracts his distaste for painting out of doors: "It's a waste of time for me to load up all my gear into the car, assemble it on location, and then find that the medium is melting in the sun and bees have landed in the bright pigments." But, just in case he is not quite sure of what a certain tree or rock looks like, he can still hop into his car and go take a look at it.

Once Coleman has worked out the composition in his head, his work routine goes like this: when he arrives in his studio in the morning, he turns the heater on and puts a jar of Maroger medium on top of it to warm up. Next he sets up his colors on his palette, which is a sheet of glass placed over brown-toned paper. Fifteen colors, including black and white, are laid out. Five of these are rarely used except for accents, and the rest are mainly umbers, siennas, and other earth colors. A Masonite panel, which has been coated three times with pink gesso, is placed on the easel. He uses panels instead of canvas for two reasons: first, mistakes are more easily and more quickly removed by scraping, and second, they withstand the rigors of crating and shipping better than canvas.

By this time the medium has warmed up sufficiently for Coleman to pour it on the palette, where it gels. But it doesn't stay in a solid state; the medium liquifies again as soon as a brush is dipped into it, only to re-gel when the brush is taken out. These transformations led Coleman to prefer Maroger to all other mediums: "The consistency of the medium preserves the striations of the brush strokes. You can overlay or crosshatch, and it doesn't flow out. Most mediums are not substantial enough to do this; they flow out, and you can't control them. I think this is why so many amateur painters have such a miserable time: they just don't use the right medium."

Coleman starts a painting by roughly sketching in with the medium a few elements of the composition: the top of a tree, a mountain ridge, and a few other key elements. Then he begins at the top and works

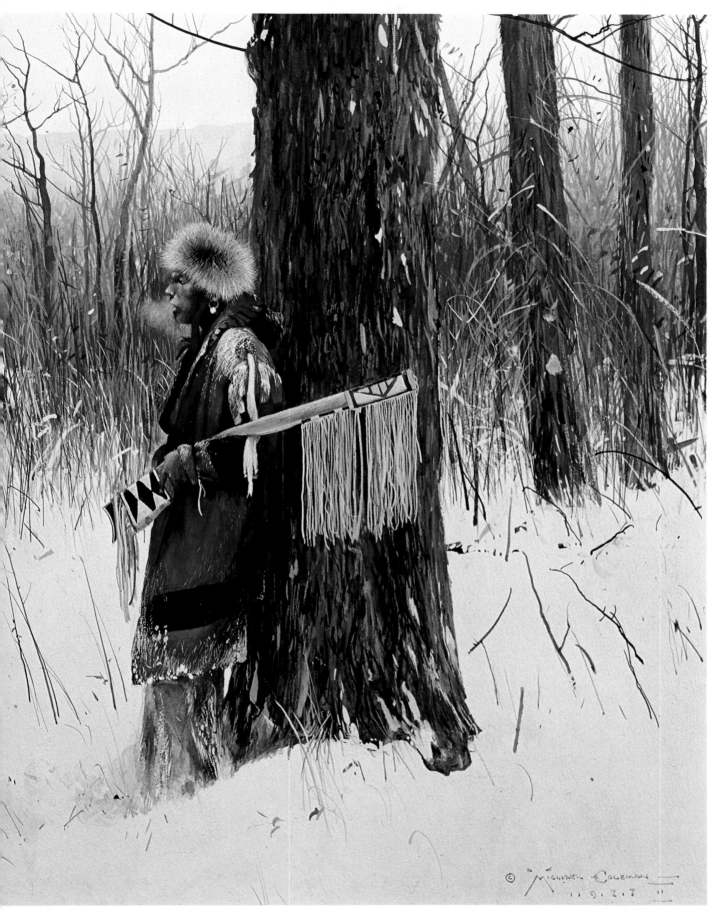

Waiting in The Woods—Crow, 1976, gouache, 13¼ x 17½. Courtesy Kennedy Galleries, Inc.

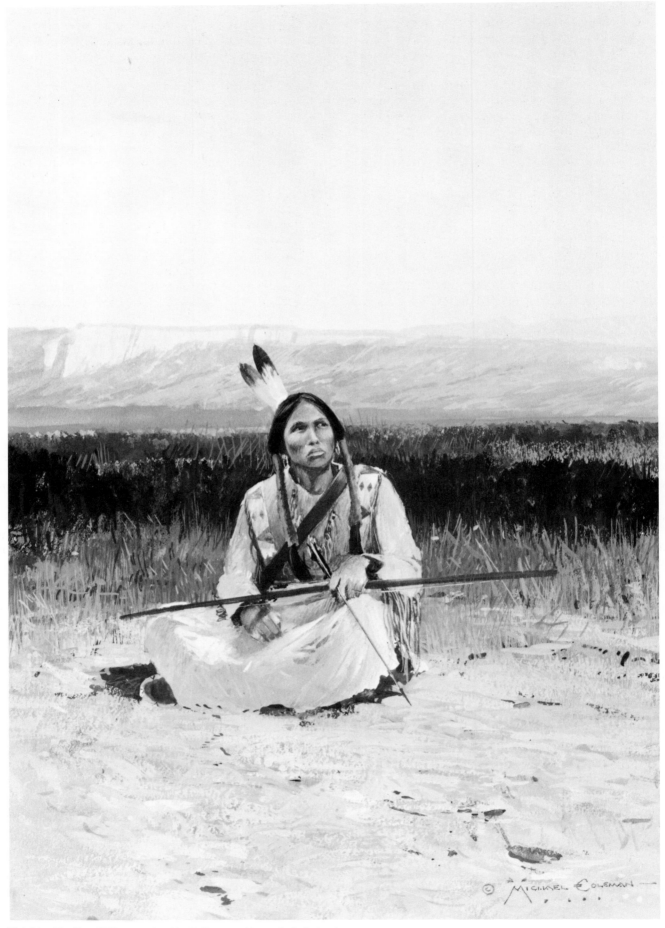

Watching The Sky, 1976, gouache, 11 x 7. Courtesy Kennedy Galleries, Inc.

down. First comes the sky; clouds, sunstreaks, different colors are put in. The pink of the gessoed panel may be allowed to shine through the blue to set up interesting vibrations. Once all the elements have been painted in, he stipples the entire sky with a bristle brush until gradations are very smooth. When he is finished, no brush strokes are visible and no light is reflected. Continuing down the panel, he works until he has laid in the whole scene with few exceptions, a process that takes a day.

Now comes the hard part: finishing. "I hate to do it; as a result, in the past month I have begun, but not finished, 21 paintings," he admits. Finishing a painting can take some interesting turns, however. Recently, for example, Coleman was having a difficult time finding the right objects to complete a composition. He puts certain objects such as animals or structures last after the panel had dried so they will have a different texture than the rest of the panel. In this particular painting he tried putting in some cows and then some other animals, but nothing worked. Suddenly he remembered another aspect of the landscape he had never painted before: Indian tepees. They were perfect, and the idea started him on a series of Indian-related panels.

As he grew up in Utah, tepees are part of Coleman's natural history, but other aspects of Indian culture are not. The funerary custom of wrapping a corpse in a buffalo robe and raising it on a scaffold, for example, was outlawed long before he was born. So, to describe this custom as well as others accurately, research is necessary. Fortunately, Brigham Young University in Provo has a large collection of books and photographs which he can study.

In the years since Coleman left college, he has achieved phenomenal success. Yet a lack of sophisticated knowledge of the business world nearly nipped his career in the bud. Anxious to prove that he could make a living as a painter, he became a natural victim for an unscrupulous agent. The man offered Coleman the security he was looking for: the price of paintings, minus commissions, plus a monthly stipend, whether or not his paintings sold, in return for all of his work. What could be more enticing for a 21-year-old beginner? Coleman signed on the dotted line.

For a time he was well satisfied. The agent in Salt Lake City had no trouble selling the paintings. And he did send Coleman monthly payments. But money from the sales was not forthcoming, although excuses were: the paintings were being bought on time, or the money was being put into an account for him. At first Coleman had no doubts. Then he read the fine print of the contract and found out just how badly he had been taken. No financial provisions were included in the contract at all. Even more catastrophic was the fact that the contract was binding not for one year, as he thought, but ten.

Coleman stayed with the agent's gallery for three and a half years, trying to get his proper share of the sales. Finally he sued, but it was too late. He was only one of many suing the agent for a variety of reasons, and the amount Coleman settled for out of court was far smaller than it should have been. Looking back on this deception, he feels it might have been prevented if, somewhere in his art training, his teachers had mentioned the realities of the business world instead of letting students learn the hard way, as he did.

Depression marked the next stage of his career. Since he had no gallery or outlet for selling, painting became painful: "I love to paint, but without knowing that someone will see a painting and want to hang it, I find it hard to paint. Even though I knew I would get another gallery sometime and even though I knew I had to paint to be ready for that time, it was all I could do to force myself to work."

Coleman was fortunate. His dealer, dishonest as he may have been, was an excellent salesman. And through his many clients, other galleries throughout the West began to learn of Coleman's work. After the contract was dissolved, they got in touch with him to ask for paintings on consignment.

Today Coleman gets along well with his dealers. He has no contracts—paintings are shipped on consignment, and accountings are made accurately. He is satisfied with the price put on his paintings by the galleries, even though they are conservative. "Smart galleries like to work prices up slowly, particularly with a young painter," he says. "Too often, if prices go way up, this goes to a painter's head. He spends wildly, gets off the track, and pretty soon his quality goes down." And Coleman keeps prices uniform no matter where they are sold—even in his studio: "People frequently feel they can make deals with the painter, so, when they ask to see my work in the studio, they're always surprised when I tell them the paintings are the same price as they are in the gallery. I think you have to be fair with your dealers and not try to undercut them."

Coleman does not have much inclination to travel any more, even if the travel involves painting. Once, several years ago, he went to Scotland to paint the landscape. He returned disappointed in what he saw but convinced that his sources of inspiration lay in the American West. If he never leaves Provo again, he has all the countryside he needs to paint: "Just outside my door I can see the high mountains, the low foothills, the canyons, the waterfalls. Even the steel mill 20 miles up the valley adds something to the scene. The ash it spews out enhances the already spectacular sunset." From the threshold of his home he can find a lifetime of subjects.

Many artists have been inspired by the grandeur of the Western landscape and have moved there to paint it. But few truly understand it in the way Michael Coleman does.

ROBERT DASH

BY DOREEN MANGAN

ACRYLIC PAINT is the perfect medium for Robert Dash. Impatient, prolific, and with a distaste for turning his studio into a chemistry lab, he wants nothing to interfere with the act of painting. His works reflect his clear, uncluttered approach. Huge landscapes emerge under his bold, broad, impetuous brushstrokes, rapidly and decisively applied. Spontaneity is the soul of a Dash painting. The artist is making a statement about his personal response to his environment and has to get it down quickly. Acrylic, he finds, provides the best means.

But acrylic paint, the wonder child of the art scene, is not regarded so favorably by some artists, who object to it on several grounds. To Dash their objections are either unimportant, or he turns them to his own advantage. For instance, an artist of the contemplative kind who likes to ponder his composition and plan his brush strokes would be unhappy with the rapid drying quality of acrylic. Yet this very quality appeals to Dash. "That's why I use acrylic," he says. To have to wait a few days for a passage to dry would be utter frustration for this painter who is so eager to get on with it.

His technique is the simplest one possible using acrylics—the opaque technique, corresponding to the alla prima method in oils. He applies solid layers of color with fairly thick brush strokes, aiming for the final effect right from the start, instead of building up layers of opaque and transparent color. As he applies the paint—dipping his brush in water, shaking it once, and loading it with color—it is about the consistency of oil, but ordinarily it takes only about seven or eight minutes to dry. If it's a humid day (and there are many on Eastern Long Island, where Dash lives), drying time is about 15 minutes.

Color is another area in the acrylic controversy. In fact, it was over color that the Dash-acrylic partnership almost came asunder. His first attempts with this plastic-based medium ended in disaster. "The colors were just awful," he says. "They were garish—something like the neon lights of a Chinese restaurant reflected in a puddle. So I threw the paintings out the window and returned to oils." Luckily, he tried acrylics again—with greater success. Although he can't

pinpoint exactly what he did wrong the first time, he has since learned to moderate the colors. "Perhaps I was beguiled by their brightness," he reflects.

Some artists feel, though, that acrylic colors can't compare to oil. "They lack a certain vibrancy," an artist complained to me once. But Dash doesn't agree. His colors now, he claims, are just as they would be if he were painting in oils. Working for a cool effect, he produces clear blues, crisp greens, and flower colors of pink, beige, and burgundy. He captures color where one would not suspect color to be. For instance, the soil in winter: "It has a bistre, white-like quality that at first seems colorless. The colors in winter are fugitive—tans, grays, blacks," he continues. "But after some study, you begin to notice touches of pink on a twig, a violet in the shadow, what the sunset does to the frozen earth."

Often, when doing a series, Dash will find himself involved in one particular color; then that color and its gradations will predominate in the series: "It could be all blues, for instance, or all pinks." In one recent series on roads, grays were the keynote.

Dash's palette is not extensive: "I have one black, one brown, one white, one blue, one red, and two yellows." These are Mars black, raw umber, titanium white, phthalocyanine blue, cadmium red medium, cadmium yellow medium, and yellow ochre ("a borderline earth color; it lifts flowers, giving them a more heightened quality"). It's a limited palette, but its potential is vast. Dash knows his few colors thoroughly, works with them rapidly, and gets maximum effects from them.

Dash feels his paintings avoid what he terms "the acrylic look"—a dull, dry finish—even though he uses no medium with his paint other than water, nor does he varnish his finished work, as many acrylic painters do, to impart an oil-like luster. "When I first began using acrylic," Dash says, "everyone turned up their noses because they felt it didn't have the luminosity of oil." He thinks his finished works look like oil paintings, though he's at a loss to say exactly how he achieves this.

The blending quality of acrylic is not that of oil. The constant brushing and rebrushing of a passage to

A Walk in the Spring, 1973, acrylic on canvas, 70 x 60. Rather than carefully blending colors to achieve subtly modeled forms and edges, Dash paints flat areas of color. Uneven brush strokes applied over areas already painted provide a rough blend of color, as in the foreground.

Sagg Cemetery and Robb House, 1973, acrylic on panel, 10 x 12. Despite the loose, spontaneous effect of this winter scene, Dash counts this as one of his more tightly painted works. He feels its small size was a major factor: the smaller the canvas, the shorter the distance available for free sweeping brush strokes; therefore, more careful control is automatic.

achieve the subtle gradations that are unique in oil painting is out of the question. Some artists would find this a drawback. But it poses no problem for Dash. In fact, rough blends and sharply delineated edges define his style. The different shades of color on the road in *A Walk in the Spring*, for example, are merely uneven brush strokes applied in the most casual manner on paint that has already dried, allowing the color underneath to show through to achieve the blend. Look too at the shadow effects on the telephone poles in the same painting: merely strokes of lighter color, applied to the edges of the poles. The result is often irregular and uneven, yet curiously effective. Dash rarely applies wet paint on wet paint—a recommended blending technique for acrylic painters: "I sometimes do it if I'm in a hurry and really don't want to stop for a few minutes to let the underpassage dry. But when I do, the result is the same as when I apply wet on dry. I'm not after a different effect, just speed."

For this artist, then, acrylics measure up to oils in every way. In every way but one, he confesses: "I miss the smell of oils." Obviously, a small sacrifice to make for a paint that allows him such freedom.

But perhaps the greatest appeal acrylics hold for Dash is that, since all he needs is a brush dipped in water, they allow him to work with paint in as pure a form as possible. For it is paint and only paint that is his métier: "I deal with large masses of color that are in themselves meaningless. It's a question of counterfoil and balance. I don't care what those masses of color end up as, as long as they interrelate."

There's no doubt what creed Dash is voicing: "If I come from any academy," he explains, "it's that of the Abstract Expressionists. Their lesson is that the sole substance of painting is paint: Why do you have painting? Simply because it is paint; just as music is tone, poetry is words, sculpture is matter."

The question naturally arises that, if paint is his sole concern, why bother with subject matter at all? The reason: the quest for individuality; for personal style. "At one point I was painting like everybody else and was doing very good paintings, à la mode," he says, referring to his work in the Abstract-Expressionist manner. At this point in our interview his dog grunted in his sleep, as if in disgust. "That's exactly how I felt," Dash smiled. "But one day I did a painting of three ladies sitting on a desert island, the sort you see in cartoons. They were hugging their knees and wearing dark blue sunglasses. It was like the return of the muses. I knew this was where my personality in art would be."

That happened over ten years ago, and Dash has been a realist ever since. That he was always meant to be a realist, Dash is convinced: "When you begin to paint, all of your themes are already in the work in a suggestive way: in a way that the painter isn't aware of at the time, but which later comes out."

"You end with what you begin," reads a self-composed aphorism, one of the many which Dash is in the habit of painting on his studio wall as he works.

Sunday Morning, 1972, acrylic on canvas, 70 x 50. Collection Mr. and Mrs. J.J. Esteve. Dash creates an illusion of atmospheric space. Notice the sky breaking up the lines of the telephone wires.

But what kind of a realist is Robert Dash? He works from color photographs of his subjects, yet he is no Photorealist. Seeking to portray a subjective response rather than photographic detail, he is concerned with the time of day, the light, the atmosphere. With a few swings and swishes of his brush he creates a whole environment. "I believe in painting what one looks at most," he states. In this sense his views are consistent with those of Pop Art adherents. But his attention is never so minute. It is not the label on a soup can that intrigues him; rather how he can use his paint—his masses of color—to show trees edging a lane, the garden through a window, a dog sniffing, clouded skies, mud puddles, and telephone poles.

John Ashbery has described Dash's work: "What is so beautiful about his paintings is that, for all their generality . . . the pathos and quirkiness of 'daily' life do come through here and there, casting a strange change over the whole nature of the picture, as though the scene had been photographed by some kind of spiritual camera."

Shadowy people move in and out of Dash's paintings, but not frequently. Two blotches of color may indicate a face. He explains, "In the instantaneity of the act of turning a head in bright daylight, the full impact of the features will not be visible except in the most dramatic outlines."

The light he paints is one of the major reasons Dash lives on Long Island, New York. "There are two distinct kinds of light here that come from the Atlantic Ocean. There's the light of milk that lasts about six months," he says, describing a light that comes "vibrating and glowing" through the wintry sky of clotted whitegray clouds. "It's a light that glows," he says. "The effect is not dull and leaden, and there's an even cast to it." This is the light Dash sought to capture in *Sunday Morning*.

"Then there is what I call 'Pilgrim' light, which comes in autumn and then around March." This is a clear blue light.

Like his work, Dash's studio indicates that for him, simplicity permits spontaneity. It is neat, uncluttered. Indeed, at first glance one wonders whether there really is an artist at work here, or if the area simply is a spacious extension of the living-room area. Where are the rows and rows of paint tubes, jars of brushes, palette knives, rags and sponges, and the one or more easels—the usual trappings one is accustomed to seeing in an artist's studio? The answer is easy. Dash works with only the bare necessities.

"As one becomes more certain, the things one needs are fewer," he points out. "A good cook, for instance, needs one pot, one pan, one knife, one spoon." So, like a good cook, this artist allows as little as possible to come between him and painting. His only easel is a small French folding one, used for his tiny panels. The large canvases hang on his studio wall. A long fluorescent light runs around the top of the wall. It enables him to work by night as well as by day: "a holdover from my days in a studio near the Bowery

in New York City. It was so noisy during the day that I only painted at night." Another reason for the fluorescent light is "a desire on my part to paint the painting in exactly the light it will later be seen in," Dash adds, "I know of no art gallery that has natural light."

Aside from his seven tubes of paint and his flat bristle brushes, his only other tool is a housepainter's brush, which he uses at times to lay in a large area of color—a clear sky, for instance. Dash uses no palette knife—"I'm not an impasto painter"—and no sponges. A paint scraper's trowel is his tool for removing paint from the palette, moistening it first with a little water.

The palette stand is actually a little cart—a doubledecker wagon built, Dash says, to resemble the wagon used in a lumber yard. It is also a distant cousin of the hospital wagon that is used to convey food and medication to patients. In fact, Dash has one of those wagons (bought from a hospital supply house) in his summer studio. The top deck of each wagon is a sheet of glass, painted white underneath, that holds his paints and two coffee cans of water. The lower deck holds his brushes. When the artist takes a break from his work for an hour or so, he drapes a sheet of ordinary kitchen Saran Wrap over the paints to keep them moist.

As simple and to the point as his tools are, so are Dash's preparations to paint. He primes rough, raw linen (stretched for him in New York City) with two coats of rabbitskin glue and two coats of gesso. The glue and gesso duo make for a strong, taut surface. When he occasionally uses a Masonite panel, he has it cut in a lumber yard according to the size he wants. "I smooth out the edges with light sandpaper. Then I very lightly brush the sandpaper over the surface to increase the panel's adhesive quality." He then applies two coats of gesso.

The painting begins with a tonal sketch of the subject in raw umber, cadmium red medium, and white. The drawing is not so much to establish the final composition as it is to serve as a guide or indicator. Or, as Dash so much more expressively states, "A white canvas is like a dark room. The preliminary sketch in its adumbrations is like a flashlight held in the hand as you walk, briefly striking objects but not clarifying them." Once the sketch is completed, he's ready to paint.

There are usually three paintings under way at the same time. When I visited his studio he was working on a 6' x 9' landscape, on a flower tondo, and on a 10" x 12" acrylic on Masonite. The latter's subject was a tennis player in motion.

Dash has a penchant for very large works of the 6' x 9' variety that accommodate his generous, expressive manner of painting, as well as for small ones of about 10" x 12". He has even done some as small as 5" x 7". Sometimes the small works are studies for larger ones, but more often they're paintings in their own right, done for discipline. "I can give them closer scrutiny," says Dash. "It's like a musician doing Scarlatti before Brahms." How long does it take him to

That July Afternoon, 1973, acrylic on canvas, 60 x 70. The artist develops a play of light areas to examine the quality of summer afternoon light. Notice the color relationship between interior and exterior light, between direct and reflected light.

Right: *Daily Blow*, 1971, acrylic on canvas, 20 x 20. Collection Londy Pirosi. The artist designs his shapes so that the diagonals of window and drapes lead the eye in to the garden, only to be countered by the flat expanse of the building, the sky area, and the diagonal of the rooftop.

Below: *Sagg Main,* 1971, acrylic on canvas, 50 x 70. As the road recedes, the trees in the foreground increase in dimension, creating a sense of depth. Notice the glowing sky. Although Dash placed it in the background, he threads it through bare branches and telephone wires to the foreground, creating an illusion of space.

complete a painting? "I don't keep records," he replies: "anywhere from a few days to a few years."

Dash's straightforward approach to painting is echoed in his ruthless appraisal of his work. "Every six months there is a summing up process," he explains. He arranges his paintings against the wall and scrutinizes them. He decides which are successful and what to do with those that are not. "There are some that seem to have hints toward future acceptance. Those are kept. Some are utterly wrong and are destroyed. I don't believe in hectoring a painting that is going nowhere. Instead I prefer to extrapolate a good section; that is, make a drawing and put it away for a few years, discarding the actual canvas." At his last weeding out, Dash destroyed "about 40"; 28 were sent to his gallery. Both figures indicate his productivity. (Before Dash throws out a painting, he slashes it. He tells why: "Once I threw out a rolled-up painting on the garbage dump. A few days later I saw it for sale for $5 in a junk shop. It was bought by a fellow painter who offered me $20 to sign it!" Needless to say, the painting went unsigned.)

The artist himself, 6′2″ and prematurely gray, is cultured and sophisticated, with a fine sense of humor. He studied English and anthropology at the University of New Mexico, but he has not formally studied art. "I'm largely self-taught," he says. "I learned in the museums and in the studios of friends."

He goes about his work with the dedication of a man who knows that the only way to real achievement is through unremitting effort. To this end he has carved out a semi-rural niche of solitude in a Long Island of rising industry and summer trippers. There he works seven days a week from shortly after dawn until late at night, with short breaks for meals, errands, and a walk with his dogs. It is a regimen that would seem Spartan were it not for the fact that Dash is so thoroughly devoted to his work, and thus enjoys it.

He has other accomplishments, including those poetical and musical. But in pursuit of his art he has eliminated these and other avocations from his life. One thing he has not eliminated, however, is gardening. Dash's garden and the summer house that surrounds it (500 feet from his winter home) are renowned for horticultural and architectural achievement and have been subjects of his paintings. The garden's rose arbors were bare the day I visited, and the garden was hidden under a crust of frozen snow. But in summer, blue lobelia, green zinnias, Russian sage, musk and damask roses, wild irises, and many, many other flowers run riot in what he terms his "old-fashioned English cottage garden."

"I wanted a garden full of easy flowers that looked as if they got together and did it all themselves," he is quoted in *House and Garden* magazine. And he has succeeded. At its best, the garden shares the same exuberance, vitality, and bravura that appear in the paintings of the man who planted it.

KEN GORE

BY CHARLES MOVALLI

A LEDGE EXTENDING out from the base of the skylight in Ken Gore's studio was filled with containers of all shapes, sizes, and materials. Over in a corner a bouquet of milkweed pods had exploded, sending seeds cascading like foam down the side of a metal vase. Gore sat in an overstuffed chair beneath the skylight, and as the daylight fell onto his plaid shirt and metal-rimmed glasses, he took an obvious pleasure in explaining how his studio "worked." He'd designed it himself, been the chief "helper" to the builders, and takes pride in its economy and flexibility. Inconspicuous storage areas hold 50 chairs for demonstrations; student easels, designed and built by the artist, hang in a side closet like so many overcoats. Organized yet open to changes, the studio symbolizes its designer, a painter interested in the world around him and awake to new experiences.

Gore puts both hands on the arms of his chair. His face brightens as he laughs and says, "Someone came into the gallery once and asked me how many *different* painters I represented. He was surprised to find I'd done everything: 'So many different approaches,' he said. Well, I asked him, what did he expect? They look different because the subjects are different; I like to respond to what I see on its own terms. That's one reason my real studio is the outdoors. I don't like to restrict my subject matter—nor, for that matter, do I like to restrict my palette. I draw with color, not line, and out in nature I want to have a full range. I have enough trouble, for Pete's sake, without worrying about mixing."

Gore points to a painting of a large forest interior on an easel in one corner of the studio. His black smock hangs from one of the easel's screws, near the palette knives, which are his main artistic tools. "In that painting," he continues, "I could have mixed a blue with my orange until I got the right color. But why spend all that time when I know terra rosa is what I want? You notice there isn't much red in that picture, either. And very little blue: how's blue going to get into it with the sky shut out by thick trees? So I set up an appropriate palette. Let's say I was restricted to ultramarine blue. What if I need a really tender blue? Ultramarine's too purple for that, but

something like manganese is perfect. So I carry it."

Gore gets up and goes to a closet that opens on a set of specially constructed sliding shelves containing countless tubes of colors. He begins to pull them out: "You'll find this interesting. I think it's good to watch new colors as they appear—as long as you check them for permanence. In commercial art you can get brilliant effects with doubtful colors, but not in, let's call it, 'serious' work. Look at these Acra colors. You can get beautiful reds with them, and they're more brilliant than cadmium or alizarin."

Gore goes on to note that, depending on his subject, he adjusts not only his palette, but his technique as well. "In that fog scene," he says, moving toward a stack of pictures in another corner, "it would have been silly to give the whole canvas an equal texture. If the distance had been filled with paint ridges, nobody could have made anything out of it. I like my viewers to see what the subject of my picture is." He laughs. "I like them to know that much, at least! So I worked up the foreground water and left the background fairly transparent. In the maple surgaring scene next to it, the foreground snow is thick—but, as you look off past the sugar house and into the forest, I've left my turpentine underpainting as is. Start filling that up with paint, and you've lost everything. It's all a matter of restraint. In this other painting," he says, moving a picture, "I've gotten a feeling of strong light by keeping only ten per cent of the canvas in full light. That's an interesting effect."

Gore sits down, stretches, and rubs his forehead. "I've traveled some," he continues. "Mexico's some place: there's a strong overhead light there, not like the slanting light of New England. Up here the dark earth absorbs much of the light; down there the earth is almost white, so the light pours down from above and then bounces back up into everything. Interesting. A change of locale is good for you. But still, I can get just as excited as ever by local places. I'm always willing to give a subject a second chance." He laughs as he says this. "Of course, you have to have sense enough to pick a subject that composes. I know loads of people who set up in front of the darndest subjects: nothing the least bit interesting in them.

Beeches on the Agawam, oil, 30 x 36. Collection the artist. Using as full a palette as possible, Gore responds to each subject in its own terms. ''I draw with color,'' he says.

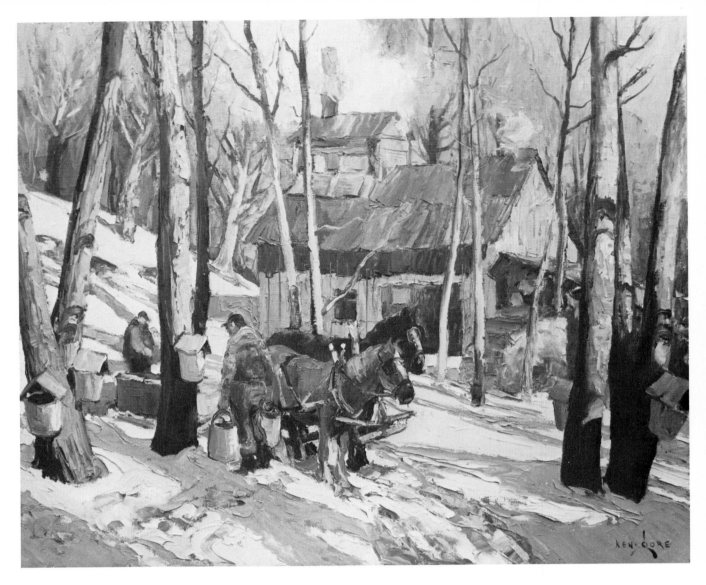

Above: *Sugaring Time,* oil, 30 x 36. Collection
Mr. and Mrs. Hugo B. Myer. Small patches of
light alternated with strong shadows create
the illusion of bright light overall.

Right: *A Footbridge in Mèxico,* oil, 30 x 36.
Collection Louis Hirshfield. Subtle differences
in texture—pueblo, brick bridge, sand—dem-
onstrate Gore's claim that the palette knife
can be as versatile as the brush.

Above: *Heavy Laden,* oil, 24 x 30. Collection James Joyce Prebble. The artist is usually attracted to shapes and light. Here his keen sense of shape relations creates the illusion of a snowy wonderland.

Left: *Symphony of Autumn,* oil, 30 x 36. Private collection. Gore utilizes underpainting, palette knife, scraping out, and a few brushstrokes to create a feeling of hazy air, a soft mauve foggy atmosphere.

Sugar House, oil, 24 x 30. Collection Gary Williams. In this scene, which new methods of gathering sap have made a part of history, Gore subordinates the background by developing a heavy impasto in the foreground.

And then they wonder why they can't paint them. Why, there's just nothing there! That's something that comes with experience, that pictorial sense.

"I can tell you about one place. In winter I go out with snowshoes and a tarpaulin. I got out in the woods one time and spread the canvas—it's about ten feet on each side—squashed it down about six inches into the snow with my snowshoes and then forced it down another two or three with my boots. In no time the area got as hard as this floor. The snow was four feet deep, so if you just set your easel up on top of it, the easel would sink down to nowhere." Gore says "nowhere" with great energy, then goes on: "I set up my easel at the tip of the diamond-shaped canvas, then put my snowshoes out on the snow at the opposite tip—just a few steps farther, so I could step back maybe eight or nine feet altogether and get a good look at the picture. I painted a horizontal picture at this spot one day. The next, I did a vertical, featuring what had been in the background of the first picture. I came back the third day, put my easel at another corner of the tarpaulin, and painted some dark trees and water. (I *love* that kind of subject.) And then, the

fourth day, I subordinated the trees and painted the whole stream. I got four pictures from that one place, but you couldn't tell it from looking at them. Something different caught my attention in each picture.

"There's another place in back of Saint Ann Cemetery: walls on two sides and a broken fence; maybe the whole place is a hundred by 75 feet. The fence has big, old nails in it, broken slats, the whole shabingle. Just the thing for me. I've gone there maybe five or six times a year for the past 20 years. That's a lot of pictures, but they're all different. Consider the possibilities: summer, fall, winter, spring; morning, noon, afternoon, dusk; sunny days, overcast days; dry days, wet days; snowy days. And then there's the matter of selection: I could do a closeup of the wall one day, then a big tree picture. After that I move 20 feet, and everything changes; maybe I work for the light behind the trees and play with disappearing edges. If I went there one day and couldn't find something new, I wouldn't bother to set up."

He looks over at some recent pictures, done on a month's tour of Nova Scotia, and points out a few corrections he plans to make. "I'm not a literary

painter—an illustrator," he says, as he turns away from the sketches. "Usually I'm attracted by shapes and light effects. Those shape relations are more important to me than content. Look at someone like Frank Brangwyn. Now, Brangwyn could make a beautiful design out of almost anything, even the most insignificant subject." He goes to some built-in cases filled with books and records and pulls down a volume: "Here's a Brangwyn I really like," he says, leafing through the pages. "Now, what could be more insignificant than some leeks and a few onions? But look at the picture he makes out of it.

"Maxfield Parrish had the same ability; a fine decorative sense, a wonderful ability to handle tree masses against the sky. I remember how I liked his pictures as a kid. Especially those landscapes that couldn't exist anyplace but in his head."

Gore takes some examples of his student work down from a series of racks that reach almost to the top of the studio. They are large pictures of working men, painted with a knife. "I use a knife," he says "because I can do with it what I want to do. I don't think the result differs necessarily from what you'd get using brushes. Of course, I *do* use a brush on my turpentine underpainting. I want to be sure the design is right before I start to lay on the paint. Otherwise, where would I start? But brushes always gave me trouble.

"You know how some people have it easy in art school? I always had trouble. I studied with George Rich, a fine painter who'd studied with Robert Henri in New York. Mr. Rich had a loose style, painting everything with one-inch brushes, flats. I've seen him do a 9 x 12 painting with them and fill it with detail! So I spent two years with him in art school and another six or so outside, on Saturdays and Sundays.

"He always had a wonderful variety of models in class. Well one time we did a little girl, pink skin with a pink dress against a pink background. The job was scheduled for twelve hours and, as usual, I got down to the last hour of the last class with about 48 dirty brushes in my hand and everything going wrong. (I didn't have any discipline; that was my trouble. Mr. Rich would tell me, 'One brush for your light warm colors, one for your dark warms; one brush for your light cool colors, one brush for your dark cools. Four brushes,' he'd say, 'are all you'll ever need.') So I was down to my last hour and in a mess. I had nothing to lose, so I picked up a palette scraper—no kind of tool at all—and began to horse around with it. I immediately found I was getting effects I couldn't get before. And I managed, in that hour, to save the picture. I thought to myself: If I could do that at the end of a painting session, why not try it at the beginning? Mr. Rich, in the meantime, had been watching me fool around. He brought over a Frenchmade knife and placed it beside me. 'If you're going to work that way,' he said, 'at least use the right tool.' And he walked away."

Gore has been illustrating his points with pictures that are now stacked three deep along one wall. "All

Bend in the Stream, oil, 24 x 20. Collection Walter F. Hildebrand. Gore feels it's important to select a subject that composes well. Dark trees and water are two of his favorite subjects.

those years with Mr. Rich were devoted to indoor work: still life, figure work," he continues. "I never had a landscape course as such, though for six weeks, when I first came to Gloucester, I participated in a series of Saturday critiques. We'd all bring pictures to Aldo Hibbard's studio, and he'd go down the line showing what was wrong with each one—why it was wrong—and then he'd suggest two or three different ways to correct the problem. With years of painting he'd developed an eagle eye. I learned more in those six sessions than in all my time at art school—except, of course, my time with Mr. Rich.

"Mr. Rich's indoor work was valuable to me because it taught me how to see. In his drawing classes, at the Meinzinger Art School, he'd pose his models first for half an hour, then 20 minutes, then 15, and so on, until we were down to a series of minute or minute-and-a-half poses. Now, when you get to that stage, you can't do much. Mr. Rich wanted us to get a sense of general pose. How did it compose: oblong, circle, square? And then, of course, the proportions: the sense of shape was what counted. Trees compose in a similar way," says Gore, pointing to the easel

Morning at the Cove, oil, 20 x 30. Collection the artist. Gore feels that nature supplies the objects for a painting and that the artist's job is to supply the composition. Here he places a slow diagonal of ships against a broad expanse of water, made to seem even broader by a high horizon.

again. "All you have to do is see the basic shape and proportions. No matter what you paint, you have to ask yourself, how do the parts fit together?"

Despite all his early indoor work, or perhaps because of it, Gore repeats that he prefers painting directly from nature. "That's where I get 'inspiration.' When I'm out there, I like to do 'em, pack 'em, and bring 'em in," he says, waving his hand for emphasis. "Later I can set them up in here and decide where the composition needs adjustment. That forest picture was done in Nova Scotia. When I got it home, I could see that I'd overdone the light filtering through the trees. Too many parallel lines. So I moved some. It doesn't matter; forest light falls haphazardly anyway. Look for the good spots and put them in. If more appear as time passes, put them in too. Use anything that helps the composition." He gets up and moves toward the painting. "I think you'd find the highlights in this interesting. The forest floor is orange with dead leaves and pine needles. What color should I make the spots where the sun is hitting hardest? Now, Mr. Rich was fascinated by highlights. He claimed that they were almost never white, that all highlights have color. In this case, a white with some yellow wouldn't have been strong enough. Look closely and you can see I added the slightest touch of the complementary, violet—but just the slightest touch.

"Look at this still life over here. The highlights were the real subject of this picture, and I had a ball painting it. Note how they're blue in some cases, red in others. And notice, too, that I tried to control my textures. I wasn't going to get a feeling of transparent area, that's okay—this is supposed to be opaque glass—but not here. In fact, there are passages in this that look more like brush work. That's what the area demanded, and so I used the knife accordingly."

Gore goes over to a corner and pulls out a slide projector. It flashes photos of his own pictures onto a small glass screen, and he explains how useful the machine is when he's working with gallery people. He notes that with the light coming from behind the slide, his work ends up looking more like nature than paint. At the same time, he shows how one brand of film can give a warm tone to the photo while another cools everything down. "For Pete's sake," he says, "if I can't get an accurate picture of my own paintings, you can imagine how misleading a slide of nature itself must be. Lots of people paint from color photos now, especially amateurs. But what bothers me is that they get too attached to them. Photos should provide objects to be manipulated into a composition, nothing more—just like nature supplies objects outdoors. The artist has to work out the design. That's his contribution. He then goes on and tries to get nature's color and, of necessity, fails. Well, photos are less than no help there. It's crazy to try to get color from them. Reds are redder; blues, bluer; greens, greener. Not only that, but the camera isn't any good

at catching what's really interesting. It can't see into shadows, and it doesn't register reflected light—at least, not the kind of light *I* see. So it's easy to tell when a picture has been done from a photo. One sure giveaway is black shadows." He turns his body a little. "I suppose I could have taken a picture of that scene on the easel and used it as reference when I brought the incomplete painting back." As he thinks about the idea, he obviously becomes less and less happy with it. "No: it would probably be more a hindrance than anything else."

"You know," Gore says, after putting his projector away, "my getting into art in the first place is sort of unusual. There weren't any artists in the family. But when I was seven years old, I announced I wanted to be a landscape painter. I still have my first oil; I did it with a set my aunt gave me when I was nine. Not much of a painting, naturally. I knew then what I wanted to be, but down there in southern Illinois there weren't any professional painters for me to emulate or study with. By the time I was old enough to travel, there was the Depression. I didn't get to art school until I was 27. I spent seven or eight years with Mr. Rich while I painted signs, did layouts and gilt lettering—all kinds of commercial work. It wasn't until I was 35 that I set up as an artist." He leans forward slightly. "That's when I began to learn things, to accumulate experience. Experience is a great teacher. Mr. Rich used to talk a lot about 'broken color,' but I'll be darned if I ever really understood it. Years later, I was out trying to get vibration in a sky, and suddenly it was almost as if I could hear him over my shoulder saying, 'Break the color up.' I did it and it worked.

"Look at that foggy sky over there. To get the vibrant quality, I had to juxtapose colors. You look at any sky—most people don't, but try it—and you'll see that, after a while, your eye begins to dance around it. That's what the Impressionists saw, And they were right. Nature really is like that."

Gore rubs his forehead slowly: "A lot of this is beside the point. I was telling you about art school in Detroit. I'd been there a while when I saw some of Emile Gruppe's Cape Ann work at one of the galleries: unbelievably beautiful things. The best stuff I'd ever seen outside of museums—and I practically lived in the ones in Detroit and Chicago. If I had a nickel at the end of the day, I'd use it to ride down to the gallery and would stay till the place closed up.

"Finally a friend and I took a trip up here. I didn't get anything out of Provincetown, but Gloucester was great. Later, I took a three-month leave of absence and brought my wife here. She fell in love with New England. By that time I'd decided that if I was *ever* to become an artist, I'd have to leave Detroit. I quit work and we moved to Gloucester with just enough for a downpayment on a house."

Gore laughs to himself. "I remember when we had only ten cents between us. That was the day I got a letter with a check; a painting I'd left out west had sold. So we were back on our feet again. Alice could tell you a hundred stories about those days. Looking back on it, I don't know how we survived. When you're young, you're willing to take chances. But it was worth it. In my opinion art is the only place left where you can still be free. Free to paint as you want as long as it pleases you—without caring boo or beans whether it pleases anyone else!"

EMILE A. GRUPPE

BY CHARLES MOVALLI

FIRST YOU PASS through Stowe, a Vermont village filled with hostels, Von Trapp family singers, medieval signs, and plywood chalets. Then through the surrealistic landscape of Smugglers Notch and into Jeffersonville, a quiet town blessed—or cursed, depending on your attitude—with one skiable mountain. It's October, too cold for the summer tourists and too warm for the skiers. Along the road you see hunters with rifles over their arms. And painters—gathered here to take advantage of the scenery, now that the overpowering colors of autumn have begun to fade. In the foyer of the local inn there's a 30-year-old drawing. It's under glass and shows the inn crowned with mall stick, brush, and palette. Beneath this vignette there is a list of the inn's most eminent painter-guests: Harry R. Ballinger, John Carlson, Chauncey Ryder, Aldo Hibbard. The drawing is signed, "Emile A. Gruppe."

Since it's between seasons, the inn is almost empty. Most of the painters who headquartered here during the '30s and '40s have either died or stopped coming. But there are still a few diehards in the dining room, and most of them have come to spend the week painting with Gruppe.

(Emile A. Gruppe was born in Rochester, New York, and spent part of his youth in Holland, where his father was an artist-art dealer. Later he studied at the Art Students League in New York under Charles Chapman and George Bridgman and in Woodstock with John Carlson. He also studied in Paris with colorist Richard Miller. Gruppe settled in Gloucester, Massachusetts, during the early '20s and was among the earliest members of the North Shore Art Association and the Rockport Arts Association.)

Today is Wednesday and Gruppe is at a table with his back to the wall, busily sweetening his coffee and putting marmalade on his toast. He urges the party to eat heartily, because, "When you're out all morning, your body needs the food. "I've never seen it fail," he says, as he drinks his coffee; "there's always an Indian Summer up here around this time." He looks around the table. "Isn't this a great place? Aren't you glad you came?" He rubs his hands.

Despite his more than 70 years, his hair is still dark.

It's brushed back so that, with his large, broadly modeled head, he looks like a lion in a plaid shirt. He rests both his arms on the table and leans forward. "I introduced Aldo Hibbard to this spot," he says. "Hibbard had been working farther south, but after seeing this area, his one trip a year was always right here. I used to *live* here six months of the year!"

There's an interlude of small talk, and Gruppe's mind seems to wander. He wants to talk about painting, his primary, almost compulsive concern ever since he was in his teens, and he brightens up as the subject returns to art. "When painting birches, work for a star pattern," he comments, illustrating his point by spreading his fingers. "And get the rhythm of their movement. Not only the sense of 'reaching' that they share with all trees, but the twisting of one tree to avoid another. Now you," he says, nodding at one of his listeners, "started with some good birches yesterday—but did you notice that the longer you worked on them, the straighter they got? I had a lumberman at one of my painting demonstrations who told me it'd be impossible to get a straight plank out of the trees I paint. That's the idea!" Gruppe interrupts himself to exchange banter with the girl who brings his breakfast, then continues: "Always keep in mind the need for variety. Get one principal tree and then play the smaller ones off against it. But only *one* center of interest. See?" He gives the penetrating glance of a teacher who wants to be sure he's understood, and, after a moment of silence, he adds, "If you've said a thing once in a picture, that's enough."

He praises the Vermont breakfast eggs as he talks, but he claims they're nothing like the eggs in Gloucester, Massachusetts, Gruppe's home town. "They're fresh off the farm up there." He soaks his bread in the yolk, enjoying the food almost as much as the conversation. "Look," he says, "the key to this business is enthusiasm. Get yourself into your work. You have to feel what you're doing, feel it as you paint. Don't be afraid to exaggerate. If it'll add dignity to a harbor scene, lengthen the masts. I remember Hibbard telling me one day that some masts I'd shown across the harbor were much too high. Well, sure they were. But was it effective? That's what I

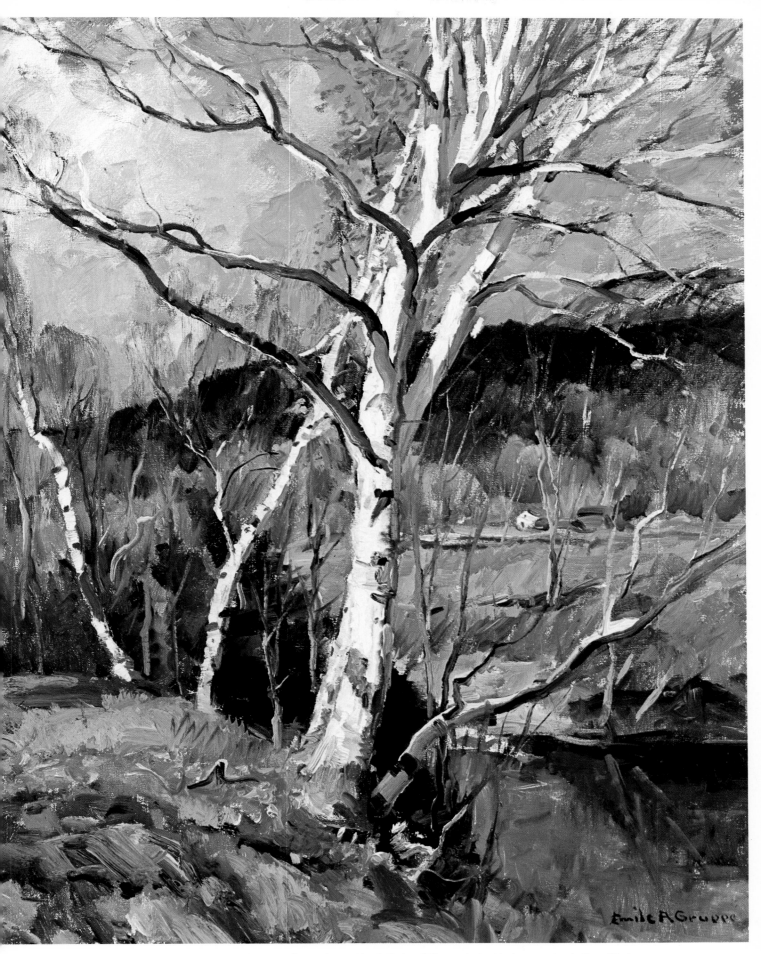

Morning Light on the Birches, 1972, oil, 36 x 30. Courtesy Grand Central Art Galleries. ''When painting birches, get the rhythm of their movement,'' instructs Gruppe.

wanted to know, and he had to admit it was." Gruppe smiles, "[Anthony] Thieme used to complain that all my workmen had pinheads. But that was the idea. I wanted them to look big—they were big guys down on the wharf—and to get that feeling of size, I'd made the heads small. You know, I went out a couple of times with a fellow up here who'd make all his mountains real humpy." Gruppe illustrates with his hand and continues, "I'd look at him and think to myself that it was too much; it would never work. But once he got it indoors, it looked okay. He'd given you a feeling of Vermont's rolling hills—and you need that if you want to get a sense of the state. Exaggerate! See that picture over there?" Gruppe points brusquely to a painting on the opposite wall, a Vermont scene he'd done 30 years ago. "I'd never paint it like that now. The hills are too straight, see? I've learned my lesson. Pick and choose. You know, a painter like Frederick Mulhaupt could take one sail and some fog and give you a whole sense of Gloucester. That's sensitive painting."

He begins to break up his bacon. "I'm a good one to go out with. I know all the best places. I can tell you where to paint on an overcast day and where to paint in the morning or afternoon. Each area is different at a different hour. Why, every time I go to a place, even if I've been there ten times before, it's always as if it were brand new!" He looks around the table again. "I'm going to try something new this year. I feel that my shadows have been too blue lately—so I'm carrying some umber in my paintbox." He adds the umber to his impressionist palette of two blues (pthalocyanine and ultramarine), two reds (cadmium red deep and alizarin crimson), two yellows (cadmium yellow deep and cadmium lemon yellow), an orange (cadmium), and zinc white. "Just a little umber, see? I remember when I was a kid, painting outdoors with the Art Students League, that I was doing up a picture all in browns. One of the instructors came along and put a bright slash of blue in the middle of a field! 'Sky color,' he said, and moved on. Boy, was I angry! But he knew how to make an effective point, something you have to do when you're teaching. It worked: it got me out of those earth colors. They're too opaque, dead. There's no light in them. John Carlson sometimes gave me an umber to carry around. But I'd

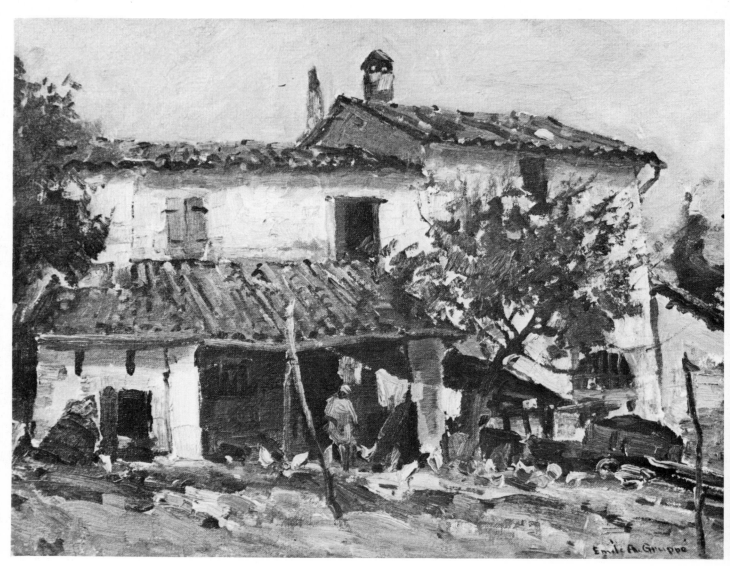

Rimini, Italy, 1968, oil, 16 x 20. Collection the artist. Gruppe's varied brush strokes capture the impression of each subject area.

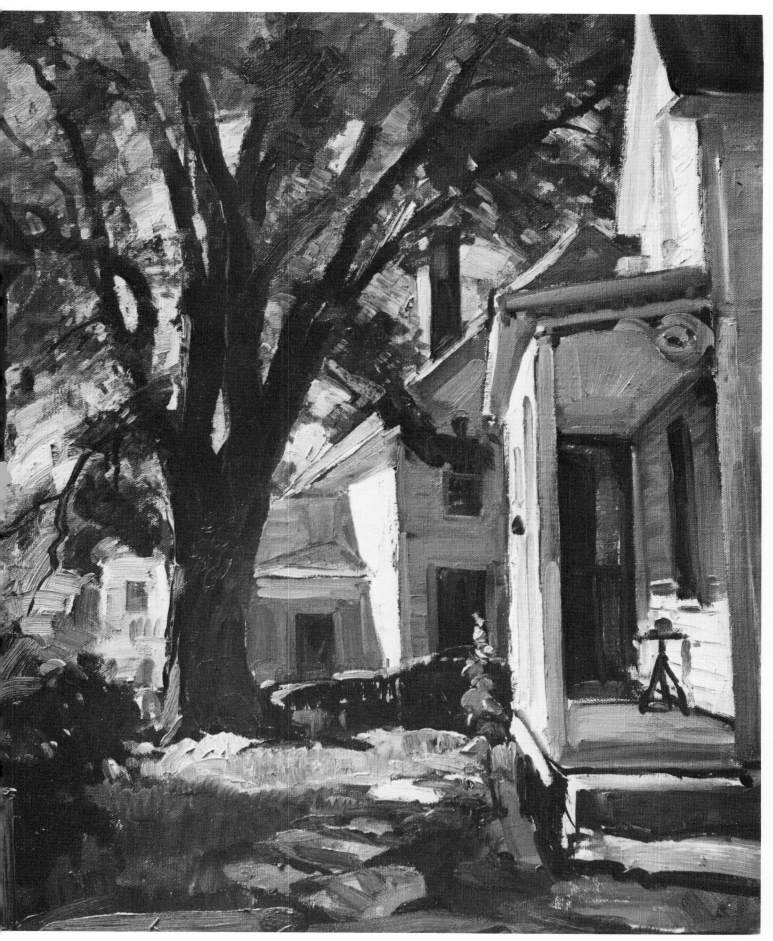

The Back Porch, 1960, oil, 24 x 20. Collection the artist. Gruppe uses the shape and placement of sunlit areas to create a sense of space and direct the viewer's eye.

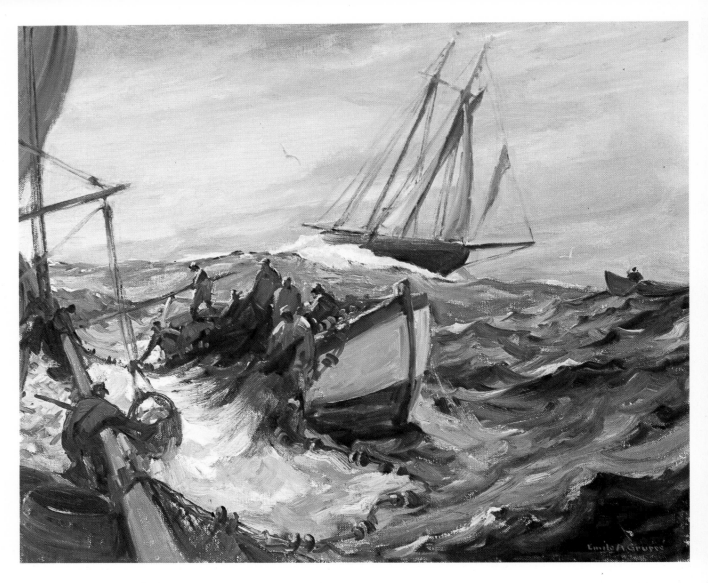

Above: *Hauling the Net,* 1973, oil, 30 x 36.
Private collection. Gruppe exaggerates the
curve of the waves and angle of the masts, to
support an illusion of turbulence.

Right: *Rainy Day, Vermont,* 1972, oil, 25 x 30.
Courtesy Grand Central Art Galleries.
Gruppe colors the barn to reflect both the
gray day and lush countryside.

never use it. Now I'm back to it." He sips his coffee. "A lot of what Carlson used to say to me makes more sense as I get older. You know, he never believed in finishing pictures outdoors. He always said the masterpieces were created in the studio. I never could agree with that. But now I'm beginning to think he may have been right."

The waitress fills up his cup. "Boy, this coffee is sweet," he says, and sips. "You know that picture I did of a farm yesterday? I'd done a similar subject before but with a cow and a horse toward the front, covered by a passing cloud shadow. You can do tremendous things with shadows—take a look at Frank Brangwyn. Now there's somebody you should study! This horse and cow: I'd seen the idea in a picture in New York. I didn't copy it. I just filed it away, see. If I see a good idea, I try to use it. I can trace most of my technical ideas back to this or that artist. Don't be afraid to profit by example. When I was young, people said I painted like Carlson. Why not? I believed in him! Every young painter needs to believe in someone. He told me values were important. He'd sit with me when I was a kid and point to my paintings: 'too dark here' he'd say 'too light there.' So I became a tiger for values."

Gruppe gestures, twisting his hand back and forth. "We're all imitators when we're young. Eventually we discover a personal language. I learned by watching better painters than myself; you learn more through your eyes than your ears. So I don't pay any attention when people tell me I'm giving away 'secrets' when I talk about my methods: people helped me when I was young; why shouldn't I help others now? Besides, I'm the only person who can paint like I do; I don't mind explaining tricks." He pulls himself short. "No, 'tricks' isn't the word. When I talk about refraction or the way reflections behave, I'm telling you facts, not tricks. You have to start a sky with reds and yellows if you want to get vibrancy into it And you have to start the ocean with anything but blue or green. Years ago, John Folinsbee came back from Paris all fired up with pointillism and talking about building pictures on the interaction of purple, green, and orange. I adopted the idea. It works because it's not a trick; it's based on certain facts about nature. In fact, it's the only way you're going to get a real feeling of light in your pictures."

Gruppe pushes his plate aside and leans on his arms. "You'll all end up painting what you like. If we set up in front of the same scene, we'd each accentuate something different. It's like four or five people telling the same story; the telling is never the same. Eventually each painter makes certain pictorial ideas his or her own.

"I can't drive along a road up here without thinking of Chauncey Ryder: you know, those little trees of his, sticking up in front of a mountain. My students liked his work. They made me ask him how he got his trees to look so natural. 'It's easy,' he told me. 'God saw me painting a tree one day and has been making them on my model ever since!' Gruppe laughs, hun-

ching up his shoulders. "Of course, it's important that you know what you're painting. That's the question I used to ask my students: Why? Figure out what you're after in a picture and direct everything else to it.

"I can tell you a story. I remember studying with John Chapman. We had an Italian model dressed up like an Indian, and I was working on one figure in the corner of a huge canvas. I must have been planning a massacre. Harvey Dunn was behind me waiting to go to lunch with Chapman. He finally came over and said to me, 'What do you think you're doing? Here's an Indian.' And in a minute he did a tremendous Indian, feathers all over the place. I was speechless." He looks as if the event had taken place yesterday. "Well, I had to go to lunch, see, but I couldn't take the picture along, and I didn't want to leave it behind, unguarded. But I finally had to—and when I came back, it was gone! You know who stole it? I later found out it was Chapman! 'You didn't appreciate it,' he told me, years later. Oh, I appreciated it! I'll never forget it!" For a few seconds Gruppe expresses a feeling both of amusement and acute outrage.

"One of you had the beginnings of a picture yesterday," he continues, again addressing his breakfast audience, "but you threw it off by having everything of equal interest. The middle distance was your subject. So mess up the foreground and smudge the back. Show the viewer where you want him to look, and keep him interested. If you finish every inch, he feels your labor and gets exhausted. Remember: don't tell him everything; let him make some of the picture himself. But at the same time, don't confuse him. Keep your design big. Look for the main line. In juried shows, the awards always go to the pictures that carry. So in your preliminary work, go for those big masses and use some care in placing them. My father's generation in Holland used to protect itself by going out with extra canvas trailing over the edges of their stretchers. That way, they could always restretch it to improve the composition once they got home.

"Well, you can make or break a picture right at the beginning. Avoid halves. When you paint a tree, make it either in full light or in shadow, with very small highlights. But not half and half; that way the two halves cancel each other out the minute you step baek from the canvas. When you use shadows make sure that, as Charles Hawthorne used to say, the things in shadow pertain to those shadows; for example, a white object in shadow is darker than you suppose. And don't overdo your reflected light.

"If you break things up too much, you lose your punch. In a surf, feature rocks or water, but not equal amounts of each. In balancing your masses, keep things off center. It's a natural tendency, for some reason or other, to put things square in the middle. Ask a kid to draw a boat, and he'll make a banana with the mast dead center. Well, you have to learn to break the symmetrical habit. Dope out what you want to do; use your head. When I'm painting a pic-

ture, I probably make 2000 different decisions."

Gruppe's glance again takes on the teacher's sharpness. "So establish your big design right off," he dictates. "But don't get into a straightjacket. Part of the fun of painting is being open to developments on the canvas. Talent is the ability to take advantage of 'accidentals.' If you want to have a good time, work all over the canvas. Keep it loose and painterly. You should have seen Hawthorne in Provincetown. He'd show up every two weeks to paint a picture in the open air. As big as this table! The whole town would declare a holiday to go see him. There'd be a thousand people on the sand dunes in back of him. Those loose pictures, done in a morning, were better, I think, than his finished work. They had a lot of *life* in them. That's what you want.

"I say that I'm an 'artist' in the studio—but a *painter* when outdoors. I like the feel of paint on the canvas. Anthony Thieme once saw me putting on a glob of paint for a sail." Gruppe makes a motion with his hand in imitation of the stroke. " 'What are you doing,' he asked me, 'painting that sail or modeling it?' " Gruppe chuckles. "See: art is all a matter of how you describe a thing. Somebody once said I 'wrote'

my pictures—that is, I used the expressive line. It may not be true, but I heard once that Sargent wanted just the right swoop of a pince-nez cord, and to get it, he repainted a shirt front a dozen times. Chapman used to say, 'Put in a lot of lines and take out the ones you don't need.' "

Gruppe leans a little farther forward on his arms. "It's all in your power of suggestion," he continues, and repeats, "the power of suggestion. I can tell a story with line or with color, but color's best. That's why I've made a resolution this trip. I'm going to try to keep my stuff 'arty'—you know, bold. Try to avoid 'pretty' effects. I came near to that with those high-keyed birches yesterday. The trunks were almost the same value as the sky. Now that that kind of thing isn't salable. People don't love high-keyed works; if you paint fogs, you'll never go broke. I think they feel uncomfortable with a really forceful picture. Artists might rave over it—but try to sell it! After all, it took them a hundred years to figure what Cézanne was up to!

"I'm supposed to be a colorist," Gruppe says, pushing himself back from the table. "People always ask me about my palette and how it works. But remem-

Above: *Melting Snow, Vermont,* 1965, oil, 36 x 30. Collection the artist. Here the artist combines a tracery of branches and broadly painted background to suggest a forest.

Right: *Rockport Church,* 1974, oil, 30 x 25. Collection the artist. Gruppe subordinates all details and development of the foreground to his main subject, the church.

80

ber, the most important thing is design. Design first, see? Then values. And *then* color. If your values are right, almost any color will be okay. Hawthorne used to make us paint with palette knives so that we'd forget about drawing and concentrate on values. Of course, you have to use good sense. It's possible to have a spot that's wonderful in color, but detracts from the picture. Thieme always liked to include one man in his pictures with a scarlet shirt. It made a great, snappy spot of color. To my eye, though, it stood out too much. It wasn't true. A spot of pure white, on the other hand, is almost always an asset. The eye, looking at the canvas, feels that the white completes the color gamut.

"There were great *painters* in the old days," Gruppe says, as he thinks about the crowd of artists who used to fill the now empty tables. "The draftsmen are in vogue today. Look at someone like Wyeth. Boy, can he draw! But that's all the younger men do: draw, draw, draw! That's why they like watercolor. You can do that with watercolor. But oil really needs the broad, impressionist approach.

"Look: let's say I splash some paint in a corner of the canvas. I try to make a nice shape. Good. I don't know just what it is, but I'll leave it there and work elsewhere; by the time I come back it'll probably suggest something. Don't finish anything! If you do, you might find later that a part is too strong—but you'll hate to change it, because you've spent so much time on it. It's only at the very end of a picture that you should nail things down. That's when I have to watch out that I don't trick it up too much. I've ruined more tree pictures by getting too involved with the branches. I'm the man to tell you what to avoid: I've made every mistake there is.

"You know," Gruppe continues, beginning to rise from the table, "there are so many painters now that the general public looks at artists differently. When I started out, an artist was either queer or a shirker.

Alan Cochran told me that he left his paints in a field for a few minutes—and the farmer called to him to come get his 'play things'! His 'play things'! I got an award in New York once, but apparently didn't look enough like an artist to suit the committee, with its flowing ties. I was told I looked like Firpo—you know, the fighter. Well, I worked hard. I made my bed, and now I'm lying in it," he says, and almost winks. "I carried pictures all over New York. I worked for a while at J. Walter Thompson. They wanted a layout man who knew dynamic symmetry. I was a color man, I thought, but had read Jay Hambidge. So I got the job. Tight, restricting work. At night I'd paint backgrounds on silent movie title cards. Palm trees, a house with a light . . . cheap stuff—but effective. I was always looking for openings. I studied with my father for a while, then with Hawthorne and Carlson. I was with Richard Miller in Paris—I just bought back a picture I'd done there in 1925. I painted portraits for a while in New York. But I got tired of that: you couldn't please anyone. Remember Sargent's definition of a portrait as a picture with something wrong about the mouth? Then I saw Lester Stevens and some Mulhaupts in a New York gallery. Boy, I thought, that's the stuff for me! And headed to Rockport and then over to Gloucester."

Gruppe begins to fill his Thermos from the coffee machine and suggests that he pick up some doughnuts to eat on the road. And he begins to think about where to paint: "I can do that, now that I've eaten—but not before." He goes upstairs to get his gear. "I hope you didn't mind my working on your painting yesterday," he says to one of the painters as he comes down, pulling a Dutch cap on his head and carrying an enormous canvas—just room enough for a morning's work. "People complain about my being too free with advice. Some of my former pupils are touchy about it. But it's a habit. After all," he says, as he heads for the door, "I've been at it for 60 years!"

ALAN GUSSOW

BY DIANE COCHRANE

NATURE in 19th century America was synonymous with religion. To some, Nature itself was God; to others, it was God's Holy Book. At the very least, the wilderness of our new country was the Garden of Eden. Nature was celebrated in the romantic novels of Irving and Cooper, in the philosophical writings of Emerson, Thoreau, and Wordsworth—and in the magnificent landscapes of the Hudson River School painters.

The Hudson River School was a name given to a group of painters who lived in the vicinity of the River and the Catskills. Among the luminaries were Thomas Cole, Asher Durand, John Kensett, Frederick Church, Albert Bierstadt, and Thomas Moran. They painted the landscape around their beloved River as well as the grandeur of the coasts of Maine, the mountains of Vermont and New Hampshire, and the newly discovered scenery of the Rockies and Sierras.

But even as they were recording the wonders of our wildness, Science was supplanting Nature as the immortal being. The works of technologists began to destroy the works of Nature. Men put their faith in Man and surrounded themselves with "unnatural" scenery. The Hudson River artists found themselves shut out of men's minds. And, it came to pass, they were expelled from Paradise.

But, hallelujah, there's going to be a second coming. The Hudson River School has been revived, and the faith is being spread. Soon there may be a Delaware Water Gap School, a Colorado River School . . . there's no telling how many converts will see the light.

The prime mover behind all this excitement is Alan Gussow, a young man with enormous ideas, talent, and energy. He is single-handedly reviving the Hudson River School by rediscovering the painters' favorite spots in the Catskills and Adirondacks and painting them in his own style. He is inspiring a whole generation of painters with an approach to nature that might be called a modern-day Hudson River School philosophy. And he's trying to save the River itself, along with the remaining unspoiled wild places in the country.

It's hard to get a handle on Gussow; he has so many careers and projects: he's a landscape painter, conservationist, author, teacher, lecturer, government consultant, and on and on. One way to tackle the problem is to compare the Hudson River School philosophy and see how he has developed his and put it into action.

Thomas Cole, founder of the original school, summed up the spirit that guided 19th century painters this way: "In civilized Europe the primitive features of scenery have long since been destroyed or modified . . . And to this cultivated state our western world is fast approaching; but nature is still predominant, and there are those who regret that . . . the sublimity of wilderness should pass away; for those scenes of solitude from which the hand of nature has never been lifted, affect the mind with a more deep-toned emotion than aught which the hand of man has touched. Amid them the consequent associations are of God the creator—they are his undefiled works, and the mind is cast into the contemplation of eternal things." (Quoted from "Essay on American Scenery," by Thomas Cole, 1835, from *American Art 1700-1960*, by John McCoubrey, Prentice-Hall, 1965.)

Twentieth-century man tends to think of nature in ecological terms. And so does Gussow. But he, too, stresses the qualities in our environment that give spiritual support: "There is tragedy in the fact that we have grayed our skies and clouded our rivers and that we have even come to take such a blight for granted, as if nothing serious was being lost so long as we did not actually destroy the life-supporting capacity of the environment. The even greater tragedy may be our failure to understand that as the nature of our 'places' is being altered, we also are being altered, we also are being subtly changed . . . we must accept the fact that we are not distinct from nature, we are part of it, and insofar as our 'places' are degraded, it follows that our spirits, too, will be diminished."

Gussow has always valued "places," but his ideas about art and nature did not crystalize until 1964. Before that year Gussow's life seemed headed in another direction. Born in 1931 in New York City, he was raised on what was then semi-rural Long Island. After graduating from Middlebury (Vermont) Col-

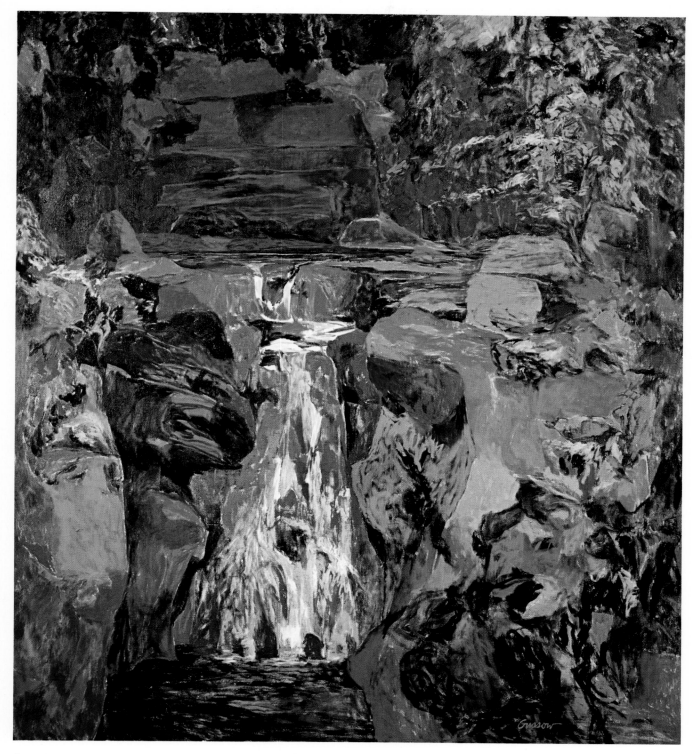

Cascade in the Kaaterskill, 1971, oil, 67 x 60, Geoffrey Clements photo. This scene, painted many times in the 19th century, was re-discovered by Gussow.

Above: *Mountain Interval,* 1970, oil, 55 x 70,
Geoffrey Clements photo. In striving to give
"a sense of place" to his landscapes, Gus-
sow recalls the earlier mysterious romanti-
cism of such Americans as Rockwell Kent.

Right: *Rock Weed in Rising Tide II,* 1971, oil,
52 x 58. Nathan Rabin photo. Courtesy
Washburn Gallery. Pointed round
brushes give Gussow a calligraphic, almost
pointillistic painting style.

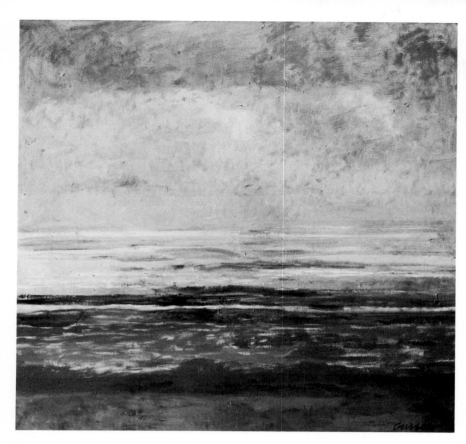

Left: *Sea at Kennebunk Beach,* 1971, oil, 38 x 40. Nathan Rabin photo. Courtesy Washburn Gallery. Originally influenced by Abstract Expressionists. Gussow now renders this Maine seascape in a Turneresque manner.

Below: *Midsummer—Marsh and Distance,* 1963, oil, 55 x 70. Oliver Baker Associates photo. Reminiscent of Van Gogh, this landscape was painted when Gussow still used flat brushes exclusively.

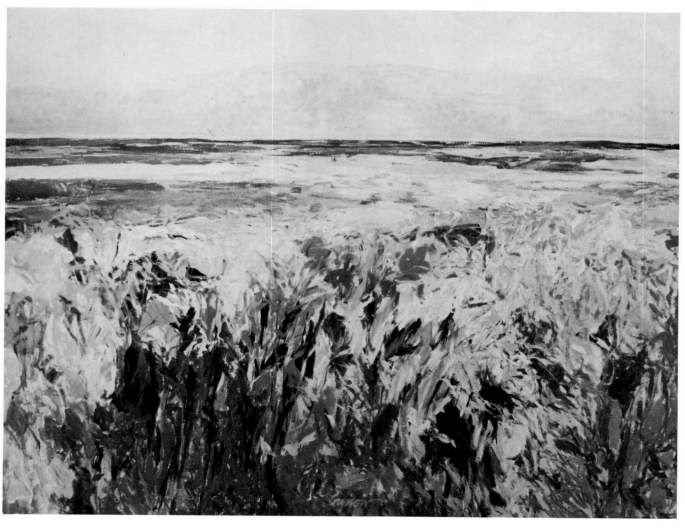

lege, where he majored in "American literature and Vermont landscape," he was apprenticed to the Atelier 17 graphic workshop at Cooper Union Art School back in New York City. In 1953 he won the coveted Prix de Rome in painting—at that time the youngest artist ever to do so—and worked in Rome and traveled throughout Europe and the Middle East until he returned to New York in 1955. Shortly after that he joined the staff of Parsons School of Design and became a department head in 1958.

His European experience left him contemptuous of things American; his art training, appreciative of Abstract Expressionism. DeKooning was a major influence on his work, and Gussow seemed destined to swim in the mainstream of modern art.

But a feeling for the land got in the way. Just as Thomas Cole had rejected the overcivilization of Europe and rejoiced in the wildness of the United States, so too did Gussow. His own wild places were Monhegan Island, off the coast of Maine, where he and his family summered, and later the Hudson River Valley, where he bought a home in Congers, New York. The beauty of these places demanded expression, so he gradually shifted from abstract to landscape painting. Aside from this change in style, which led critics to label him "his own man," Gussow's career progressed smoothly.

Then came Con Edison. In 1964 the utilities company announced plans to build a power plant on the Hudson at Storm King Mountain, near Gussow's home. The River was already badly polluted, and the proposed plant might kill it completely. The citizens of the area were outraged. And so was Gussow. Furthermore, he frequently painted the River and its surroundings. What if that landscape were destroyed? Would that make his paintings nonobjective and him a nonobjective painter?

The thought spurred Gussow into action. For the first time in his life, he went to a public hearing and spoke out. He was not "for" the conservationists, he said, nor "against" the utilities company; he was "on the side of the River." His eloquent testimony helped defeat the proposal. It also made him a sought-after expert witness on the aesthetics of pollution at hearings all over the country and a lecturer at schools and groups such as the Sierra Club. From that time on he decided he would do his "damnedest to help preserve the environment," a vow that meant giving up his prestigious job at Parsons.

In 1968 Gussow conceived a fascinating idea: why not have artists-in-residence at national parks, just as they have at universities? The intent behind the concept was that artists, inspired by their location, would create works that would make these places visible and communicate their spirit. Unlike earthwork artists, who gouge and scar the land, these artists would celebrate it in the same way lyric poets do. The hoped-for end result would be to make the land more valuable to the public, who in turn would demand its preservation.

The National Park Commission bought the idea,

and Gussow himself was appointed the first artist-in-residence at the Cape Cod National Seashore. His experience was so gratifying he persuaded the America The Beautiful Fund to award "seed grants" to a dozen artists to go and do likewise at the Delaware Water Gap. (These artists are now jokingly calling themselves the Delaware Water Gap School.) More money from the National Park Service (for which Gussow is now a consultant) in 1972 funded artists-in-residence programs at the Grand Canyon, the Everglades, and other parks.

Gussow is a man in a hurry. There are so many paintings to be painted, books to be written, lectures to be given. He speaks and talks rapidly. Thoughts tumble out, because there are so many and so little time to say them. For all that, he is wildly enthusiastic about life—in particular, his life since 1964. Says Gussow, quoting one of his favorite poets, Bob Dylan, "I was so much older then; I'm younger than that now."

One of Gussow's most brilliant accomplishments is a book called *A Sense of Place* (published in 1971 by Saturday Review Press, Friends of the Earth, New York). Over the years he had refined his theory about places. "Everybody knows that people can change the land, but few realize that the land changes people." All of us, he goes on to say, have our favorite places—a mountain, a tiny stream—and we feel they somehow belong to us. But whether we know it or not, we are also in some way products of our sense of place. To illustrate this idea Gussow chose 67 paintings from 1585 to the present by artists with a sense of place: Church, Cole, Durand, Catlin, Remington, Audubon, Thomas Hart Benton, Edward Hopper, Georgia O'Keeffe, Edwin Dickinson, and Rockwell Kent, among others. He then asked the living artists how places affected their creations and dug through the journals and writings of the deceased painters for an answer to the same question.

A Sense of Place is an ecological *tour de force*; Gussow succeeded in getting from each artist a definition of the fusion of human and natural order. But the book is also a masterpiece of Americana. The reader gains not only a sense of place, but also a sense of pride in our country. As the book reviewer for *The New York Times* pointed out, "One can be forgiven a little flush of chauvinism on closing *A Sense of Place*. For all the fashionable rejection of everything 'American,' one discovers that there is far too much—too much that is truly great—for it to be denied." (Subsequently, Gussow organized a show based on his book *A Sense of Place* for the Sheldon Art Museum at the University of Nebraska in Lincoln and the Joslyn Museum in Omaha.)

Gussow is expanding his own sense of place, and in a unique way. He is searching out the places loved by the Hudson River painters and painting his own experiences of them. Kaaterskill Falls, for example, was painted many times by Cole, Kensett, and others, but its exact location was forgotten through the years. It became a secret place, far from roads and,

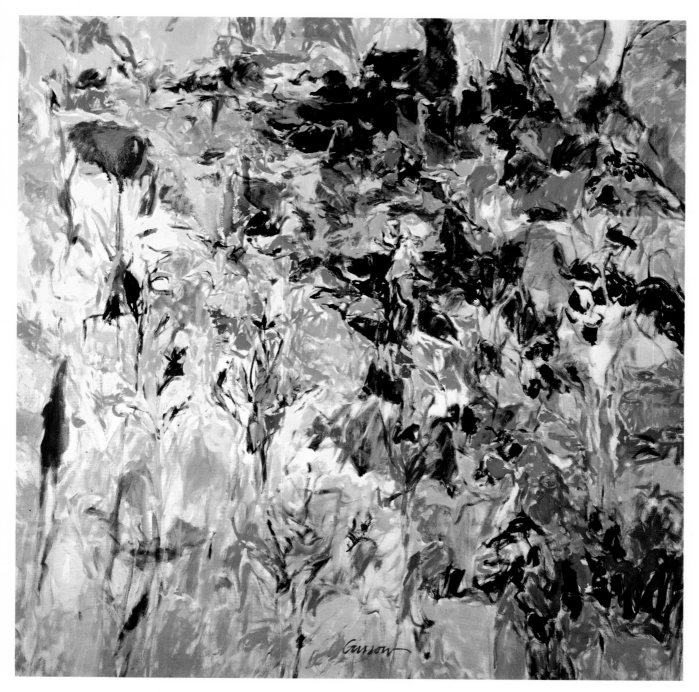

Loose Strife and Wineberries, 1966, oil, 50 x 58. Collection of the artist. Color separations courtesy the Saturday Review Press. Patterns of light and dark values are woven through the painting.

Small Falls on the Tiorati (in the Palisades), 1971, charcoal, 18 x 21. Geoffrey Clements photo. This protected scenic area on the New Jersey side of the Hudson River is in sight of bustling Manhattan.

Storm King Mountain, 1971, pen and ink, 18 x 21, Geoffrey Clements photo. Even harsh, precise outlines of tonal areas render a romantic effect due to Gussow's free, expressive linearism.

fortunately, from the littering crowds.

Armed with maps and information culled from previous research, Gussow set out to look for the Falls. When he found them he was overwhelmed by their beauty: trees overhang great rocks down which cascades crystal water. "I threw myself down in the water right before it goes over the cliff. It was pure and very cold. I could not think, only feel. I was very aware of where I was." Some might call this a mystical experience, but words are not important; the creative act—*Cascade in the Kaaterskill*—that resulted from it is.

Kaaterskill Falls is only one of the scenes in the Hudson River Valley where Alan Gussow paints. He has already completed a series of drawings done at Mink Lake in the Adirondacks near the source of the River. Mink Lake was the subject of several paintings by Winslow Homer. Although not part of the Hudson River School, Homer painted at the same time and also dedicated himself to the splendors of nature. Gussow made a pilgrimage to the remote spot and did what he thought Homer had probably done when he visited Mink Lake: "I canoed out in the Lake at sunrise and listened to the loons flying overhead. It was incredibly beautiful. I felt transported back in time." Gussow believes that these experiences forge a link between the past and the present and that his paintings can do the same for others.

Gussow's myriad interests take much of his time and energy, but they never take the place of his art. "I get edgy when I don't paint for a period of time. I really have no substitute for painting." Fortunately, he doesn't feel the need to paint every day, and he never has. Come spring and summer, however, and painting claims him almost exclusively.

The reason, of course, is color. Gussow rejoices in the blatant shades of the most colorful wild flowers as well as in the subtle hues of algae-covered rocks. And he feels an almost moral urge to portray the inherent quality of whatever he paints. Take the rocks in *Cascade in the Kaaterskill.* As the sandstone cliffs were red, he concluded, "this is an important characteristic, and I must honor it." His use of color makes black and white reproductions of many of his paintings almost meaningless, which is why the illustrative emphasis here is on his drawings.

Gussow has always loved to draw. He sketches on location, and at times he sketches from memory and from other drawings, as he did with *Kaaterskill.* But for a long time he found it hard to move from drawing into painting. The reason was surprisingly simple. One day someone noticed that he painted with a flat brush and asked why he didn't use a round, pointed one. Gussow switched, and his problem was solved. Round, pointed brushes gave him the calligraphic effect he was seeking and enabled him to work directly from drawings. "So much of my painting involves linear, or drawing elements. They weave together and form a pattern. Now that I can paint these elements, I can achieve more massive organization."

Gussow's approach to painting is ritualistic: "I must feel strong so I will be equal to my forms, but my mind gets filled up with other things." So he resorts to rituals to clear his mind in much the same way ancient Chinese landscape painters did. He smokes a cigar or burns incense to get a certain feeling. He plays 19th century American music, particularly Charles Ives. ("I also love American church music. I should have been a 19th century Calvinist or transcendentalist, rather than a 20th century Jew.") He puts his drawings around the studio (the octagonal turret room of his tall Victorian house) to surround himself with a sense of place he wants to paint. "This is the key. When a feeling of physical reality of place occurs, then I can paint. I can tell when the feeling is coming—like seeds coming from the ground—but I can't force it." If it doesn't come, Gussow goes out to dig in his garden.

The sense or experience of place is the most important element in Gussow's work, and because of this he feels he is much more a realistic painter than a strictly representational one. Says Gussow, "A representational painter gives information, not experience. Whatever the scene, everything in it is equal. He gives you more than you could see if you were there." Gussow, on the other hand, strives to recreate the situation as he experienced it so that the viewer will feel as though he were there. He wants his paintings to be tactile; he wants the viewer to feel them with his eyes. If the scene were a path through the woods, for example, the onlooker should be aware of the branches that might trip him, the light that filters through a hole in the leaves, the dampness where the light never reaches. Or if rocks in tidal pools are the subject, they should seem so slippery that the viewer will think he would have to crawl across them. In *Loosestrife and Wineberries* Gussow has hidden the berries so the viewer's eye has to work through the painting to find them, just as the berrypicker (Gussow) had to work through the leaves to get to them.

"Art for me has always been a byproduct of a whole series of experiences," says Gussow. The real subject of his painting is not a mountain or tidal pool, but how the painting has changed him. And, hopefully, how it would change the viewer. Gussow tries to evoke a sense, not of nostalgia, but of discovery, of nature.

Or rediscovery. People know we have mountains and streams, but they forget about them. And this is where Gussow and his disciples differ from the old Hudson River School:

"Nineteenth century painters went out into the wilderness to bring back reports about a land we did not know; painters now report about a land we risk forgetting. These paintings put a value on certain qualities in the environment. Acts of salvage in a desperate time, they can become models against which we measure our success or failure as restorers of the land."

Study of Kaaterskill Falls, 1971, charcoal and pencil, 18 x 21, Geoffrey Clements photo. Although he doesn't paint every day, Gussow loves to draw and sketches regularly, both from memory and on location.

Rock Weed in Rising Tide I, 1971, brush and ink, 18 x 21, Geoffrey Clements photo. Blobular brushwork given meaning and expression by Gussow's freewheeling control.

PETER HOMITZKY

BY DIANE COCHRANE

THE AMERICA Peter Homitzky paints is not the land of the beautiful. He sees no particular value in painting the traditional landscape of mountains, forests, or beaches. It's not that the wonders of nature elude him or even that he eliminates them from his work; it's just that he recognizes the other side of our national landscape—the factories, the refineries, the sewage disposal plants—as valid, too. And instead of rejecting them as blots on the countryside, he sees them as exciting shapes to be utilized in the picture-making process. So the glories of Vermont, Cape Cod, and the Rockies give way to the realities of New Jersey.

Even more exciting for Homitzky is the interaction between natural and mechanical forms. The world, as he sees it, is an arena where objects vie with each other, releasing enormous amounts of energy as they interact. In a pastoral landscape one could show this electrifying atmosphere by painting the tension-producing confrontations between treetops and the sky, for example. In industrial landscapes, energy generated by the arrangement of mechanical shapes infuses paintings with life. Put the two forces together—the natural and unnatural—and the explosion packs an even greater wallop. When factories menace the resisting forests and concrete slabs threaten to overpower ice age boulders, violence is imminent. But Homitzky doesn't allow all this tremendous energy to run amuk. He harnesses its chaotic force, and out of the haphazard juxtaposition of nature and industry he imposes order. The results are elegant canvases throbbing with color in powerful geometric shapes.

Homitzky's dualistic approach to landscape is unique in American art, but his interest in industrial painting is not. The tradition of industrial landscape was started back in the early '20s by a group of artists loosely known as Precisionists. The leaders of this movement, Charles Demuth and Charles Sheeler, had been profoundly influenced by Cubism, and they took their cues from Cézanne's dictum that all of nature could be reduced to the cylinder, the sphere, and the cone. Unlike their European counterparts, who expressed this concept abstractly, these Americans were interested in stating it realistically. Forms were to be painted in the simplest, most precise way to enhance their geometric shapes, but they were still to be recognizable forms.

As the Precisionists pursued their search for simplified geometric forms in nature to its logical conclusion, they soon discovered machines and machine-made structures. These shapes suited their needs far better than natural ones.

The movement quickly broke into several splinter groups, each of which has influenced generations of painters up to the present day. Certain painters became so obsessed with their subject, they imbued the machine with spiritual significance; it became, for them, a symbol, an icon. Another group fell increasingly under the influence of a particular machine—the camera—and the kind of art it could produce. Today's Photorealist painters could be considered heirs to these camera-oriented painters.

Homitzky stands apart from both groups. He is not spellbound by industrial forms. To him, these shapes represent an aspect of our landscape that cannot be ignored as well as a language in which he can express himself on canvas. Nothing more, nothing less.

He also has little in common with the Photorealist. Although they may paint the same subject matter on occasion, the similarity ends there. Photorealists record scenes more or less as the eye of a camera does. Some believe that truthfulness is all, that composition is unnecessary. Others pay lip service to design, but even they work in a very restricted manner, since they are more fascinated by the accidents a camera might make, such as lopping off a head, than the options offered by the accidents of paint. So they work their compositions out in advance and never deviate from them once on canvas.

Homitzky, on the other hand, lets his paintings grow organically. Before he picks up his brushes, he may make as many as 20 on-the-spot drawings of a scene. "I love to draw," he says; "this is probably one reason I have stayed with realism."

Putting these drawings aside, he paints a composite of them on canvas. This initial painting is never a duplication of a real scene; instead it is an altered version of what he saw. The two buildings on opposite sides of the river in *Near Fairlawn*, for example,

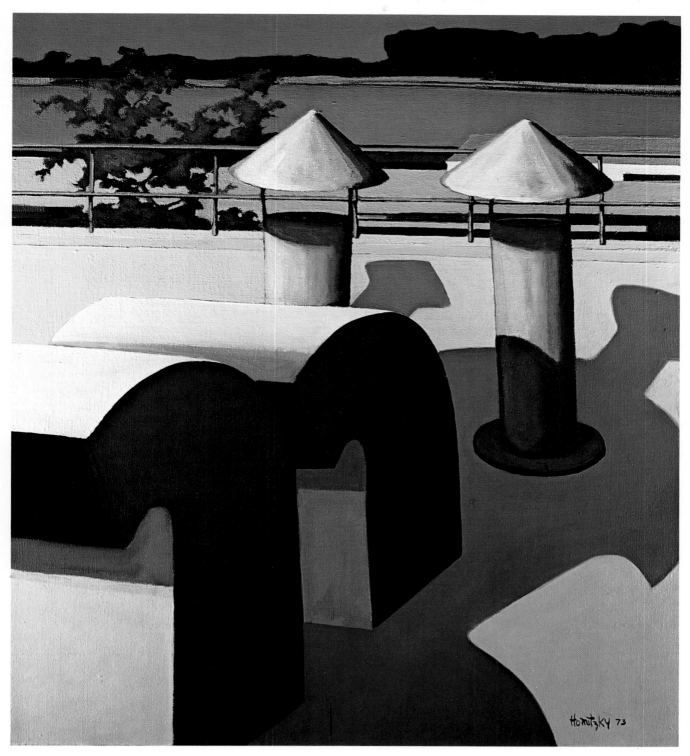

Staten Island Rooftop, 1973, oil, 25 x 22. Homitzky develops a particular color—the shadow side of the air vent, for example—by applying several layers of thin oil glaze. Notice the rhythmic relationship between these rooftop forms.

are a mile apart in actuality.

Then comes the editing: the adding and the subtracting. *Port Reading* was about one-fourth done when I saw it. A group of barges on the left side of the picture was being balanced by the beginnings of a reflection of a refinery on the right side. Whether or not the balance would work, Homitzky wasn't sure. The reflection looked as if it might get out of hand and assume a dominance he hadn't intended. If that happened, something else would have to be added to reestablish an equilibrium.

The juxtaposition of machine and nature dominates Homitzky's work and gives it strength. But it is more than just an interesting theme. It represents a point of view he has developed after years of uncertainty about the direction his work was taking. Before it crystalized, he was plagued by such questions as: What should his subject matter be? How should he paint? Abstractly? Figuratively?

But these were the wrong questions: "What I was really searching for was a point of view, a direction. When I found it, stylistic problems began to clarify themselves. Style doesn't precede a point of view, it follows it."

The realization of this philosophy took nearly ten years. In the late '50s and early '60s, after two years at The Art Students League, studying with Frank Reilly, Homitzky painted in a realistic manner that almost bordered on illustration. A little later, while still in New York, he adapted the figurative techniques of the California landscapists, such as David Park: the loaded brush, the volume painting, "the whole pastry decorator approach."

Abstract art was rejected out of hand. "I couldn't relate then, and I still can't, to people like Ellsworth Kelly, Barnett Newman, or Ad Reinhart; I just can't take that forced aesthetic." But after continued study of the abstractionists, rejection gradually changed to acceptance of painters like Mark Rothko and Franz Kline. The carefully thought-out imagery of Kline, in particular, appealed to him.

His prejudices demolished, Homitzky then became increasingly convinced of the validity of Abstract Expressionism. In making a picture, color and form, he felt, should take precedence over realistic interpretation, and all parts of a painting should be equally important, not just the subject. So he turned away from figurative painting and began working abstractly. It wasn't long, however, before frustration set in, even though he had achieved a certain success. "The people who praised my work were usually of the intellectual-arty variety who were always adding footnotes to my work. They'd look at a painting and tell me what I was doing, but I couldn't see it." Today, Homitzky thinks this is probably understandable. He admits that, without a recognizable image, he becomes ambiguous about what he is trying to accomplish.

Homitzky's return to figurative art coincided with a move to California, where he was hired as a restorer for the prestigious Maxwell Gallery in San Francisco. The job proved invaluable in several ways. First, he became so expert on the 19th and 20th century paintings he restored that he was asked to organize a show for Maxwell on "200 Years of American Painting" and then later to produce a television documentary entitled "American Painting, 1890-1940" for W.R.E. Films, Inc.

More important, his insight into landscape painting deepened through the study of our old masters. John Henry Twachtman (1853-1902), he feels, was—at least in his pre-Impressionist period—perhaps the greatest American landscape painter: "Most landscape painting is based on the way tension is built up to the horizon line. The horizon makes what is above and below it work, and nobody succeeded better at creating this tension than Twachtman." He admires Edward Hopper for his overall abstract composition. "There is never a subject in his painting. In *Gas*, for example, a man is pumping gas outside a filling station, but neither the man nor the pump nor the station is the subject. Everything, including the trees behind them, is equally important."

Landscape painting, then, became Homitzky's primary concern. But the grandeur of the Western landscape disturbed him. "Who can paint Big Sur or the Grand Canyon, if you can look at it." Similar sentiments have been experienced by many other painters. There is a story, for example, about Hopper, who wandered through the magnificence of the New Mexico desert for days looking for something to paint. When he finally found it, it wasn't a glorious sunset or mountains shimmering in the distance—it was an abandoned locomotive. Apparently, there was just too much beauty, too much natural composition for him to cope with.

Homitzky's rejection of the overwhelming natural beauty of the landscape took a different direction. He turned his back on the land and painted seascapes. Again, this was probably the result of his knowledge of American painters. This time his model was George Bellows. "I liked the color of Bellows's seascapes, and I managed to get some nice color into mine, too, but they lacked energy."

At this point Homitzky nearly gave up painting. He wanted to use color abstractly, but as soon as he reduced a tree to a green cone, it lost power, and instead of making a picture, he found himself making a design. Furthermore, a certain challenge was missing: "There isn't any real thinking involved when you aren't trying to solve a paint problem like perspective." In essence, what he was groping for was a way to combine a figurative language with an Abstract Expressionist attitude: "I wanted a way to use recognizable images which keep me in check, but are geometrical enough to allow me to work with color abstractly."

The problem began to resolve itself when he painted a series of farm landscapes (one of which now hangs in the Wichita Museum). The geometrical patterns formed by fields of wheat or flowers were perfect vehicles for the sort of abstract realism he

Left: *San Luis Obisbo Waterworks,* 1968, oil, 40 x 65. Notice the brushwork. At this time the artist painted with loaded bristle brushes only. Now he uses both bristle and sable.

Below: *Passaic River Near Fairlawn,* 1973, oil, 16 x 20. Collection Dr. and Mrs. Leon Grossman. Homitzky uses color rather than a loaded brush to develop the foliage area.

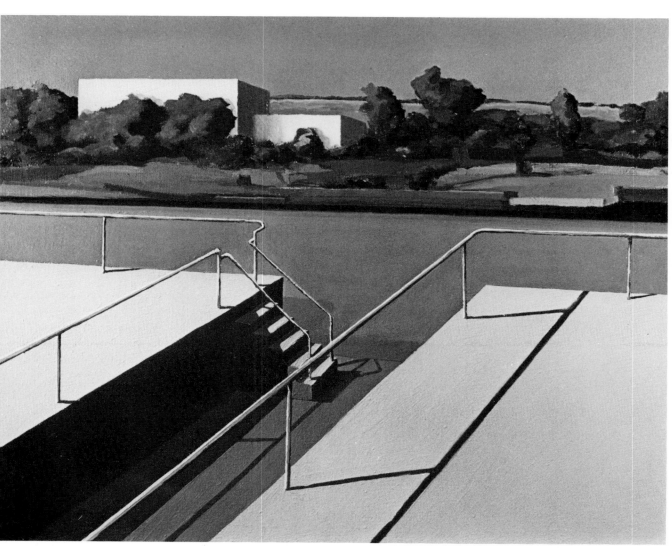

Right: *Connecticut Binderleaf,* 1972, oil, 48 x 60. Collection the Jewish Community Center, Union, N.J. Homitzky considers this one of his more literal works. The rectangular yellow forms were inspired by fields of cheesecloth hung over poles to diffuse the sun.

Below: *Fairlawn,* 1973, oil, 16 x 20. Collection Mr. and Mrs. Seymour Mark. Homitzky stays away from arbitrary texture. He prefers a flat use of color areas to emphasize the general simplicity of forms.

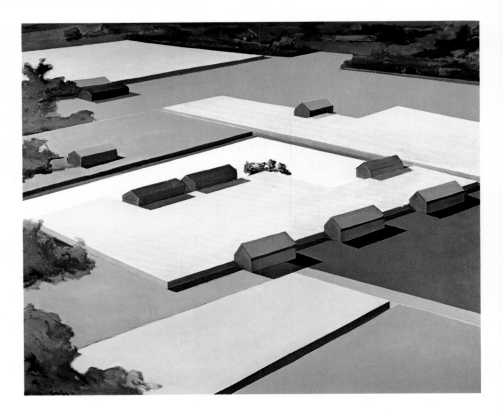

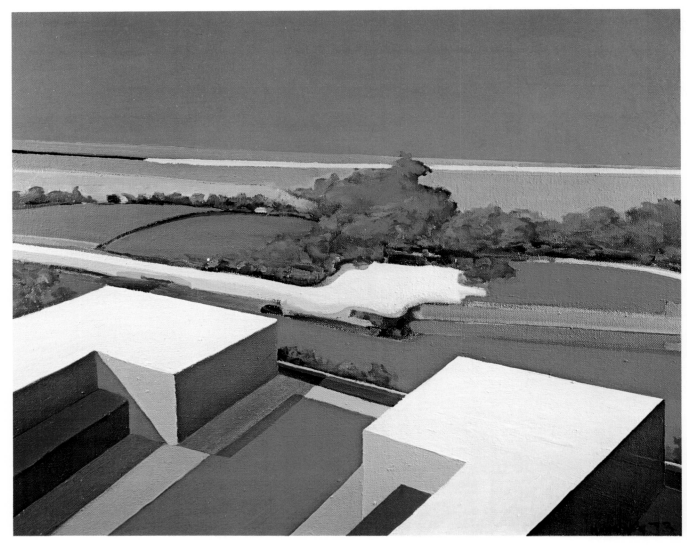

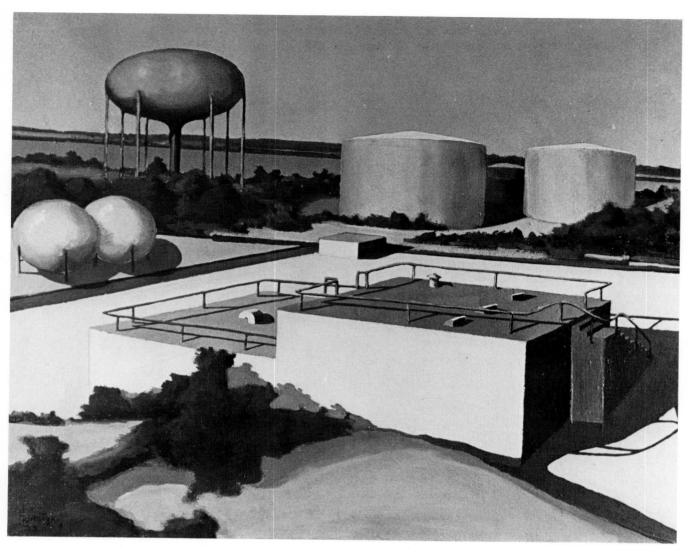

Staten Island II, 1973, oil, 18 x 20. Collection Dr. and Mrs. Stanley Weinberg. Cast shadows give additional information about a shape and act as design elements as well.

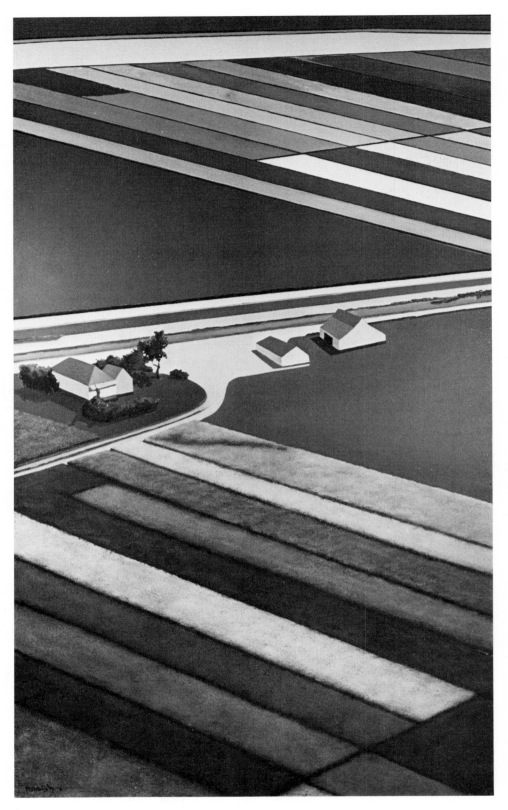

Sonoma Flower Farm, 1973, oil, 60 x 36. Private collection. Deciding the lower part of the zigzag was too flat and geometric—it didn't "read" flowers—Homitzky added texture with contrasting glazes. He also softened the edges of each diagonal area.

was looking for. Then, like the Precisionists, he discovered that the structures that clutter the landscapes provide additional forms that are at once realistic and abstract.

At last everything seemed to fall into place: an idiom to make pictures out of scenes was secured; a point of view was established. Now he had the means for solving the problems involved in landscape painting. If he wanted to create excitement around the horizon line, for example, he could. Like Twachtman, he had a set of tools to work it out. He might decide, for example, to do this by raising the horizon with geometric shapes, as he did in *Sonoma Flower Farm*. The zigzagging blocks of color carry the eye above the level where the horizon would normally be. Or he might want to lower it. In *San Luis Obispo Waterworks*, he did just that. The picture is an impossibility, of course. If one were really standing in the drainage area in the foreground, as Homitzky was, the trees would fill the entire top of the painting and the vanishing point would be off the picture plane. But by making it appear as though he were looking down on the geometrical area of the drain, he lowers the horizon. The horizon shifts to an area behind the building. But he doesn't allow the flow of energy to travel up the rectangular area toward the water and be swallowed up by a vanishing point. The band of trees above the horizon flattens out the inward flow, and the vivid, blue sky bounces it back out to the picture plane. In so doing, the sky prevents the foreground from becoming the subject of the picture.

The impact of Homitzky's semi-industrial paintings stems from the collision between the natural and mechanical worlds, and the drama is heightened by the way he handles both elements. Nature is treated lyrically: trees and bushes are painted with a loaded brush that occasionally results in impasto; light falls naturalistically. Structures, on the other hand, are given a hard-edged treatment: they are painted in pure, flat color to emphasize the generalized simplicity of forms, while a glaring light exaggerates the reality of the cold, impersonal world of the machine.

The use of very flat color might suggest that acrylics are Homitzky's medium. Not so. He finds them wanting: "I can't get the color or depth I want with acrylics." Instead, he applies layers of thin oil glazes. The sky and the river, for example, in *Staten Island Rooftop*, both started out the same color, ultramarine. By the time it was completed, however, many layers of lighter and darker transparent greens and blues—as many as eight, perhaps—transformed the two elements into tones that are quite different.

Homitzky—a young man who possesses an extraordinary vitality himself—is dedicated to the new American landscape in a way few painters dedicate themselves to their subject. It is not a sometime interest or a fascination from afar. His commitment virtually compelled him to move to Elizabeth, New Jersey, smack in the middle of one of the country's most heavily industrialized regions. There he is near Port Newark, Port Reading, Staten Island, Bayonne. There he is near the tremendous energy sparked by the haphazard arrangement of oil refineries, storage tanks, cranes, derricks, docks, airports—the industrial apparatus of the 20th century. And there he paints not America the beautiful, but the real America.

CLARK
HULINGS

BY DIANE COCHRANE

Grand Canyon, Kaibab Trail, 1973, oil, 27 x 54. Collection National Cowboy Hall of Fame. This painting won the esteemed Prix de West from the National Academy of Western Art.

WHAT IS IT ABOUT Clark Hulings' paintings that makes them so appealing? "I paint what people like. Fortunately, I don't have to make a decision, like some painters do, between painting what I want to paint and what will succeed. It means that when I wake up in the morning I can do what I want. People simply like the way I paint."

Explaining one's appeal is a difficult job. Often the characteristics that make a painter unique are never recognized by the artist himself. But Hulings struggles to articulate exactly why his sun-drenched canvases of exotic places are practically snatched off the gallery walls.

"Nostalgia plays a part," says Hulings. Many people who own his paintings have been to the areas he paints. They had good times in Mexico or Spain and then want to remember them.

Remembrance of things past isn't always pleasant, however. When Hulings gave up a lucrative career as an illustrator to paint full-time, experts in the business told him potential customers wouldn't want to be reminded of the poverty found in the countries he paints. They said that buyers didn't want to see run-down villages, downtrodden people, overburdened donkeys. But the experts were wrong. Hulings disregarded their advice and his paintings sold anyway.

Why? People, Hulings thinks, don't mind relating to bittersweet situations. Take an unhappy or lonely person, bathe him in sunlight, and he doesn't seem so sad after all. "People don't mind the unhappiness of the scene because the sunshine somehow makes it all right."

But the whys and wherefores of success don't bother Hulings, a rather shy but frank-speaking man in his late forties. There may be another explanation for his popularity. His technique, rather than subject matter may be the key to his success. Customers like his work because of the way he uses light ("They like sunniness in their rooms," one dealer explains) and builds up interesting textures.

Hulings agrees that textures are his obsession. Textures, he says, must not only provide a third dimension, but they must also make the surface of the painting interesting in itself. "I am an admirer of Ab-

Rhodes at Noon, 1968, oil, 24 x 36. Collection Mrs. Clark Hulings. Building up ridges of paint that trap the light is one method by which Hulings is able to obtain texture and dramatic effects of light and shade.

Sunday Morning after Fishing, 1967, oil, 32 x 46. Collection Mrs. Clark Hulings. A scene from Hulings' childhood. The artist has not yet discovered anyone who can identify the car he painted so accurately.

Little Boy Holding Dead Bird, 1968, oil, 20 x 16. Private collection. When Hulings first painted this oil, the canvas was horizontal rather than vertical. Several years later he reworked it to this format.

stract Expressionist painter Jackson Pollock because his textures are so interesting; they make his paintings fun to look at."

So creating different textural effects preoccupies Hulings. He hits his brush with a knife, splattering paint all over the canvas; he blots wet paint with a facial tissue. Sometimes he lets the paint do the work. For example, if he wants a rust-coated building, he mixes a little brown pigment with a lot of thinner, presses the brush against the canvas, and lets the paint drip down by itself. But he tries to avoid developing what he calls "a bag of tricks": "If I find a way to produce certain textures well, I am tempted to repeat myself, but I know this will become boring. The fun of painting is to keep fooling around with paint."

The most difficult textural effect to pull off, Hulings thinks, is a tree with leaves. To prove his point he notes the lack of successful trees in painting. "Several years ago I went to a superb show called the 'Triumph of Realism' at the Brooklyn Museum of Art. In the entire show I counted just one tree that had leaves." Most artist, he goes on, when they do attempt a tree make it look like a lollipop, or else they paint in every leaf. "Instead, a tree should look like a mass of color that will sway if you blow on it." Easier said than done, of course, but Hulings, helped by a study of Corot's techniques, is pleased with some of his accomplishments. "The trick is to use soft edges, softer than you think you should. Mush everything into the sky and then use a sharp knife to draw into the mush."

If Hulings is reluctant to explain the reasons for his wide appeal, he is more at ease describing his painting procedures. Frequently he likes to go on location—Spain, Italy, Portugal—for three weeks and brings home enough ideas to last until his next trip. He wanders around rural villages and marketplaces with camera and sketchbook, recording things that interest him as background or foreground elements. Later he will incorporate some of these visual vignettes into the composition of a painting.

He doesn't always wait to work on the composition, however. Occasionally he sees a scene he wants to paint that needs another major and complicated element—reflections of water, for example. Take the Louisiana bayous Hulings loves to paint. When he finds a scene that strikes him as particularly lovely, he may want to paint it, but he may also want a boy looking into the water and being reflected by it. Now two choices are open to him: sketch or photograph the setting and later, in his studio, a boy; or bring a boy to the bayou. Hulings would choose the latter. He would complete the scene he wanted, posing a boy and taking as many as 70 shots of the composition. "I could take pictures of the bayou and the figure separately and then figure out the reflection on canvas; it would look okay. But I would prefer to see the figure reflected in the water."

If he could he'd like to carry the procedure even further: "I'd like to plunge right in and start painting on the spot. You don't need so much imagination when you have Nature working for you, telling you how the water reflects an image or how the sun changes the colors of things, for example. But I have difficulty concentrating in public."

Back in his studio Hulings reviews his sketches and projects the slides on a ground glass screen, pretending he's on location. He organizes all the background and foreground elements and works on the composition in his mind.

Once he has worked out the composition in his mind, Hulings starts in on canvas, making a detailed drawing with a felt-tipped pen. "I use a trial-and-error-approach. If the drawing doesn't work, or later if I don't like what I've painted, I start over. It's probably a bad technique, but it works for me." Next he lays in a wash in a neutral color to get rid of the white, and he's ready to go.

Hulings works from dark to light, so he begins with a fairly dark wash and, while it is still wet, applies lighter tones with brush, knife, or his splatter technique. His fascination with texture goes hand in hand with his interest in light. In fact, it's hard to tell which one comes first. At times he piles on paint only as a means of catching physical light. At other times he paints light glancing over an object so he can get involved with texture.

Hulings' palette of oil paints is unorthodox. It includes Indian yellow ("My favorite color—I use it as a glaze as well as mixed"), cadmium yellow light, yellow ochre, cadmium orange, vermilion, Indian red, alizarin crimson, Van Dyke brown, ivory black, olive green, sap green, viridian, manganese blue, ultramarine, and phthalocyanine yellow-green. ("Many of these pigments are already grayed-down, so they can't be mixed.") The heretical character of the palette stems not from the colors, but from the number of colors. Many painters, including Hulings' teachers, prize the limited palette. But he rejects such purism: "Painting isn't a performing art, so how you achieve a result is unimportant." This statement sums up Hulings' whole approach to painting: what you produce counts, not how you produce it.

Hulings has another idiosyncrasy: he doesn't use turpentine. His objection to the thinner is physical, however, not philosophical. He developed an allergy to turpentine, so he thins paint instead with an inert, odorless, commercial paint thinner (mineral spirits). Otherwise, his materials and tools are fairly standard. He paints on Belgian linen canvases on stretchers and uses flat sable and bristle brushes, painting knives, facial tissue, and "anything else that will give me the textures I want." Milkglass ("because it's easy to clean") placed atop a taboret serves as his palette.

Hulings road to success as an artist was circuitous. It was marked by what some might call misfortune: others, serendipity. As a child he traveled with his engineer father from job to job around the U.S. and Europe. It was a lonely life, particularly the time spent in Spain, but it helped shape his future. Hulings frequently returns to these childhood scenes (see *Sunday Morning after Fishing*) to paint them and use

Conversation—Spain, 1971, oil, 20 x 30. Hulings is challenged by the problem of painting trees, here he piled paint on in certain areas to catch the light while leaving dark areas thinly painted.

Pierreparte, Louisiana, 1970, oil, 21 x 34. Private collection. Hulings prefers to sketch the reflections in the bayou on location rather than work them out later in his studio.

them as inspiration. He also speculates that he now endows these scenes with as much beauty as possible to compensate for his early feelings of sadness.

Hulings' bad luck began when he graduated from high school. He was planning to go on to college when he learned he might have tuberculosis and was advised to rest for a year. He used the time to study painting and anatomy.

Back on the track, Hulings went to college and majored in physics. After graduation, during World War II, he was sent to New Mexico to wait for clearance to work on the Manhattan Project at Los Alamos.

Ill-health again diverted Hulings from his original intentions. Clearance was delayed, then denied, because of his suspicious lungs. While he had been waiting to go to Los Alamos, however, he had begun to paint again. The Southwest landscape made a tremendous impression on him, and it was there that he decided he wanted to be a painter.

Wanting to paint and painting professionally are poles apart in realization. Fortunately for Hulings, luck was on his side for a change. His father had settled in Louisiana, and after the War he rejoined him. Through family and friends he met some of the most influential people in the state, and one of his new friends asked him to paint a portrait for him. Portrait painting in the South is an old tradition, dating back to early plantation days, and a strong one. The rich still prize portraits of family members. Hulings' painting was a success, and over the years he has been commissioned to do many more. Today he still feels grateful to his friends for their early and continued support. "Without their faith in me I doubt I would have made it as an artist."

Louisiana, however, did not provide enough opportunities for Hulings, so he went to New York to get a job in an art studio. But he found, as thousands before him had discovered, few jobs are available to those who lack experience. The solution was more training, and for two years he studied with Frank Reilly at The Art Students League of New York.

At last the hard times were over. During the late '40s Hulings found a market for his oils: paperback book covers. "This was the heyday of illustrators in book covers, before gimmickry took over, and I was an instant success. I had money for the first time." The money, of course, had to be spent. And what better way to spend it than on traveling? As a bachelor with no responsibilities, it was easy for him to pick up and go whenever he wanted, and he quickly established a pattern he was to follow for many years: earn some money, go to Europe, return when the money was gone.

As pleasant as this work-travel routine was, Hulings became increasingly dissatisfied with his career. He wanted to do his own thing and not what an art director wanted. Still, he wasn't sure what his "own thing" was. He felt he needed to experiment with other forms and techniques. So he went to Europe for two and a half years to work and study on his own. And study he did—old masters, Impressionists, modernists. "I tried to fit myself into a lot of molds. I particularly tried to get inside abstract art, and that was a valuable experience. It helped me see things in a different way. But in the end I realized that what I really like doing and could do well was realism." This self-revelation gave Hulings the impetus to return to the States and embark on a career as a fine artist.

Has success spoiled Clark Hulings? Not so you'd notice. He seems a kindly man with courtly manners and unassuming ways. Take his painting habits, for example. Before the onset of affluence, he painted in a tiny studio in New York City. Then he built a dream house (he has a family now) in Connecticut and designed a 32' x 24' x 18' studio. But he still worked in the same amount of space he had in his old studio. "I just don't feel comfortable in a big place." Then Clark Hulings moved to New Mexico. He's back where he first decided that painting was the only thing he ever wanted to do, and he's surrounded by the people and places he loves to paint. He's doing what he wants, and his public continues to want what he does. Summing up his life and his career, Hulings says, "I'm just lucky, I guess."

WILSON HURLEY

BY MARY CARROLL NELSON

WILSON HURLEY, NEW MEXICO ARTIST, fills a special niche in American art today as a landscapist in the grand tradition. Whether his format is the huge 9 x 6 feet used in *Grand Canyon* or the small 12 x 18 inch *After the Rain*, Hurley's subject is the majesty of nature. The tradition he follows is a familiar one in American history, exemplified in the works by Thomas Cole of the Hudson River School in the first half of the 19th century and continuing as the poineers moved westward in the work of George Caleb Bingham, George Catlin, Thomas Moran, and Albert Bierstadt. For these men the American continent represented the manifest destiny of those brave enough to conquer it. For Hurley the vistas of pure landscape, still found in abundance in the West, represent a beauty of form, color, light, and order whose abiding quality is one of silence and spiritual peace.

"I think the first thing that fascinated me about the West was the direct light, almost as though it were on a stage," says Hurley. "When you paint in this country, you have the direct wash of light from the sun, the bounced light, and the mild, cold wash of light from the top of the sky. There is multiple light everywhere. To show the beauty of the sun reaching and really hitting some object could be likened to the chiaroscuro of Caravaggio—which he applied to interiors—applied to landscape. To me this is exciting. This is the lasting effect of the Southwest landscape; each object is very strongly illuminated."

Hurley's paintings are dramatic. They capture a moment of heightened emotional contact with nature in which one element has a spectacular impact. Most often the drama is that of light hitting cloud or cliff: a luminous, fleeting last pause before twilight. The immensity of cloud formations, their particular variations of density, and their reactions to the light cast upon them is a recurring theme in his work. Another theme, the intense light of desert storms, also is caught by Hurley in a series of paintings.

That Hurley's work brings an appreciative response from the viewer is attested to by the success he has achieved since he became a full-time professional artist. His work is highly regarded and sought after by those who share his reverence for the beauty of the land. This is all the more remarkable, then, because art is Hurley's third career, arrived at after daring changes from one career to another in an indirect path leading from the military to the law and then to a renunciation of the security he had achieved in both. Yet no sooner had he made a complete break from his law practice than he was recalled to active duty as an Air Force pilot following the *Pueblo* incident. This delayed for a further 18 months not only his change of career, but even his part-time painting. Despite the delay of 20 years in finding his true calling, Hurley applied his innate qualities of integrity and scholarship to the honing of his talents when the time was again available.

Hurley, with a 1945 B.S. degree from West Point and a 1951 L.L.D. from George Washington University, came to art virtually self-taught. However, he says, "Ralph Mayer is one of the best things that ever happened to us; no one can plead ignorance, since Mayer is there to study."

Wilson Hurley had two aims when he began to paint full time: to paint oils representationally as well as he possibly could, and to do so in a manner that would be technically as sound and lasting as current knowledge will allow. He began by borrowing anatomy books from a doctor and a military veterinarian, both friends of his. He studied these with precision, making careful renderings of the illustrations in ink. When he felt they were as perfect as he could make them, he framed them. (These inks are hung in a frieze around the studio in Hurley's home.) He approached each area of painting with the same studiousness; color, in particular, was analyzed with a scholar's desire for understanding. Drawing presented few problems to him and he credits his required mechanical drawing course at West Point with the basic training he needed. Hurley continued to apply these drawing skills through the intervening years, but the actual practice of art has been a part of his life since early childhood.

Much can be learned about a person from a visit to his home. Hurley's home is truly a reflection of both his art and life. Located in one of Albuquerque's finer residential areas, his house has the look of territorial

On the Manzano Highlands, 1972, oil on panel, 35 x 45. Collection Mr. and Mrs. Rogers Aston. Photo Baker Gallery. The low-placed, predominantly horizontal horizon lends an illusion of deep space. Dramatic lighting and vistas of pure landscape are in keeping with Hurley's main subject, the majesty of nature.

architecture, a style that dates back to the period of the earlier settlers in Santa Fe, where his parents, General and Mrs. Patrick J. Hurley, made their home. Inside the house, white walls reflect the light and add to the clear, uncluttered, and understated elegance. Polished hardwood acts as a background for Oriental rugs and traditional furniture. A few Hurley paintings adorn the walls. An orderly peace with a few idiosyncrasies, such as huge ship model in a mahogany and glass case, make the house entirely pleasant and a fitting home for gentle living.

To follow his talent, Hurley has paid dearly. It has cost him heavily in mental and emotional anguish. Had he begun to paint in his youth, perhaps those nearest to him, relatives and friends, would have learned to think of him as an artist first. But because he did not choose an art career first, most of his associates who knew him in other professions voiced only criticism when he wished to become a professional artist. Hurley has spent the largest part of his life in the law. During a period around the early '60s when he first tried to break out of his law practice and arrange for some time to paint, he worked as an engineer. But the effort did not succeed, largely because of family pressures. He then helped found a bank and became chairman of its board of directors and general counsel. That he could manage to perform successfully in many areas failed to satisfy him. The duality between what he was doing and what he wanted to do finally led to a long period of struggle, not so much a financial as an emotional struggle to find himself as an artist and to develop the knowledge he deemed necessary. Almost every step of the way he taught himself by experiment and continuous work. Luckily for him, he met and married his strongest and most devoted supporter, Roz Hurley. Together they have built this calm and quiet home whose most important room is the studio.

In the Hurley studio—a 20 x 20 feet area with a concrete floor, dominated by a big north window—the visitor comes upon Hurley the artist. The first impression is one of professionalism, order, and cleanliness. Hurley's studio could almost be a laboratory. Hurley painted the studio walls a medium gray in order to absorb some of the intensity of the light and prevent glare. Twelve feet behind the oversized easel is a large, square mirror. Near the easel is a hand mirror. Hurley checks his progress constantly by using this pair of mirrors. The large one he uses to see the composition in reverse, turning frequently to check it during the painting. With the two together he can see his work from twice the distance the dimensions of the studio allow. Each aspect of the studio has been arranged with this concern for usefulness; a practical inventiveness is evident in the arrangements.

Hurley spends his days in this studio, usually from 9 a.m. till the light begins to wane about 4:30 in the winter, 6:00 in the summer. Prepared panels are standing against the walls in a variety of sizes; the sheer number of them suggests the planning and long-range organization of the man. There is spare space in the studio, rare in the private sanctuaries of artists. He works here, when things are going well, straight through until the painting is finished. He takes irregular short holidays, but generally his output is steady.

Everything Hurley needs to paint with is immaculately housed in a movable palette he designed and built. This is a white table, about 22 x 30 inches in surface, with casters on the legs for easy mobility. The top is mostly devoted to his glass palette. This is made from two sheets of glass, which would have appeared slightly greenish when placed over the white top. So he painted the top pale pink rather than white to compensate for the green in the glass. In a recessed area of the table top is a box of tissues. Below is an open drawer divided into sections. He has arranged his tubes of paint in a precise order; each fully visible and not crowded. His paints take up two sections, the first one is devoted to the Mars colors, earth colors, and white. The center section is arranged in this way from left to right: alizarin crimson, permanent rose, cadmium red deep, cadmium red, cadmium scarlet, cadmium orange, cadmium yellow deep, cadmium yellow, aureolin, cadmium yellow pale, cadmium lemon, viridian, phthalocyanine green, phthalocyanine blue, cobalt, and ultramarine. The final section is given to brushes, notably new and clean and mostly soft sable rounds.

In the studio there is an extra large drawing board with excellent lighting. Shelf-type workspace runs along under the window. And near the ceiling, hanging nose down, is arrayed a group of very big aircraft models which were skillfully designed and made by Hurley. His love of the air has not abated since he first flew planes as a teen-ager. He has, when requested, painted portraits of aircraft much as other artists might paint portraits of favorite horses and dogs—understanding the affection with which a pilot remembers his plane.

Having searched for his role so long, Hurley knows his own mind. Talking about his approach to art, he says: "I don't like to go sketching, I like a quick sketch—to lock the mind. Once, when we were at Lake Powell on a trip with friends, I had to get away from the others on the boat and spend a lot of time looking. After a while, when you look at nature, you come to understand the shapes, internalize, even come to expect what is around the bend. It is a way to study the forms of nature: mostly by eye and mind. When I'm looking at nature, I'm anticipating that I'm going to paint it. I'm trying to retain that shape. I'm trying to build the real object in my imagination.

"The hope is to hold this thing in your mind, but the worry is that you cannot conceive it correctly. You're afraid you can't create a faithful image of what you've built in your imagination. Maybe all you'll get is 50 per cent accuracy."

When sketching, Hurley uses a fountain pen, filled with india ink, on ordinary spiral-bound drawing pads. He searches only for the outline of form. Colors and impressions he holds in his mind until ready to

Burning Blue, 1967, oil, 36 x 48. Photo Baker Gallery, Lubbock, Texas. The artist's monochrome sky provides a flat backdrop for billowing cloud shapes.

Cañon Storm, 1967, oil, 38 x 60. Courtesy Richard Ettinger, Photo Far West Studio. Intense lighting accentuates this moment of heightened emotional contact with nature.

Mummy Cave, Cañon del Muerto, 1971, oil, 24 x 48. Courtesy Dr. and Mrs. Albert G. Simms II. The artist uses impasto for highlights.

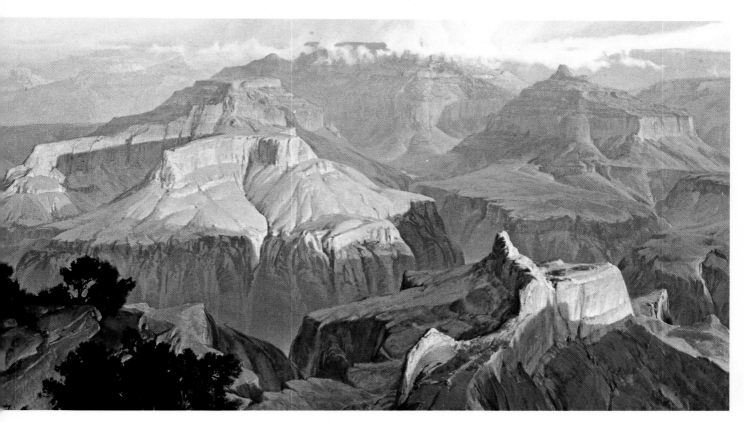

Grand Canyon, First Light, 1973, oil, 51 x 92. Photo Far West Studio. The artist uses carefully placed shadows to define his shapes.

In Santa Fe, 1972, oil 8¾ x 12. Collection John Lewis. Hurley's looser, freer treatment accentuates the character of the New Mexico terrain.

paint. He makes several sketches to a page in a notational style, each showing only a dominant formation of rock or cliff. When he is finished with a sketching trip, he writes a prose description in his sketchpad of what he has seen.

"People who in my opinion are great masters with technical ability and experience can take these imaginary models and communicate them with maybe 75 per cent accuracy. A painting can be a sum total of many impressions, not always a specific spot. Misunderstanding on the part of the public, even among those who are knowledgeable about art, is great. They think the artist has copied nature, measured it with his thumb and put it down exactly, or duplicated a slide in his studio if his style is realistic."

Hurley believes that the representational painter must be as conceptual as the nonobjective painter. All artists first must conceive their work mentally and then create it: "Representational art as it has developed in Western Civilization is just as much a language that has to be learned by the people in the culture as writing. Experiments have shown that if you show a three-dimensional landscape or drawing to a primitive native, he will not be able to understand it. We were taught to look for graphic clues of perspective and atmosphere as children; most people don't realize they have once actually been taught to read paintings.

"To argue between representational and abstract is like arguing which is the better novel, one written in English, or one written in Esperanto. The one is understandable to many and the other only a few. The place of the abstract in my own art is inextricable. Pattern, composition, two-dimensional relationships of color, light and dark are the bones upon which any painting is built. If an artist is enchanted with detail without thinking what the skeleton of his painting will look like, he should paint on Masonite so he can crop a lot.

"I am becoming a bug on proper technique (with longevity in mind). In putting on my grounds, I follow the techniques recommended by Ralph Mayer. I stretch raw canvas and size it with rabbit skin glue. I apply a first layer of white lead with a brush. When it is dry, I scrape the nubs smooth with a painting knife; then I paint a second layer of white lead and scrape it

with a plasterer's trowel, keeping it all fairly thin. I cure it two or three months.

"When I begin a painting I underpaint first with a lot of turpentine, Mars colors, ultramarine, and ochre. This is in thin imprimatura with less oil, relatively brittle. You want to put more flexible, fatty paints on last. The theory is: don't paint a thin, brittle layer over a fat layer or it will crack.

"After blocking in, I use my opaque palette. I try for the painting at this time, all wet in wet. For this I use titanium white; all the cadmiums, from the yellows through the maroons; cobalt blue; and the phthalos. I let it set up. It is not too thick. I draw large areas together by glazing with transparent colors and the umbers. Lastly, after glazing, I add deep accents and highlights. If I want to spang it out—a highlight, then I will sculpture it out. Then and only then will I use impasto. The impasto will catch the light because of its dimensionality, a rise at a slight angle.

"The dry weather here allows me to add damar varnish in three weeks to a month. If it is cold or damp I wait longer. To finish the painting, I send it to the framers unvarnished and leave it there for a month. After I pick it up, I study it for several more weeks. Then I make corrections or changes. This is when I follow Mayer's instructions: take the painting out of the frame, lay it down flat, and varnish it with damar and turpentine. This will dry in about four hours.

"I need to know from 18 months to two years ahead in order to plan for a show, even though the shows come about every six months now. "If you start forcing paintings out just because you've made commitments, they don't have the quality. This is a major caveat for the painter because you remember when you didn't have the demand and it's hard not to try to fill it. My answer is: don't make the commitment."

When asked his view of the future, Wilson Hurley has this to say: "I may as well paint as if the quality will be important after I'm dead." Such a view is a fitting summary for an artist who feels an obligation to apply himself to being the best painter he possibly can be. He has much to apply: talent, integrity, honor, and a profound sense that the grandeur of nature is beautiful.

MARSHALL JOYCE

BY CHARLES MOVALLI

AFTER A SERIES OF RIGHTS and lefts down narrow Massachusetts roads, you pull under a big shade tree near a comfortable brown house on the edge of a river. A small sign hangs from a post: "Marshall Joyce: Marine Paintings." The driveway ends in the backyard studio. And, as you round the corner of the house, you see distant marshes. Two of Joyce's grandchildren are down for the day; you can hear them digging in a nearby garden, gathering the carrots and beets that were forgotten during the summer. Joyce steps out into the strong fall breeze and looks toward a path across the marsh. "That's my dory out there," he says, pointing. "I paint it all the time."

He leads you through the sliding glass doors of the studio. There's a strong smell of oil paint in the air. Easels are in every corner, and bins on the floor hold wet student work. Joyce's own sketches are hung on the walls, piled on shelves, and stacked haphazardly in freestanding display racks. Near his own built-in easel, a piece of 9 x 12 inch illustration board contains a dozen small watercolor sketches.

"I'm working up ideas for my next series of

The Sea Moss Gatherer, 1974, oil on Masonite, 24 x 36. Collection the artist. The exact color of a thing is not important, according to Joyce: "What matters is the warmth or coolness of a color and whether it's light or dark."

114

Page of thumbnail watercolor sketches, actual size. Joyce paints hundreds of these watercolor sketches—generally 4½ x 6, though—which serve as guides and ideas for future paintings. Most of the painting problems are solved in these sketches: values, mood, color, compositions, design, and so on. They take Joyce about the same time as black and white sketches.

classes," he says, holding the board in his hand. "I have eight classes a week, and they all work in here." He looks pleased at the popularity of his class. The more you talk with him, the more this pleasure seems to be part of his character—as if he's surprised every day by the smooth workings of his life. Joyce is tall and wears checkered pants and bulky sweater. His Vandyke is graying picturesquely. He frequently stares off into space as he talks, like someone who sees the shapes and stories hidden in the passing clouds.

"I tried outdoor classes," he says, tossing the sketches onto his work bench. "But Kingston isn't geared to them. Up in Rockport, people are used to students. But here I'd get permission to bring a class into a neighborhood—and then would be chewed out by some resident I forgot to ask. You always miss somebody! I'd also lose part of the caravan on the road: somebody takes a wrong turn, and I have to go looking for them." He laughs shortly and briskly. "So I decided there must be a better way."

He pours coffee into throwaway cups; there are ten on the table, ready for tomorrow's students. "They get here early, some of them, and have to have their fix of coffee before they can start work." You stir the coffee, breaking down the lumps of Cremora. "I don't let the class talk about their children, their troubles at home, or their business worries: Don't tell us what little Johnny did today—tell us about shows you saw and pictures you like. Take my pictures apart if you want. But stick to art!"

He tugs lightly at his beard. "I also try to make everyone keep up with the lesson. I gear the class toward the quicker students, forcing the slower ones to speed up. Everybody has to work, too!" he says, showing a belief in hard work that will run throughout the day's conversation. "They'd like me to touch up their canvases: 'Oh, we learn so much from watching you.' But you don't learn much by watching; you learn by taking the brush in your hand and getting to work."

He takes his cup of coffee and moves to a lawn chair in the center of the studio. A nearby stool serves as a makeshift table. "The classes do a picture every two or three weeks. I demonstrate during the first half hour, painting like the devil. That's the heart of the lesson. Then I talk to them as they work.

"When they arrive, the week's project is on my easel, drawn in raw umber. I square it off so the class can draw it more easily. I'm a nut on drawing," he says, hitting the arm of his chair with the flat of his hand. "That's why I square things up for the students—and recommend that they also square anything they want to copy. Copying can be an educational experience; but when you copy, copy! Don't just swipe at it, or you won't get anywhere. I tell them to draw and think about what they're drawing, to just look at the direction of the lines. The gunwale of a dory, seen from a three-quarter view, actually swings back on itself. But students never see that; they're too busy thinking about a "boat." " He laughs, surprised again by the tricks of the hand and eye.

"If the student wants to change the color of the boat or the position of the trees, who cares? Let him put in two trees or ten, high or low. But don't draw a boat that looks like a bathtub!"

Taking a sip of coffee, he talks about classroom materials: "I try to give the students materials that are both serviceable and inexpensive. In my oil class they paint on gessoed Masonite. In the watercolor classes I suggest a piece of illustration board. Look at it this way: once they learn to work on illustration board, they'll have a picnic with d'Arches paper!"

A chart on the wall lists the colors for the oil class. "I suggest Grumbacher red—an 'azo' color—as an inexpensive substitute for cadmium red light. Then there's yellow ochre or raw sienna, and raw umber—a nice greeny-brown. Burnt sienna is a warm brown. Thalo green is a good sea color, though it's far too bright for trees and bushes—I mix my foliage greens with blue and yellow. Alizarin crimson is a dark red that doesn't have the dead, rusty character of cadmium red deep. I like permanent blue because it's less red than ultramarine. I use Permalba white because of its texture; it's buttery and doesn't stick to the palette. It also dries quickly—unlike titanium white." He's been looking at the list as he speaks. He turns and leans back in his chair. "You don't need black with this palette; you can mix it with Thalo green and alizarin or with permanent blue and burnt sienna."

He again looks over his shoulder at the list. "I use almost the same palette when I paint in watercolor—but substitute new gamboge for the cadmium yellow. The new gamboge is more transparent, and I like transparent watercolors to be just that: transparent. I put a daub of the gamboge with my warm colors so I can make orange and a daub with my cool colors so I can make green. You need both spots. When you mix a green, you get blue in your yellow, and it will never again make a good orange.

"I avoid opaque colors, like yellow ochre and white. When you use white in a watercolor, it jumps out at you; you can't keep it a secret!" He laughs. "I'd rather correct a watercolor with less obvious touches of pastel." He leans forward slightly. "I also add black to my watercolor palette. With oils, you have time to mix black; when you're working with watercolor, your color has to be ready when you need it."

He reaches for his cup. "Students often worry too much about the 'exact' color of a thing," he says, sipping. "What matters is the warmth or coolness of a color and whether it's light or dark: what is its value? The specific color doesn't amount to a row of beans. If you had twelve professional painters do the same scene, they'd end up with twelve different color schemes. And they'd all be great."

He again looks into space. "Photos tell you how things *look*. I always tell my students: don't make things up. When you work at home, there's the danger of inventing piers and boats that could exist only in fairyland. If you're going to paint something like

that, take a photo of it—or at least go to the site and study the subject. That's the key to painting a convincing picture."

Joyce gets up and rummages in a nearby corner. "I tell the students to practice with a good book of landscape photographs. I don't see anything wrong with studying photos. I suggest they use these things," he says, holding up two L-shaped pieces of cardboard and moving them back and forth over one another so that they create a variety of square and oblong openings. "Move these finders over the photo, cutting it into different shapes. When you see something you like, mark the area with a pencil. One photo can give you dozens of ideas—and a really good book of photographs could keep you busy forever! Remember, though, *never use a whole photograph*! You have to design things—you have to get some of your own stuff into the final painting. Don't pick the photographer's brain clean!"

He looks out the window. "I tell my students to decide first what they want to paint. Then give 75 per cent of the picture to the subject. Get up to within six or eight feet of it; paint it big. Students rarely have too little in a picture; they usually have too much. That's why I keep my eye on the student who tries working from a colored postcard. Remember that postcards are made by photographers who want you to visit the state. They have to get everything in: hills, farms, rivers—everything!" He continues to look out the window, his back to you. "As a general rule, I tell students to stop whenever they work on an area too long. They're probably creating monotony in the picture—like when you try to put all the leaves on a tree. Simplify the area, or move on to something else."

He turns from the window, having obviously enjoyed the look of the sunny marshes after a rainy and overcast weekend. "I think of a painting as light traveling across a canvas," he says, sitting again in the metal chair. "It goes from one side to another or from top to bottom. What makes the picture interesting are the objects that get in the way—the objects the light has to go around. Outdoors, students often forget that the sun is moving. Their shadows go in different directions. But shadows are an important part of the picture. They put things on the ground—and they're a basic part of the light-and-dark design."

He gets up again and points to the picture of the building in Key West. An angular shadow cuts across the porch and leads the eye right to the door. "The shadow catches your eye and directs it. It's like an arrow. I'm a great believer in arrows," he says.

Outdoors, the shadows begin to get longer; inside, the conversation slowly turns to the paintings of clippers and schooners that are Joyce's special stock-in-

Watercolor sketch, 4½ x 6. *Notice that the sketch has been squared off. "I'm a nut about drawing," says Joyce, who insists his students square up anything they want to copy to get a feeling for the direction of lines in their subject matter.*

The Doryman, oil on Masonite, 24 x 36. Collection Mr. and Mrs. John Wilson. Joyce is mainly interested in capturing his impression of a scene—big units w

dark patterns. ''After all,'' you don't need a lot of sailing vessels to say ''ship at sea.''

Sintram, oil on Masonite, 28 x 40. When painting his tall ships, Joyce spends most of his time developing the hull and modeling the big sails. He then quickly creates the illusion of detailed rigging.

trade. "My father sailed up and down the coast in an old three-masted schooner," he says, admitting that he's told this tale so often that his friends run whenever he mentions it. "He hauled lumber and coal, and I'd join him in the summer. I worked on the boat and learned what made it tick. When you've actually sailed the tall ships," he notes, "it's easy to see the mistakes many painters make. Some, for example, load their pictures with rigging. When a boat comes at you, you don't see all that stuff: it's just a mass of confusion. I spend all my time working on the hull and the modeling of the big sails. Then the rigging goes in, during the last 15 minutes." He imitates the quick strokes: zip, zip, zip. . . . "People look at it and ask, 'How did you do all that detail?' But there really isn't any detail. It's all suggestion."

He pulls out a drawing from behind a student's easel. "This is one of my flops," he says. "I made a common mistake; the ships and masts are almost vertical. The thing looks like it's standing still. Try to paint ships on the move." He pauses, then adds quickly, "Of course, you can overdo it. You've seen pictures where ships heave out of the ocean, pushing mountains of water aside as they go. They look like there

must be 16 diesels in the hold. Clippers were fast—but not *that* fast!"

He sits down, patting the arms of his chair as he speaks. "I like doing clippers," he says. "You can reflect the tan color of the sails down onto the ocean. That warms it up. I'm always fighting blue in my pictures. My water has a tendency to be too dark and cool." He again leans forward to make a point: "You'd be surprised how far a little blue can go! I try to use the purple of the sea and to take advantage of the greenish-brown seaweed and the warm skies that reflect down on the surface of the ocean. Remember the Old Masters. Their work is always on the warm side: brown, yellow, ochre. I think of that as I work."

He reaches for a box of slides, searches through it, and hands you one. "Here's a picture I'd planned to send to a show. But when I took it outdoors to photograph it, I was shocked at how blue it was. So I decided to fix it." He opens his eyes wide. "Never 'fix' a painting! Whatever good you have in it will go right down the drain. Instead, do another one from it. I fooled with this one; and later, when I looked at the slide, I decided I should have left it alone!"

Through the glass door you can see one of the

grandchildren carrying a bunch of carrots almost as big as he is. The trees throw dark shadows on the lawn. Joyce pours another cup of coffee and reaches for a cookie. "When you're going to be a painter," he says, "you usually know it early. I planned to be one right from the beginning. I didn't want to work on the ship—and I hated school!" He laughs at the recollection. "I finally got into advertising. And I still remember my first job. It was a painting of a four-foot cucumber for a 'cool as a cucumber' window display." He thinks about that for a second. "What a great experience," he says loudly and with enthusiasm. "Everything had a deadline, and I learned to draw and paint fast. You learned to get things right the first time. And you had to draw *everything*. I don't know how good some of this stuff was. But it didn't *have* to be really good—as long as it was ready by five o'clock!" He laughs again, amused at his own industriousness.

He sips his coffee and stretches out his legs. "If you're just starting out," he continues, "I recommend that you paint what you know. My friends from the North Shore tell me there's nothing to paint down here: 'it's too flat.' But you have to know the area. If you live in New England, paint New England—don't try to do the Western prairies!" There's wonder in his voice—amazement that anyone would do otherwise.

"The young painter should also present his work to the public as if he were proud of it. Get good frames; use clean, well-cut mats. A company executive told me he sometimes got advertising ideas that were dirty or in mats that looked like they'd been chewed by the artist's teeth. 'If the artist himself doesn't think his work deserved to be packaged properly,' he said, 'why should I give it a second look?' " Joyce nods in agreement. "In the same way, you should always show your best. You can have bins of unframed work. But there should be some relation between the work on the wall and what's in the bin. I've seen things in bins that should have been in the wastebasket!"

He lets his eyes wander over the pictures on the wall. "Also keep a record of what you sell—both on paper and with photos. I woke up late. I don't even know where some of my best pictures are!" He thinks for a few seconds about the ones that got away.

"I also tell young painters to send big pictures to the shows. You could send a little jewel—but it's almost sure to get lost in the shuffle. It has to be big enough and different enough to 'upset' the judges a little. After looking at a couple of dozen so-so pieces of realistic art, judges only see a blur. Along comes a piece of rusty iron with a mirror in it and some soldered do-dads. It's called *Sunrise*—and it stands out. There's imagination in it. That's happened to me as a juror. You think to yourself, 'My God, I'm going to give this hunk of iron First Prize!' But when everything else is run-of-the-mill, you haven't any choice."

He takes his seat. "I don't believe in inspiration," he says briskly. "If I had to wait for inspiration, I'd never get anything done. I'm not inspired; I'm *challenged*. When I start to plan class projects, it's a job. But then I begin thinking about the problems involved. Maybe I want to do a house and a clothesline. Do I want the house to have clapboards or shingles? If shingles, what kind? What condition will they be in? What color will they be? If there's a door, what kind of door? Should it be simple, carved, or fluted? If drying clothes, what shapes will they be? How will I use my warm and cool colors? What will the light and dark pattern be?" He becomes more and more animated as he lists the possible problems. "Once you start, you have to answer a hundred technical questions—knowing all the time that one wrong stroke will make or break the picture. You want to solve the problems and so get interested in the subject."

He points to the pile of small watercolor paintings on his workbench. Some are five by seven inches, some even smaller. And there are hundreds of them. "That's where all these sketches come in. I check the idea on a small scale. It's easier to see possible errors in composition; and it's a lot better than discovering a mistake only after you've begun a large canvas. You have a chance to figure things out." A thought suddenly strikes him: "That's why my demonstration pictures often come out better than my studio work. When you demonstrate before an art organization, you have to know exactly what you want to do. You don't paint off the top of your head. I think it's fun, when you're working alone in the studio, to imagine there are 150 people looking over your shoulder!"

He laughs and admits to being a ham. He likes an audience—almost as much as he likes hard work. "Art is everyday," he says. "This studio is my home. This is where I live—and I don't like being far away from it for long. I tell students that they can't be satisfied with one class a week—or with one picture. Go home and work! It brings tears to my eyes when I see someone who really knows how to *do* something. Ballet dancers, figure skaters, musicians, even golfers. Popular singers are created by promotion—but you can't promote a great golf shot or a piece of fine dancing. They're both the result of hard work."

He gets up for the last time and again looks out the window toward the golden marshes. "When the job's done, I lose interest in it." He shrugs. "It's disappointing. You're excited and then—all you have is another picture." He shrugs again and cocks his head. "Just another picture. It may be good, but I'm no judge." He thinks for a second. "Besides, it's better not to be too in love with your own work. Look at it with a fishy eye and take the oohs and ahhs of your friends with a grain of salt."

He turns from the window and scans the studio before looking directly at you. "I'm a firm believer in one thing," he says, his eyes bright. "My next picture is going to be my best! Always the next one!"

WOLF KAHN

BY DIANE COCHRANE

Pond And Pinewoods: *Late afternoon in Vermont. The sun lingers on treetops, a meadow beyond. The increasing dusk throws the woods into deep relief. The scene contains several basic elements of 19th century landscape painting—an air of mystery in the woods, the promised land in the brilliant meadow. Or does it? A blink of the eye transforms the composition into alternating bands of color that melt into one another and move back and forth on the picture plane. Is the image realistic? Abstract? Impressionistic? The answer is unimportant; it is singularly a Wolf Kahn, who can say without contradicting himself, "I love 19th century American landscape painters—Inness, Ryder, Blakelock—and want to paint what they painted from nature." And, at the same time, he says, "Minimal art contains a big contemporary truth. We crave spaciousness, a minimum of encumbrances, details, specifics. But why only minimal stripes and stains? Why not minimal landscapes?"*

IF A SINGLE THREAD runs through Wolf Kahn's work, it is a persistent effort to bring landscape painting up to date. His concern for the past and its relevance to contemporary painting is not pedantic, for Kahn, a most likeable, generous man, is not a pedant. But he does believe strongly that the presence of the past is essential to good painting: "There are two types of painters—the traditionalist and the avant-garde painter who denies the past. In the latter's total alienation from the tradition of Western painting, he is as crippled as are those who are alienated from the present." His own commitment to the Western tradition is a natural outgrowth of his past. As a child in Germany and then in New York, Kahn copied drawings of the Old Masters. At the Hans Hofmann school, where he enrolled as a student after high school, he continued his studies in an effort to discover the underlying principles of great art.

Knowledge of the past is not enough, of course. To depend on it is to run the risk of becoming involved with nostalgia, the easiest way to forfeit the life of painting. Instead, Kahn leaves himself open to contemporary work, too, whether it be of dubious origin or serious art. Although he's not particularly interested in pinpointing their contributions, Kahn counts as possible influences on his work Abstract Expressionists Hans Hofmann, Jackson Pollock, Mark Rothko, and even some New Realists.

What he is concerned with is his own experience of the visual world and how he expresses it on canvas. Repeated and intimate contact heighten his perceptions of a subject, and he often returns to a certain place before he realizes its potential as an image. *Pond and Pinewoods* is a good example of how he fulfills the potential of an experience: "I knew the place well. I had seen it many times before in different lights, but one day I saw it when the middleground was in shadow. The late afternoon sun lit the upper meadow, which seems remote, and brought the woods into relief, making them seem mysterious. I painted the first version outside. Later, I made another version in my studio which was less descriptive. I concentrated on only a few elements: the way the pond was tucked down into the foreground, the way the light came through the trees, and the intensity of the yellow meadow. As the composition became simpler, the scene was no longer the same scene. Now when I look at it, the painting seems to possess symbolic overtones—darkness and uncertainty must be overcome before the clear light of the farther world is reached—but I only see that now."

The experience Kahn seeks before he can paint may sound mystical, and indeed it could be, but it is essentially a perception of space. He looks for the connections between things: how one color flows into another; how forms engage and separate; how one point in space influences another. But connections aren't always easy to come by in nature: "Take the horizon, for example. There is a great divide between these two very separate elements, and to discover the connections between them could keep a painter busy for two lifetimes."

And this challenge fascinates Kahn. So, despite his natural alliance with the Maine and Vermont countryside that he paints so lovingly and frequently; despite his belief that landscape painting is more relevant than ever, because it relates the contemporary

Adams Barns, 1973-4, oil, 52 x 52. Collection Mr. and Mrs. Robert K. Lifton. Kahn feels the 18th and 19th century rural past was America's heroic age. Barns become a symbol of this tradition: monumental yet intimate.

person to his ancestors, and describes how our feelings toward nature have changed, and more importantly have remained the same; despite all this, his decision to concentrate on landscapes is not based on a love of nature. It stems from the accessibility of certain motifs—the sky confronting a barn roof, trees merging with hills—that allow him to discover connections and manipulate form and color. What emerges are paintings that capture the essence of nature, and these "minimal" portraits of the land represent his contemporary approach to landscape painting.

Landscapes dominated by archetypal images are a far cry from Kahn's original intentions. As a student of Hofmann's in the late '40s, he was exposed to the principles of organizing space that could lead either to Abstract Expressionism or to figurative art. Choosing the latter course after he left the Hofmann School, he became an expressionistic figure painter (perhaps as a reaction to Hofmann's vehement objection to Expressionism) and worked his way through the German and French schools, imitating Van Gogh, Soutine, and Bonnard. "Their influences are still visible," he says.

The style that resulted brought almost instant success. The genre-like scenes he painted in short, broken strokes appealed to both public, critics, and fellow painters. His first show in 1953 at the Hansa Gallery, a co-op he helped to found, sold well. Lead-ing critics of the day—Fairfield Porter, Frank O'Hara, and Dore Ashton—wrote favorable reviews. Abstract Expressionist Willem de Kooning offered high praise: "You are a lucky man. You are able to paint everyday life. I always wanted to, but I don't know how."

Kahn's reputation continued to grow. A few years later he sold out a second show at the Borgenicht Gallery, his dealer for the past 17 years. More interestingly, he was mentioned in "Recent Directions in American Art," compiled by Thomas Hess, editor of the 1954 *Art News Annual*. With these successes under his belt, Kahn gave up his job as an arts and crafts teacher in Harlem to devote himself full time to painting, because, "If Tom Hess said you were hot, you were hot."

But he didn't have to worry whether success would spoil Wolf Kahn. Before long he began to feel uncomfortable with his figures: "They presented a problem that almost made me give up painting. What should the figure be doing? Just sitting at a table like a contented bourgeois? That's Bonnard and Matisse, and, beautiful as they are, this kind of figure certainly had nothing to do with my lifestyle at the time, in which I disdained all possessions and comforts and didn't even own bed sheets. Perhaps Giacometti would have been more appropriate to the kind of cold-water-flat living at that time of my life, but my outlook was too cheerful. So I had the old hangup of painting

Red Mountain, 1972, oil, 36 x 66. Courtesy Grace Borgenicht Gallery. Kahn chooses to express the connections between things: how forms engage and separate, how one point influences another. His motifs are selected from nature: trees merging with hills, lush hills confronting the sky.

figures easily but being forced to invent an unreal world for them to live in, a world I didn't believe in. Furthermore, I had lost the flow between the figure and the surroundings. My figures tended to get imprisoned in a wall of paint."

Even more important, Kahn hated his brushstroke to stop at a door or a window. He wanted no edges or confinements; instead, the expansiveness of an overall surface attracted him. And during a two-year sojourn in Italy, he changed his mode of expression: "In Italy I became interested in landscape, because there were no confines except the edge of the canvas."

Back in New York, Kahn found that while his expressionistic figures had been popular, his new landscapes were not. Some critics remained faithful, but sales at his first show after returning from Italy revealed an unfaithful audience. Still, there was no question of trying to revive the old style: "People used to tell me how heroic I was to change my work, which had been so popular, but it wasn't a question of heroics. I had simply come to a halt, and I had to start over to survive."

Despite his interest in landscape, however, he gave little thought to subject matter at first. His main concern was to build up a total surface by applying layer after layer of luminous, though nearly monochromatic, color. Under this surface floated the barely discernible outlines of objects in nature. And if the image didn't work out, it wasn't a complete loss: he could turn an unsuccessful horizontal seascape into a vertical landscape with the same detachment the Abstract Expressionist feels for his subject.

As time went on, one or two large forms began to loom out of these muted canvases. He discovered his archetypal images—or "presences," as he sometimes calls them—during a sketching session in Maine. His aim had been to draw a pond seen through a light fog, but when it grew thicker, he turned to go. Then, "As I got up, I saw the silhouette of a town hall looming up in front of me, filling nearly my whole field of vision. I found the confrontation exciting and sat down again to make a pastel, using what for me was a whole new scale. In the process of working, I thought of a large, black sculpture by the minimalist Ronald Bladen I had recently seen. His work seemed much like that ungainly wooden building with its Mansard roof that I was trying to put down on paper. Since then I've been on the lookout for similar moments of confrontation with barns, large boulders standing by themselves in the woods—anything that could be seen as a large volume in a simple surrounding. And once I found it, my drive is to express the kind of space which will explain its importance."

Kahn's initial perception of an archetypal element was spatial, not psychological. Nevertheless, he feels such forms as intrinsically interesting, and it's no accident that painters choose certain objects—brooks,

Beaver Swamp, 1974, oil, 42½ x 60. Collection Mr. and Mrs. Arthur Colins. When Kahn finds something he wants to paint, he uses a few objects to represent a heightened experience. Here he develops the space that expresses the swamp.

Barn at the Edge of the Woods, by Wolf Kahn, 1973, oil, 28 x 36. Courtesy Grace Borgenicht Gallery. Kahn prefers landscape painting because offers greater flexibility in working out formed complexities. In other words, if you're doing a figure, you can't add a third leg just because you need it for the formal considerations of the painting, but adding another branch to a tree is no problem. Here Kahn uses the tree, left, to move the viewer's eye back behind the barn and up to the surface. Its tonal contrast with the sky causes the sky to move forward.

Afterglow, 1974, oil, 40 x 66. Collection Whitney Museum of American Art. Kahn combines the drama and mystery of a 19th century landscape with a 20th century perception of spaciousness in nature and the planar space of a canvas.

Pond and Pinewoods, 1973, oil, 36 x 50. Collection Mrs. Janice Hanely. Concerned with the direct sensual experience of color, the artist develops a total glow or vibrance in each painting.

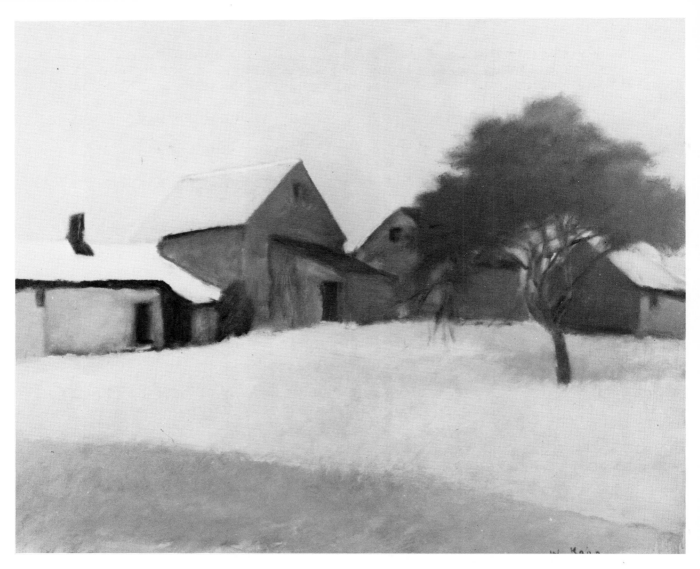

Above: *Outbuildings,* 1973, oil, 40¼ x 48. Courtesy Grace Borgenicht Gallery. Kahn uses color to clarify form: the planes of the buildings, their relationship to the sky and to the foreground.

Right: *Barn at the Edge of the Woods,* 1972, oil, 52 x 66. Courtesy Grace Borgenicht Gallery. Rather than specific objects, Kahn is interested in continuity between objects and landscape, life, and nature.

barns, churches, bridges—to build their work around. "Take a bridge: it's a thin connection across an empty, alien space. Or a covered bridge: a house above a void. The landscape practically drapes itself around these subjects. Painters know this; but what prevents them from making a work of art of it is that they don't get beyond conventional reactions colored by past habits, bad art, and bad teaching; they don't work hard enough to rediscover the intrinsic interest of the subject by getting deep enough into their reactions toward it."

How does Kahn do this? "By placing an object as securely as I can into a specific setting." In other words, he is not interested in a particular object (Wolf Kahn's barn or Jack Jones's meadow), but in its unique functions and qualities that supply the connections—the continuity—between object and landscape. "For example, a barn in a landscape is equally part of the life of nature and the life of man, and its site is generally chosen to utilize available topography. The slope of a hill, for instance, might provide access to different levels for different purposes: the top for the hay wagon, the middle for the animals and milk truck, and the bottom for the manure spreader. Storage, production, elimination, in descending order, quite like the human sequence." And once he has understood this specific flow of activity, the object tends to become more archetypal and closer to the universal, and elicit a direct emotional response from the viewer.

Searing orange skies, purple trees—these are not the colors found in nature. They are colors found joyously in the act of painting. "Paint isn't just a way of carrying out one's prior ideas; it has a life of its own. Artists, if they are smart, follow where the brush leads them," Kahn wrote a few years ago. And in a recent interview he said, "In my own case, I had to go through hundreds upon hundreds of paintings involving several disciplines and aesthetic modes to take seriously my natural bent as a colorist."

Kahn has always been a colorist. Even the palettes used for his misty paintings of swamps or ponds identified this particular bent. But he seemed to reject vibrant or diverse colors as if some puritanical streak prevented his natural proclivites from running amok. However, during another Maine vacation, in 1968, a new direction opened up. The more vivid colors of nature began to filter into his work: "Every night we had a different sunset, and I began to let the color come through in my canvases. The funny part of it was that the whole time I had been so restrained in my use of color in oils, my pastels were always in-

tense, and finally my painting caught up with them." Today Kahn is concerned with the direct, sensual experience of color. "I look for an incandescence, a vibrance, even in the most ordinary street colors. I try to get a different total glow in each painting."

Kahn's new use of color affected his forms. Previously they had merely lurked beneath the opaque curtains of pale tones. Now they burst forth. By using color to describe forms rather than veil them, obscure images were clarified, and intense color demanded less painting to realize them: "Before, I didn't always know what it was I wanted to do. Now, when I see something I want to paint—a few objects that represent a heightened experience—I know its potential and when I have fulfilled that potential. It's great to walk away and know the picture is finished."

Because he was comfortable with both subject and style, Kahn's productivity increased many times. A seven-day-a-week painter, he has always had an enormous appetite for painting, but, in the days when images were elusive, 20 canvases a year were all he could manage. Now he completes well over a hundred. Most are begun during the summer months in Vermont, where he owns a farm. Every morning and every afternoon, equipped with a French easel, a canvas, and a paint box, he sets out to find the right combination of objects that will set in motion an intriguing flow of space. ("Still the hardest thing to do.") Depending on how good the start is, it might be almost finished on the spot or require another 200 hours back in his New York studio (the same creature-comfortless flat he lived in 20 years ago, although he now uses it for work only). Kahn may also do several versions of the same scene back in his studio. These lose a certain amount of the spontaneity of location painting but gain in simplicity and quality of color. "My technical setup is much better, naturally. I can wash my brushes more often and do things with more deliberation."

All goes well for Kahn now. He has resumed his role as a widely acclaimed painter. His works, both old and new, hang in such prestigious museums as the Museum of Modern Art, the Whitney Museum of American Art, the Brooklyn Museum, the Jewish Museum, and in some of the best private collections.

Of more importance, one might say that he continues to revitalize the tradition of landscape painting. But these words are too solemn. They reflect none of the delight he derives from his work. Kahn wholeheartedly enjoys the act of painting. And as he indulges himself by transforming sensual experiences of color and form into glowing canvases, he asks the viewer to join him in a joyous celebration of nature.

ROBERT MAIONE

BY RUTH CARTER

The artist at work in his Italian studio; a converted farm house with north light. Photography by Emmet Bright.

Opposite page: Drawing, pencil and chalk on gesso-prepared paper. Maione feels the complexity of the human experience makes the human figure the most complicated form to realize.

ROBERT MAIONE'S STUDIO, a converted farmhouse, sits on top of a high hill overlooking the Umbrian countryside which spreads out in quiet beauty. From the valley below one can hear a rooster crow or a dog bark. Beyond the valley the hills are softly rounded, and in the distance the spires and domes of Perugia are awash with light and shadow. A sense of peace and privacy pervades the atmosphere. There is no intrusion of violence except for the slashes of orange, plum, and crimson that streak across the skies at twilight.

One has only to walk through a gallery hung with Maione paintings or browse through his skylighted studio to understand why this part of central Italy has become home for the American-born artist. One's attention may be caught by a portrait so vivid and alive it seems effected out of space and movement or by a seascape that emerges from the canvas with a kind of misty energy, the silver blue spray challenging the darkening skies, but for the most part, there is a profusion of landscapes, Maione's primary expression. These landscapes, transmuted by the artist's imagination and personal vision, reflect the natural beauties and seasonal changes of his present environment. Sculptured haystacks lean into a sunlit barn; a panoramic vista of wooded hills glows with the renascent colors of spring; a mistbound village rises out of a valley; a stone bridge arches over a stream reflecting the silvery light of early morning sun. These are the subjects that absorb Maione's imagination, and Umbria offers up her multiple riches for him to select from.

Maione was born and raised in New York where his feeling for art developed early. When he was twelve years old, he was already enrolled in Saturday classes at the Art Students League. When he graduated high school at 17, he became a full-time student at the League where he studied with Frank Mason and Frank Vincent DuMond.

As Maione's feelings for art as a means of expression grew, his involvement with the dynamics and mysteries of nature deepened. His first contact with the countryside came when he was 18. He arranged to study with Frank Vincent DuMond in Vermont, and

when the bus that brought him from New York pulled up in front of the inn where he would be staying in the Pownal Valley, Maione stepped off onto the valley side of the road. This was his first encounter with space that is vast, awesome, and uncontained. As he remembers it, he felt a "rush of joy and wonder that was mingled with fear, almost the feeling one might experience adrift in a small boat in the middle of the vast solitude of the ocean." From this moment on his artistic way opened out for him, and in his continuing contact with nature, the initial response of joy and wonder mingled with fear never left him.

For several years Maione lived in New England, where he taught art and painted. Then, ten years ago, he left America to travel around Europe, finally putting down roots in Rome. When the increasing freneticism of that city no longer made it viable for him, he moved to Anticoli Corrado, a small mountain village north of Rome.

The study and execution of a series of barns painted during his stay in Anticoli brought about a major breakthrough in Maione's personal technique. For the first time he began to *perceive*, which he considers something quite apart from seeing. "It is not enough," explains Maione, "just to be an observer, to see. One must perceive. Perception is a larger vision, a coming together of all one's knowledge—emotional, intellectual, intuitive. It is this knowledge one begins to encompass in one's paintings. It is like breaking through into another visual dimension, a naked intensity that reveals itself to the artist as if he were a conduit through which all memories, experience, and feelings crystallize and pass through on to his canvases . . ." For Maione, perception is a synthesis, but also a purification of ideas.

The time came when even Anticoli Corrado felt too claustrophobic for his expanding perceptual values, and he searched for and found his farmhouse in the province of Umbria. Here, space seems to have no boundaries. The forested slopes, the deep valley bowl, the changing lights and shadows of each day and each season provide the endless inspiration, excitement, and wonder that are the springs which nourish his creative spirit.

Maione's working methods are of special interest because they derive from the techniques of the Old Masters. His paintings began with Italian *canapa* cloth (somewhat like linen, but more fibrous), the material used by the painters of the Venetian School. Onto the heavy, tight weave of cloth he applies several coats of white lead. Between each coat he allows a month and sometimes longer to permit proper drying and to prevent cracking later on. Instead of white lead, he sometimes uses gesso as a primer, which requires even more applications than white lead. After the coats are applied, he sands down the surface until it becomes silken smooth and enables the brush to ride over the surface without any interference from the original weave.

The preparation of the ground is of infinite importance, Maione feels, since it determines the eventual paint quality of the finished canvas. After this initial preparation, the imprimatura is applied—either a middle tone gray or umber—using the Flemish medium discovered by Jacques Maroger. The Maroger medium consists of linseed oil, mastic, turpentine, and white lead and works best when it is fresh so that it must be cooked at least once every 15 days. Into the medium pure, dry colors are ground, either every day or once every two days.

Behind this painstaking preparation of ground, paint, and medium lies Maione's basic concept of artistic excellence: "Technique and creativity have been erroneously separated in recent times," Maione states. "Technique has become something to be ridiculed, looked upon with contempt, put down. But in the best works of art, they are inseparable, because, while painting is an art, it is also a craft. It is manual. It is doing. It is not pure meditation. It has to be transferred from the mind of the artist for other eyes to perceive. And the way in which that idea is transferred is the way in which the idea will be communicated."

Before starting the actual painting, Maione will occasionally draw a primary sketch on paper or will brush a small sketch in a corner of his canvas at the moment of inspiration in order to use it as a guide as the work progresses. But most often the artist paints directly on the prepared canvas using the gray or umber imprimatura either as transparent halftone or as shadow. The essential masses, established boldly in terms of light and shadow, form a general design or abstraction from which the forms and subtleties of value are gradually "pulled out" as the painting progresses. Once a particular light effect is determined—that is, the time of day and its particular mood—this is retained, regardless of the changes that occur in nature, particularly if a painting is done out of doors on more than one occasion.

Maione applies colors sparingly and thinly, except for the lights, which he paints more opaquely. Each time the painting is worked, a thin coat of medium is put on the canvas to facilitate the ease of brushing. When a painting is nearing completion, he will sometimes use thin veils of glaze, either black or rose madder to unify and enhance a particular atmospheric effect. "The glaze," Maione says with a twinkle, "is the mystery and the illusion, like a conjurer's sleight-of-hand. It is the element that gives depth and luminosity to the painting and increases its range because of the sense of light coming through from beneath, a radiance without which the color would feel dead."

Despite his years of landscape painting, Maione still begins a painting on the spot, working out of doors for two or three sessions at the same hour of the day before going in to his studio to finish the work.

Painting out of doors, the artist is confronted with such abundance that it is necessary to choose and eliminate and not become seduced by seeing too much: it is not necessary to paint every leaf on a tree in order to give the impression of thousands of leaves. Working out of doors, the artist also lacks the sense of security he finds within the studio, where his light is constant and controlled, and the confined space holds no terrors. But at the same time, the enclosed studio withholds the excitement and wonder that the painter feels when confronting vast expanses of free space. To hold on to that sense of wonder and excitement and surprise after the first moment, when inspiration strikes and the act of painting begins, is one of the most difficult problems for the artist, according to Maione. Maione has overcome this problem by working on the spot as much as possible where the moment-to-moment variations within nature are a source of invigoration and renewal.

Although Maione works mostly with nature, he is both challenged and intrigued by the human figure. He feels that the problems of conveying the material significance of the human body with its energy, tensions, resistances, and emotions make it the most complicated form to realize. He also sees figure painting as a discipline which can enlarge one's vision so that a tree trunk, for example, is eventually seen not as part of a tree but as a body, twisting and pulling in different directions.

Maione prepares his drawing paper with a gesso ground that has been tinted various tones—sometimes a gray, sometimes a blue, rose, or green.

His subjects are never professional models, as Maione prefers to select from chance observings: a farmer tending his fields, a schoolboy, an old man sunning himself in the square, a shepherd, an itinerant musician.

As another exercise in discipline, Maione once again refers back to the Old Masters and their practice of copying. Copying does not imply an imitative transfer of someone else's inspiration. Rather it is again a question of *perceiving* or *reading* the painting selected to be copied which, by so doing, enables you to tune in to the knowledge, experience, and feelings that gave birth to that particular work of art. It is a method of research and study of models of the past in order to benefit your own perceptions and your own stores of wisdom.

Discipline serves many purposes. Besides enlarging the artist's vision, it also develops his individual

July, Umbria, 1971, oil, 37½ x 20⅝. Courtesy FAR gallery, New York. For Maione space has no boundaries in Umbria. The changing lights and shadows provide the artist with endless inspiration.

Oaks and Haystacks, 1974, oil, 24⅜ x 36. Courtesy Capricorn Galleries, Bethesda. Sculptured haystacks illuminated by the sunlight. When a painting is near completion, Maione will sometimes apply thin veils of glaze to increase its luminosity.

Trees, oil, 19½ x 28⅜. The artist begins a painting on the spot. After two or three sessions at the same hour of the day, he continues in his studio.

English Village, 1972, oil, 8¼ x 17⅛. Courtesy Galleria D'Arte Classica, Milano. Here drawing and painting become one: the artist draws directly on the canvas with his brush.

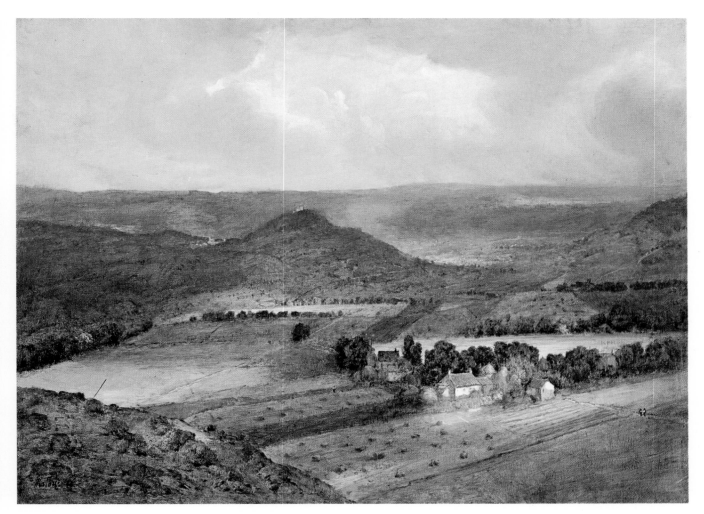

The View from Agello, oil, 25⅜ x 36. The artist establishes essential masses in terms of light and shadow, using his toned ground as transparent halftone or shadow. Subtleties of value are ''pulled out'' as the painting progresses.

East Anglian Farm, 1972, oil, 10½ x 17⅞. Courtesy Harbor Gallery, Long Island, New York. Maione prepares a smooth-primed surface that enables his brush to ride over it without interference from the original weave of the canvas.

The Barns, Anticoli Corrado, 1968, oil, 35¼ x 54¼. Courtesy Harbor Gallery, New York. A series of barns painted during his stay in Anticoli Corrado brought about a major change in Maione's thinking.

hand—his signature, so to speak—which makes his paintings recognizable as uniquely his and no one else's. Perhaps its greatest significance is that it ultimately brings freedom, because as Maione sees it, "the challenge of painting is walking the tight rope between discipline and freedom. Only through the mastery of discipline can unlimited freedom be achieved."

As in any other art form, painting combines the inner vision of the artist and the dexterity with which he controls and manipulates his tools. Since no idea springs full blown from the artist's eye directly to his canvas but must be transferred manually, Maione feels that the artist's medium should interfere as little as possible in this transfer. This minimal interference can only pertain if the artist is thoroughly schooled in his craft.

If there is a single message that comes through in Maione's work and in his personal attitude toward his art, it would be that the young artist should understand that there are no easy roads to freedom. Painting is not a careless game played for success and prestige. It entails hard work, study and preparation, and for this one should have devotion and dedication, "and," Maione adds with a smile, "the good fortune to find a teacher willing to point the way."

Maione's exhibitions have covered almost as much space as he himself has. His paintings have shown in New York, Cold Spring Harbor, Bethesda, Cortina d'Ampezzo, Rome, Milan, and London. His canvases which capture the mutability and intensity, the mystery and energy of Umbria, continue to attract the attention and enthusiasm of art lovers all over the world.

JEAN PARRISH

BY MARY CARROLL NELSON

AS JEAN PARRISH SITS in her New Mexico adobe home, she speaks in a refined voice, explaining why she couldn't paint in her native New England: "New England was all trees, no open vistas. It wasn't anything I wanted to do anything about—too much fuzzy green covering the structure of the earth and hills. But when I saw New Mexico, it was like coming home. With me it was immediate. I smelled piñon smoke. There's the big sky, room to breathe. It suited me right down to the ground.

"I still didn't think of painting then. I still had this clamp on my mind that I couldn't paint unless I did the painstaking type of painting my Dad did." (Jean Parrish is the only daughter of the artist-illustrator Maxfield Parrish.)

Now, following her own unhurried system, Jean Parrish paints landscapes in oils that range from small to medium size. Beneath their matte surface, her paintings reveal her response to a place: realistic, but simplified; emotional, but intellectual. There is a Jean Parrish look, a muted coloration of blues, pale rose, and tawny colors, that produces a somewhat solemn reverence. She creates a personal art that reflects, with formality, a deep attachment to her subject.

Rock formations anywhere on the Navajo Reservation, architectural themes from San Jose, a village between Santa Fe and Las Vegas, New Mexico and the mountains north of Taos are data banks for Jean Parrish. She goes to these areas for specific visual information. Using a Marsh pen, she records the subjects in the thin or thick line she requires; the pen allows both. She sketches for future use: not whole compositions, but isolated fragments. She does not find a whole painting ready and waiting, instead, she builds a painting from various pieces of memory stored in her sketches. She might sketch an adobe house without any landscape detail around it. Later, when composing a painting she might fit the form of the house into one of her mountain scenes. Mountains and rocks impress her with their character. Details of shape and shadow remain in her mind long after she has seen them. Her sketches, which she says are "not deathless," serve to refresh her memory.

Feeling the need to go out on a sketching trip just to look and see things anew, she says, "I can feel the splinters in my hands from scraping the bottom of the idea barrel. I've got to get out and stretch my eyeballs."

To begin a painting, Jean Parrish buys full sheets of tempered Masonite and cuts them in half with a handsaw in her garage workshop. She takes a day out once in a while to prime a stack of these.

Laying newspapers on her brick floor, she spreads out the Masonite pieces and rolls on each a neat coat of Craftint's Blockout White such as sign painters use. It can be thinned with turpentine. After the first coat is dry, she adds a second coat. The result is a nicely smoothed, nonabsorbent white layer on which to paint. A day's work nets her a large supply of prepared panels. She finds this surface akin to gesso and easier to care for: it is not as sensitive to handling as gesso.

Jean Parrish likes using Masonite because it allows her the freedom to cut off any unpleasing parts and save the salvageable. "I am fascinated by work done on canvas," she states, "but the mechanics are difficult. I want the option of cropping, too. You may start out big and then find only 9 x 12 or 12 x 16 worth saving. You can cut Masonite!"

The artist's procedure is direct and logical. She cuts the primed Masonite into the size she needs, sands it, and washes it off. She then follows a system for locating her central point of interest. By lightly drawing the diagonals from corner to corner in pencil and then bisecting one with another line at right angles to the diagonal, she fits a roofline or mountain ridge into the rectangle of her painting. She prefers a low horizon. By plotting these points, she creates a relationship of parts to the horizon and the whole that satisfied her. Her approach is a modification of the classic theory, *Dynamic Symmetry,* published by Jay Hambidge in 1917.

Having established her reference points, the artist lays in her underpainting with a juicy mixture of Payne's gray and medium. She might rub her brush through the paint for high- and middle-light areas, or she might use a book of matches to scrape down to

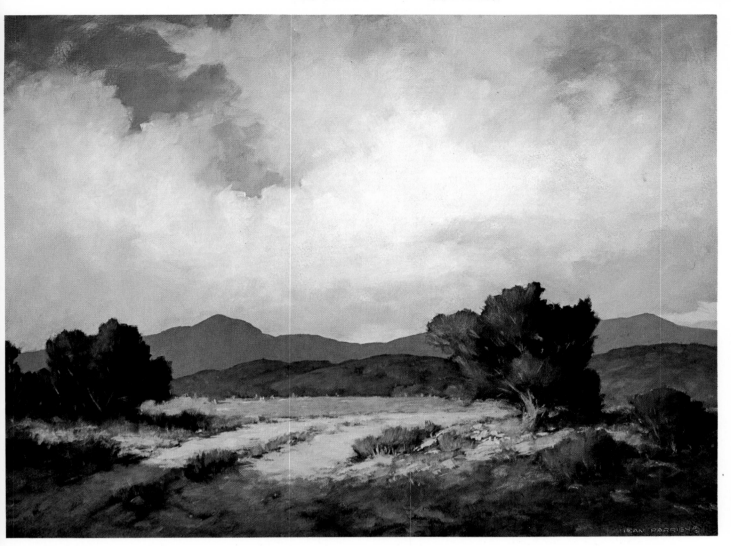

Cloud Shadows, 1973, oil, 18 x 24. Collection Florence Lathrop. The artist focuses attention on the middle ground by making it the only lit area. Also, Parrish uses a low horizon, which she prefers, to create an illustion of deep space.

the white ground. "I work on the theory that before the sun comes up everything is dark. So I begin dark," she says. She does not do much drawing on the panel unless her subject is architectural. "I do the earth parts first; the sky is last." She begins painting into the wet Payne's gray immediately, mixing colors on the painting rather than on the palette. She might use Venetian red for warmth or emerald green for cool in this first stage. As a painting develops, Jean Parrish modulates her colors, layering subtle variations of warm and cool tones.

Maxfield Parrish used to say: "You've got to make your foregrounds believable, because the beauty is in the middle ground." Remembering this advice, Jean Parrish works on the foreground areas first, which she wants to keep simple and credible. She complains that "You have to put in all this other stuff to make the one thing you want to paint believable."

During the painting process, the artist puts the painting into a frame and studies it by turning her back to it, leaning over and looking at it upside down through her legs. This turns up any compositional errors immediately. "It's a trick Pop taught me," she says.

Since she is using Masonite, she adds, "If I don't like what I've painted, and I've let it dry too long, I use steel wool and mineral spirits to scrub it off."

For Jean Parrish, the terms she uses about painting have their own meanings. She prefers to consider relative value in terms of warm versus cool rather than the range of light to dark. In other words, she thinks of a warm value or a cool value, whereas shading from lightness to darkness she refers to privately as chiaroscuro. By controlling chiaroscuro and the cool versus warm contrast, she uses paint "to sculpt with light, letting the light reveal the structure of things.

"I hate doing landscapes with a lot of green, but I sometimes do one—and add a lot of white. It's awfully hard to get an effect of light on green.

"I like one area to be lit. If the foreground is dark then the middle ground is lit against the dark background. The title of a book by Ross Calvin, *Sky Determines,* had a terrific effect on my painting because out here what's exciting on the earth is caused by what's going on in the sky. Without clouds, the New Mexico landscape would be dull."

References to Maxfield Parrish crop up frequently in his daughter's conversations when she speaks of little aids he tossed out about painting or composition, but generally she's developed her own procedures. Her father did not teach her how to paint. He advised against art schools, saying that each artist must develop an individual point of view. Jean Parrish has done this.

She likes to keep two paintings going at once so that one is always ready for a new assault. Her studio is a 20 x 20 foot brick-floored private area with three exposures. Across the eastern window frame, she has stretched a wire. She supports her panels against the wire, letting them face the early morning sun. This helps them dry quickly to a tacky stage allowing her to paint daily. She uses a collapsible tabletop easel, which she made for herself years ago.

A movable low tambour table with a glass top is near the heavy table upon which she paints. On the tambour placed beside her chair is a lean array of tubes: Payne's gray, which is her darkest dark; the siennas, raw and burnt; yellow ochre and golden ochre, which are rarely used; Indian yellow; cadmium yellow medium; phthalocyanine or Winsor blue; rose madder or alizarin crimson rose, both used rarely as glazes; Venetian red; emerald green; and, if she could get it, her favorite Orpi's ultramarine turquoise. Also on the tambour is Frederic Taubes' Copal Painting Medium, and a tear-off palette. The unexpected feature of her equipment is the huge supply of immaculate sable oil brushes, one eighth to three quarter inches wide, that she keeps in pots. (Flat edged brushes are preferred because they allow a broad stroke and hard edge.)

By the door of her studio is her drafting table. Around the walls she's taped sketches of mountains, some in pencil, some ink, felt tip or dip pen, or scratchboard. She saves things that give her inspiration, perhaps a color reproduction from *American Artist* of a painting whose scheme she finds pleasing. These ideamakers are taped near her drafting table. Frames in quantity are stored in a corner; Masonite already primed is in another; spray retouch varnish is on the shelf. (She uses a light coat of it to finish a painting.) This is the studio of an artist who works at her art. A visitor, however, will see no painting while it is in progress.

Within the cool, spacious home, there is not a sign of a Jean Parrish on the walls. She feels she might begin repainting any painting that remained on her wall even a short time. Besides, she needs to sell her work. "As I now live—yes, I must live on my painting." Her production is absorbed almost immediately by three galleries.

The spare, self-designed environment Jean Parrish has created is well-suited to her. She does not care for a cluttered painting. She is the same about herself and her home. A handsome woman with good bones and graying hair, she dresses in a manner that is simple without quite becoming austere. This is also true of her home. It is mellow, full of textures of rubbed wood, brick, adobe, and iron—but wide expanses are empty. Her treasure is a private view of the Sandia Mountains. Her home in the Rio Grande Valley commands a view of the entire range.

The creation of this home is central to her development as a painter. She began by building a 17 x 30 foot adobe, complete with Spanish fireplace. She did it herself, brick by brick. It was meant to serve only as a studio. At the time, she rented an apartment on the adjacent lot. One evening she sat in the shell of her building and decided she would live in it. Plumbing and wiring turned it into a little house where she lived and painted for a number of years.

She still likes to work with her hands. "If I can't

Left: *Canyon De Chelly,* 1968, oil, 16 x 20. Collection Mr. and Mrs. Spencer Schwartz. Of special interest to the artist is the abstract quality of the canyon walls.

Below: *Sacramento Mountains,* 1971, oil, 18 x 24. Collection Mr. Pat Sheehan. Parrish creates a simple, believable foreground as a setting for her main interest.

Right: *Canyon Sunset,* oil, 1973, 16 x 20. Collection James D. Hill. Parrish uses the shadow areas to reveal the muted ruddy tones in the sandstone.

Below: Detail from *Mora Valley Farm,* 1973, oil, 16 x 20. Anderman collection. Broad shapes and muted colors provide a quiet contrast to the billowing cloud shapes.

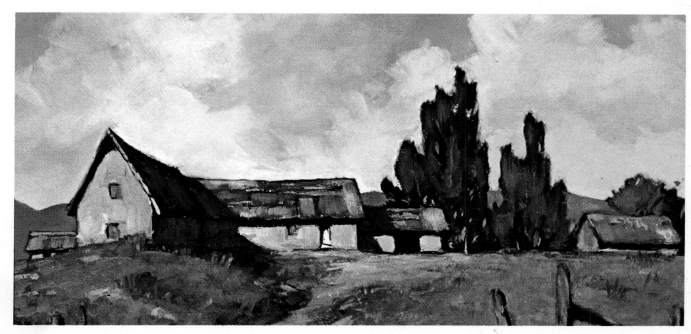

Penassco Valley in Winter, 1973, oil, 14 x 18. Collection Dr. Stephens. The artist captures essential forms by the subtlety of her palette and the shape of her shadows.

Sun and Sandstone, 1968, oil, 15 x 30. Collection Mr. Anthony Russo. The artist works from dark to light, using light to reveal the structure of her forms.

paint, I have to be making something." A new hand-rubbed coffee table attests to her ability as a craftswoman. She no longer builds homes, but she has added to her home with others doing the building. It is now a large ell with plenty of room for her daughter's family and the grandchildren. As she speaks of them, her eyes twinkle with pleasure. She is a woman with a large capacity for love and feeling, all of which shows in her eyes.

The life Jean Parrish has lived has not been easy. She arrived at painting, her greatest love, after many years of problems. Her need to paint conflicted with her marriage—the marriage that brought her west in the early 30s and put her in the one spot she wants to paint. Between her arrival in New Mexico in the '20s and the real start of her career as an artist in the '60s, years of time were spent in a battle against alcoholism—successfully resolved with the help of friends. She believes winning the battle against alcoholism was a turning point for her as an artist and as a person.

"You have to get to know yourself. Fighting alcoholism provided me the opportunity to grow up mentally and emotionally. I wouldn't give up being an alocholic for anything. The dearest thing to my heart is the power of choice. When you're on the jug, you have no power of choice. You do things you don't want to do. Since I've sobered up and found my little patch, I'm only interested in painting."

She used to do about six to nine paintings every two years and have a show in the local library. After her career got going in the early '60s her output in-creased. "Now I paint about 30 a year."

Jean Parrish has eliminated unnecessary clutter from her life, including the worry over what the world thinks. She is her own harshest judge and makes comments with some of the bite one would expect from a Yankee. "I do the best I can but some paintings just bark at me," she will remark. "The dogs always sell first." Self-disparagement laced with humor is an attribute of the artist and makes conversing with her a verbal treat.

She believes that the first planting of her love of the west came from her father's paintings. At one time he had gone to Arizona for his health. While in the west, he was impressed by the Rocky Mountains, so much so that thereafter he managed to incorporate a distant range of rocky peaks into the background of his paintings. "I was familiar with the western mountains," Jean Parrish remembers.

While growing up in New Hampshire in the small art colony, Jean Parrish had an unconventional, but stimulating life. She did not go to school until she was enrolled in Ethel Walker's School for Girls at the age of 14. Prior to that time, she had tutors and was reading Shakespeare and du Maupassant at ten. Her parents and their friends were a group of talented people involved in the charming ways of a time already past. The women continued to wear long skirts and large floppy hats long after they were out of style. They amused themselves at games of charades with gaiety and wit. Although comfortable they were not wealthy, but they were well-bred intellectuals, confident and accomplished. Their children picnicked,

drank beer, and referred to themselves as the lost generation. They admired their parents, but felt the weight of their established reputations.

Did any of this contact with genius help in the formation of a painter? Jean Parrish says, "What you have in you that makes you a painter is how you look at things." Surely, how Jean Parrish looks at things is related to her family life. Her mother and grandfather were both artists from whom Jean Parrish acquired her taste perhaps more directly than from her father. Stephen Parrish, her grandfather, was a renowned etcher and a painter whose brushwork was fresh and direct. Although Jean Parrish reacts similarly to nature, she is put off by the wealth of precise detail for which Maxfield Parrish is famous. Whereas he worked at photographic realism under the glow of intense light, Jean Parrish attempts to capture an essential form through a searching reflection of her emotional reaction to it.

The deep canyons of the Southwest hold a special fascination for her. She remembers happy days of camping early in her marriage, seeing the rock walls of high cliffs on the bare sides of Lake Mead dropping cleanly into the water. "For years afterward I carried the memory of those great rocks going into the Grand Canyon."

Her marriage ended in 1949, but her love of the massive, sandstone formations continued. She is at work off and on painting the canyon walls and hopes to eventually concentrate totally on them.

"I feel pregnant with cliffs. If you've ever given birth to a 200 foot cliff—it's quite an accouchement.

"I've been having a love affair with Canyon de Chelley. If I ever go abstract, it will be with the sheer sides of Canyon de Chelley with their little bas reliefs of fissures and flaking half-moons, giving the suggestion of caves where the sandstone has slipped—the luminous shadows.

"Do you know Eliot Porter's The Place No One Knew? If it were possible to do a painting only of a rock face—My God! It would be like Wordsworth's definition of poetry, 'Poetry is beauty recollected in tranquility.' What really fascinates you is to stand on the bottom [of the canyon] and look way, way up at the shallow areas where the people lived.

"Great simplified rock formations, I want to draw them and draw them.

"It's always delicious to treat myself to a motel in Taos and sit out on the terrace and soak in the Taos Mountain. I hope I never do get it in painting. It would be a sacrilege."

Jean Parrish's enthusiasm is as contagious as her smile. "The minute I shut my eyes," she says, "I see the most beautiful things. I keep a notebook by my bed to write about what I see. My original ambition was to be a writer, and I find words evoke the memory of a picture almost as well as a sketch."

She is frank in discussing the selling of her work. "I'm a severe critic of myself. People will say, 'That's beautiful.' and inside I'll say, 'No, that stinks.' I get horribly depressed. There's something about selling a painting that's good for my ego but when I finish a painting I'll think, 'It's done well enough, but I swung and missed again.' "

Despite the inner qualms of the artist, Jean Parrish's paintings are a pleasure to critics and collectors. Her glowing, romantic scenes are a clear demonstration of a mature style by a colorist with a discerning eye, a Yankee eye, that searches only for the essentials, leaving the details to the photographer.

KARL SCHRAG

BY DIANE COCHRANE

Large Self-Portrait (detail), 1975, oil, 43 x 32.

KARL SCHRAG IS SOMETHING SPECIAL. Schrag's work has earned him dozens of one-man shows, including a retrospective at the Smithsonian Institution, awards such as an American Academy of Arts and Letters grant, a Ford Foundation fellowship, and a permanent place in nearly every major museum in the country (The Metropolitan Museum of Art, the Museum of Modern Art, the Whitney Museum of American Art, the Art Institute of Chicago, and the California Palace of the Legion of Honor, to name but a few).

But such dry facts tell nothing about the man's vision, his reasons for pursuing the landscape, his experiences of it. The most important things about his paintings and prints cannot, of course, be expressed in words. But motivations can be articulated, certain misconceptions about his work clarified. And what better time than now, as he looks forward while he is in his mid-60s to a new era in his art?

Transmitting the essence of an intuitive response to the landscape has been a continuous challenge to Schrag. Unlike others who seek to trap the momentary image, his imagination is activated by the intensity of light or the relationship of two colors or forms. "While I believe that the outward appearance of nature is but the shell of a deeper and richer inside world that I wish to understand, I also know that the forms of art are in their infinite relationships charged with profound meanings. This idea of nature and this concept of meanings of related forms in art are the two main sources of my work." When they unite, they create what Schrag calls the afterimage of an experience. "What we carry away from an experience often lives in our memories more intensely and more eloquently than that which we actually see. And if the artist's feelings are strong enough, he can convince others of the rightness of the vision and reach states of feeling common to all men."

The urge to transform themes into universal statements underlies all of Schrag's work, although it did not always find fulfillment in the landscape. His own memories of nature date from many pleasurable excursions he took as a child into the Black Forest near his home in Karlsruhe, Germany. But for the most part these experiences remained simply memories.

Throughout his studies, first at the Ecole des Beaux Arts in Geneva and later in Paris, where his most valuable training came from working with Roger Bissière of the Académie Ranson, landscapes received short shrift compared with portraits, still lifes, and city scenes. The same pattern persisted through the establishment of his first independent studio in Brussels in 1937, immigration to the United States in 1939, and an apprenticeship in printmaking with Harry Sternberg at the Art Students League during World War II.

In 1945, however, Schrag's unconscious but overwhelming attraction to the landscape could be suppressed no longer. Just as a visit to the South of France triggered the conversion of a host of artists to landscape painting, the discovery of the Coast of Maine provided a similar stimulus to Schrag. Here he found not only a remembrance of things past—mystical forests not unlike the Black Forest—but the most awe-inspiring of all natural elements: the sea. In 1972, in Alan Gussow's *A Sense of Place*, Schrag summed up his mystical experience of Maine this way:

"The great forces of the sun, moon and winds and rain—the vastness of the sea and of the sky in ever-changing light and weather—the sensation of growth and mystery in the forest have a haunting quality—a spell I wish to find again in my paintings. There seem to be no 'big' or 'small' themes—a few seagrass in the wind and the stars written into the immense sky above the ocean have equal importance for me."

Today, he elaborates on the powerful effect of the Maine Coast: "Much of the inspiration for my landscape comes from Maine because it has so many contrasts—the darkest woods, the most luminescent distances—and so many moods which correspond to the feelings one has about life—great light, great darkness, great drama, even great tragedy can be seen in the upheaval of trees during violent storms. I see it all as a mirror of life."

Not all of Schrag's landscapes deal with the more dramatic moments in nature. Many works are devoted to the calm of a hazy afternoon or the quiet of early morning. Each painting or print summons up its own essence—and one that's not always visual. The

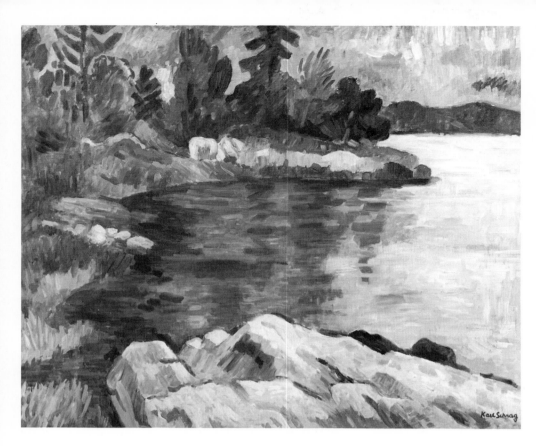

Left: *Reflections and Silence II,* 1975, oil, 48 x 58. The quiet of early morning summons its own essence.

Below: *Garden Meadow and Woods,* 1970, oil, 32 x 42. The *S* of the overall design seems to emanate from the bouquet-like garden.

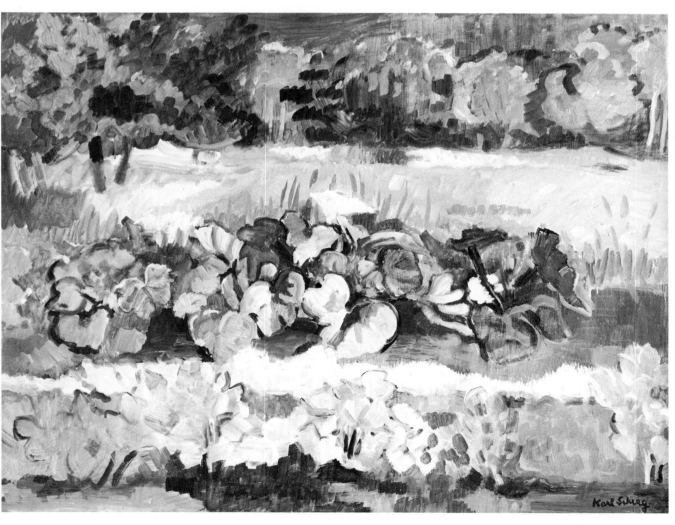

whisper of the wind, the feel of the rain, the fragrance of flowers may be an integral part of an experience and must find expression to interpret the truth of nature. In *Autumn Night*, for example, the artist's fantasy life takes over to communicate the essential spirit of a sensuous, velvety night aglow with perfume of flowers.

Schrag's interpretation of pastoral mysteries demands more than an intuitive response, however, to succeed in communicating a state of mind to the viewer. In 1959 he wrote, "Feeling and thinking find their union in an artist's work. I consider both alone and in a pure state as enemies of life and art. It is good for me to observe how a tree bends in the wind and to make a hundred drawings to reach a deeper understanding—it is also good to find visual symbols to express what has been understood and felt. But this is not enough. The spirit of the tree in the wind must be the spirit of the entire work in which all of its elements contribute to completeness and unity of expression."

Schrag's insistence on a synergistic combination of feeling and thinking is what sets him apart from the German Expressionists, with whom he is frequently, though incorrectly, compared. While admitting to a common Germanic tendency to be strongly interpretive of nature, he believes that their primary concern is the expression of their own general moods. As a result they neglect to think about the unique emotion that a theme calls for. The outcome is that all themes—whether the subject be a sick child, a turbulent landscape, or whatever—are treated to the same violent method of constructing a painting.

Schrag, on the other hand, lets the experience dictate the mode of expression. He may describe a driving rain with an overall composition of short, delicate lines or limpid tidal pools with large blocks of color. The choice of medium, color, and line depends on the object as it is affected by the sun, moon, heat, or whatever.

The strong linear and calligraphic style of Schrag's work has also been thought by some to be the result of a special training or leaning toward Oriental art. Not so. As John Gordon, curator of the Whitney Museum of American Art, put it in a profile on Schrag, "It comes from Schrag's 20th century economy of means in expressing himself and from his dedication to the study of the essential in nature. Both these traits are also typical of the traditional Oriental artist." And this preoccupation with interpreting the essential or poetical spirit of the landscape had led to a lifetime preoccupation with both line and color.

Few artists place equally strong emphasis on both. Yet perhaps this is only natural in an artist who is a superb printmaker as well as a gifted painter. So Schrag's predilection for the discipline of graphics must be considered both in itself and as a force affecting his painting.

Even as a teenager, Schrag was drawn to printmaking, but the year 1945 represented a break-

Shadows on the Forest Road, 1967, oil, 44 x 49. Schrag invites the viewer to walk along a path surrounded by luscious foliage yet subtly reminds him of his essential separateness, humanness, by the illusion of solitude.

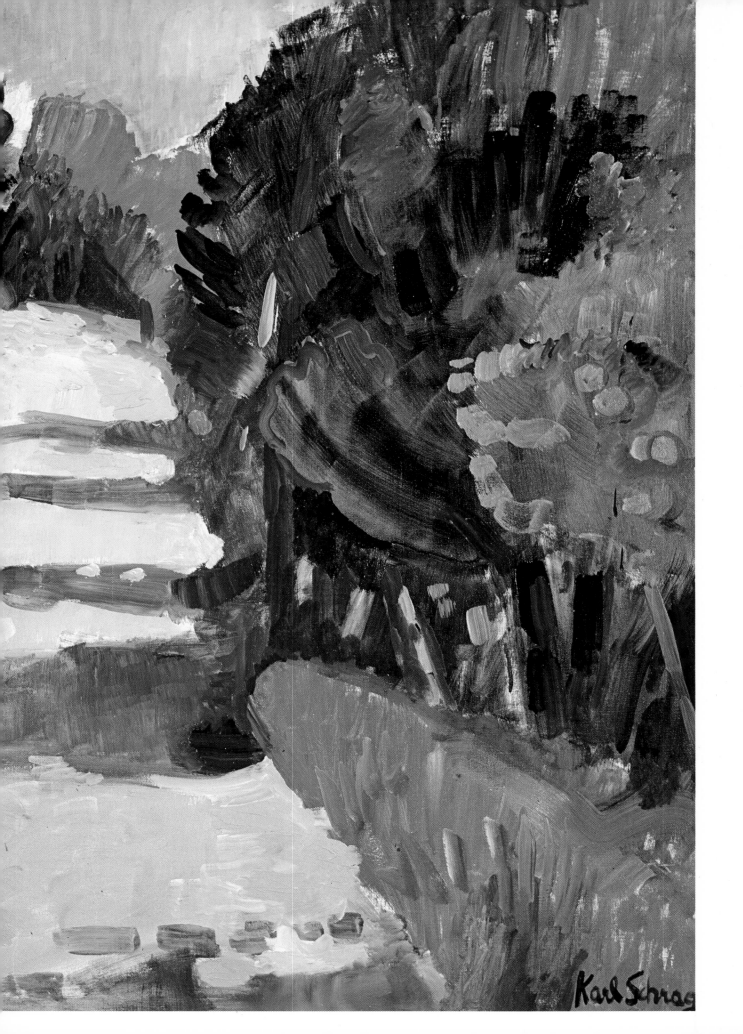

Karl Schrag

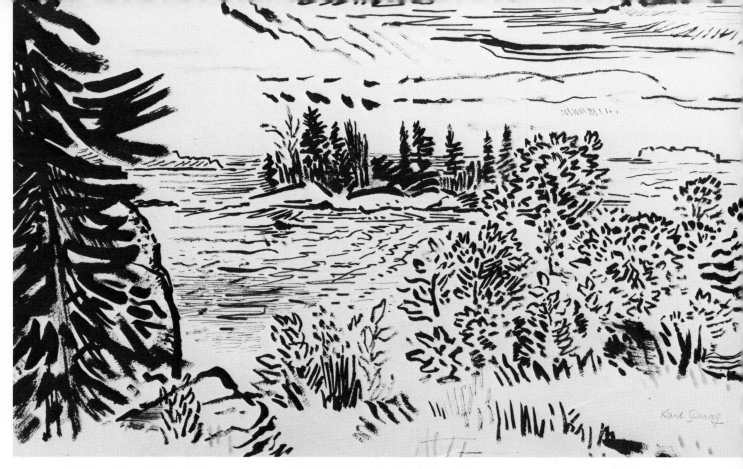

Land, Sea, and Clouds, ink, 18 x 24. Schrag captures the essential linear rhythms of his subject matter.

through in his approach to the medium when he came under the influence of the inspiring tutelage of Stanley William Hayter. Having fled from the war in Europe, Hayter established his prestigious workshop, Atelier 17, in 1945 in New York, instantly attracting many luminaries of the art world. Miró, Masson, Jacques Lipchitz, Chagall, Henry Moore, Jackson Pollock flocked to the workshop, spending long hours working with needles, burins, scrapers, nails, and other tools. "The method of engraving itself and Hayter's approach brought out the line in all the artists working there." The burin, in particular, played an influential role in reinforcing Schrag's feeling for line. "The tool hides line from sight [as you're working], so you develop tremendous sensitivity to line—how it starts, shifts, stops, starts again."

But it was more than just line that captured the attention of Atelier 17 artists; it was line that expresses movement. Jackson Pollock's fascination with it culminated in his famous drip paintings. Schrag's love of line spilled over into a series of ink drawings expressing the movement of water through the interplay of linear rhythms. And these drawings set the stage for thousands more to come. When Schrag returns every year to Maine, new drawings are made in his ongoing search for the essential: "They may be skies or studies of wind and trees, clouds and ocean, or of islands and cloud formations. All concern themselves with movement and the spell of distance."

Over the years Schrag's reputation as an ex-

traordinary printmaker has spread. After Hayter returned to Paris, Schrag took over as director of Atelier 17 and later taught graphic art at Brooklyn College and Cooper Union. In 1961 the USIA featured him in a film entitled "Printmakers USA," produced for international circulation; in 1962 the Ford Foundation awarded him a grant to execute a series of eleven lithographs at Tamarind Lithography Workshop; and since then various other organizations have circulated his prints throughout the world.

But printmaking has in no way dominated the other media in which he works. The prints, which Schrag prints himself on the original Atelier 17 press now in place in his Manhattan house, parallel in character the themes and artistic concepts of his paintings and drawings, but he is constantly aware of the essentially different qualities and possibilities of the various media. "The medium itself (oil, gouache, watercolor, ink) and the support chosen (canvas, cardboard, or one of many different kinds of paper) offer their own special characteristics which contribute to the expressiveness of the work. The handwriting of the brushstrokes or the colors can be very differently inspired. The vague and the forceful, monotony and brilliance, calm and clashing color, opaque density and spacious transparency, all these unlimited and indescribable possibilities of painting speak to us with endless variety of meanings."

Which brings us back to Schrag's other love: color. Schrag thinks of line as performing a role similar to

the melody or score in music and color as the orchestration. For him the palette is an instrument that is capable of producing sounds and harmonies. Each color has a certain intensity of light in relationship to other colors, and the kind of orchestration possible by mixing and juxtaposing colors, he feels, is still in its infancy. Each artist, says Schrag, if he explores the shifts between great luminosities and dimmer ones, can get completely new harmonies.

Certainly there is no denying that Schrag is a virtuoso conductor of color. Take the intense red of the tree trunk in *Apple Tree*. It is more than a color; it is an intensity of light produced by setting up a relationship among a whole family of colors. And look at the shimmering yellow house. It gives the sensation of an object shedding rather than receiving light. Yet, by obscuring the center of this radiance or glow, an atmosphere of something mysterious and totally remote is communicated. And this is precisely the essence of the exuberant landscape in which Schrag lives at the end of a long, lonely road in Maine.

Schrag is a gentle man, yet an exuberant one too. Perhaps he is what he paints. He talks enthusiastically about his future from an interesting point of view: "I am approaching the moment when, both as a person and as an artist, I have the possibility of great freedom. I feel I am breaking down more and more barriers in my work, taking more chances. I am attracted to the danger zones. Take the *Large Self Portrait*, for example. I made it five times life size. I painted the flesh with a whole family of greens. I emphasized the movement of the body away from the vertical with a horizontal orange border. I gave the eyes a startling, dark quality without pupil or flecks of light. In each case, I feel I came close to overstepping."

Schrag intends to explore more fully what he calls the freedom of old age painting. It won't mean a new style, but simply a change in emphasis: "Malraux said that what appears in the background in youth comes to the fore in old age." If he pulls this off, the world will be able to see the essence of Karl Schrag.

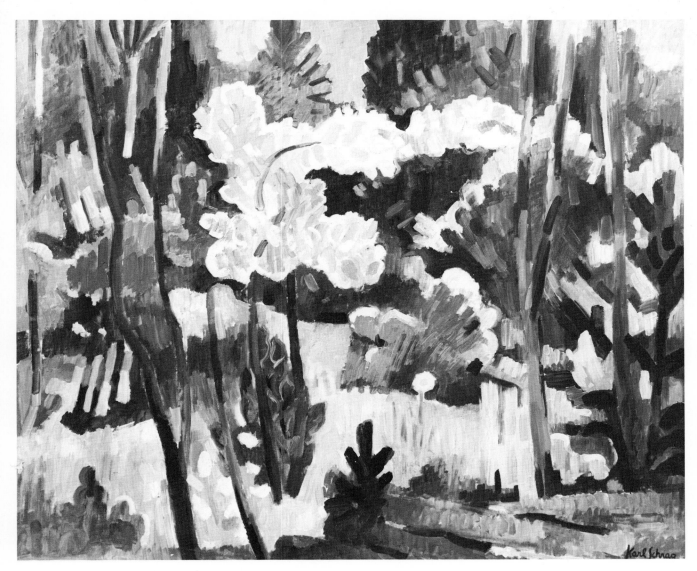

Noon Sun in Summer Woods, 1969, oil, 48½ x 58. Using each brush mark as an independent statement, Schrag invents shapes that capture the drama and joyfulness of the Main landscape.

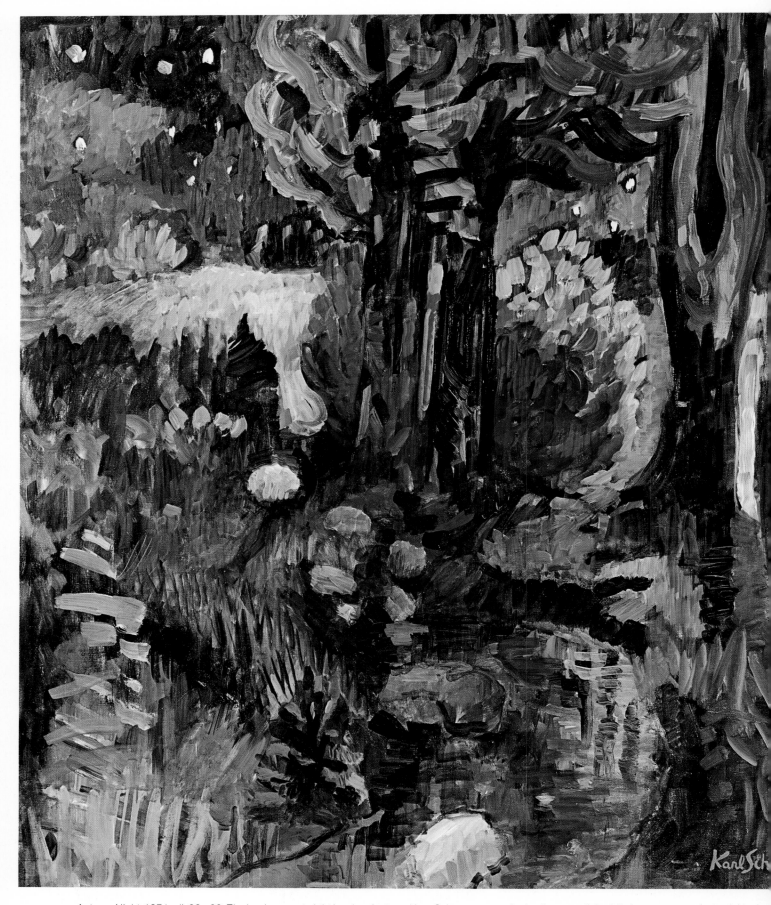

Autumn Night, 1974, oil, 36 x 32. The landscape at night inspires fantasy. Here Schrag communicates the essential spirit of a sensuous velvety night aglow with the perfume of flowers.

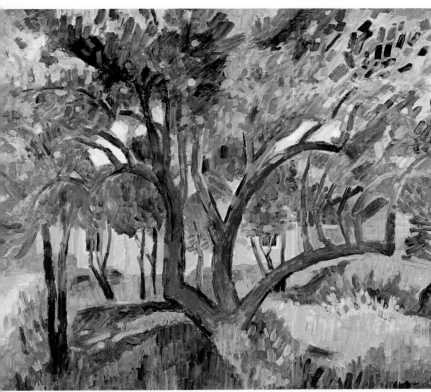

Left: *Summer—Apple Tree and Yellow House,*
1975, oil, 50 x 58. By obscuring the central glow
of color, Schrag communicates an atmosphere
of mystery.

Below: *Orange Earth—Gray Trees,* 1976, casein
on board, 25 x 38. Schrag creates a quiet bal-
ance: the color is stepped up, intense, yet the
general impression is not violent because of the
broad, quiet treatment of the shapes.

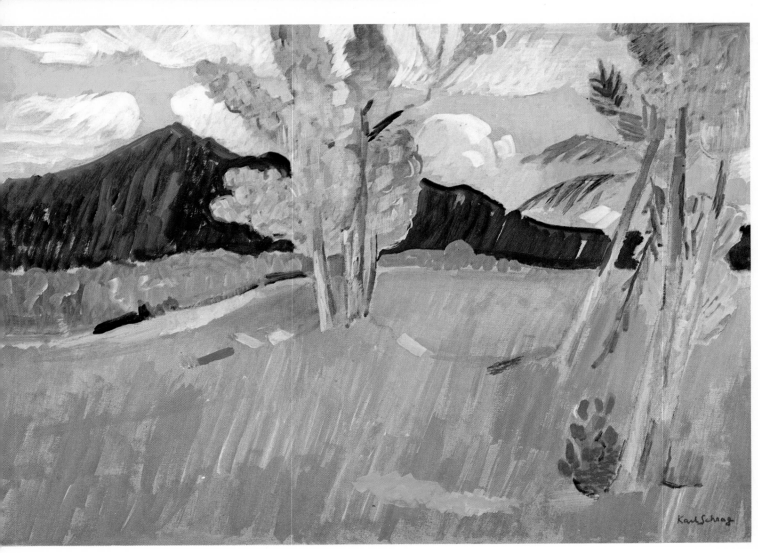

ROBERT E. SINGLETON

BY KIT YOUNG

ROBERT E. SINGLETON's earliest paintings were of stylized, slender trees found near his childhood home in Williamsburg, Virginia. Years later these trees reappeared, to become the first of Singleton's image themes, which recur time and again in his paintings. Singleton's painting is like the inexorable flow of a young river, crashing over rapids, always broadening, making its way to the sea in the path of its own momentum.

Singleton was born in Jacksonville, North Carolina, in 1937, and his family moved to Williamsburg, Virginia, in 1948. He began to paint in 1953 while still in high school and later attended William and Mary College and Richmond Professional Institute and studied with Teresa Pollack, a student of Hans Hofmann. Although Singleton feels he learned a great deal about theory in school, his actual painting method is primarily self-taught.

From 1954 to 1964 Singleton experimented with many styles and techniques, studying, teaching, and holding a variety of art-related jobs. "Primarily I was learning the use of materials, the handling of paint itself," he allows. "I used very simple compositions to achieve an understanding of how color works on canvas. Subject matter, too, was only a vehicle toward learning to handle the tools."

In 1964 Singleton moved to Florida, living most of the next nine years in Altamonte Springs near Orlando. He began to paint full time in 1965, the result of a long illness that prohibited him from holding a regular job. In the years following, Singleton won numerous competitions, primarily in painting, but in sculpture and graphics as well. His influence spread over the South through one-man exhibitions from Florida to Washington, D.C., and through his representation in many private, corporate, and museum

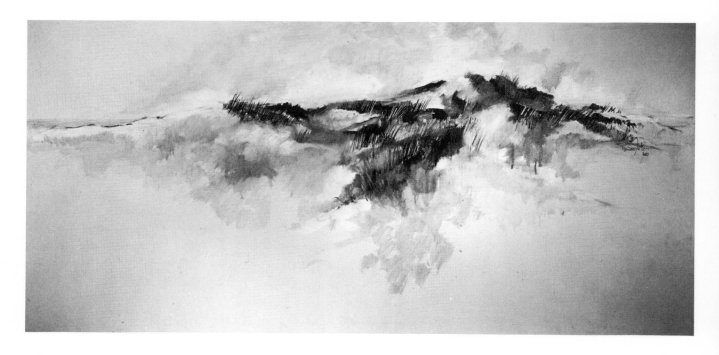

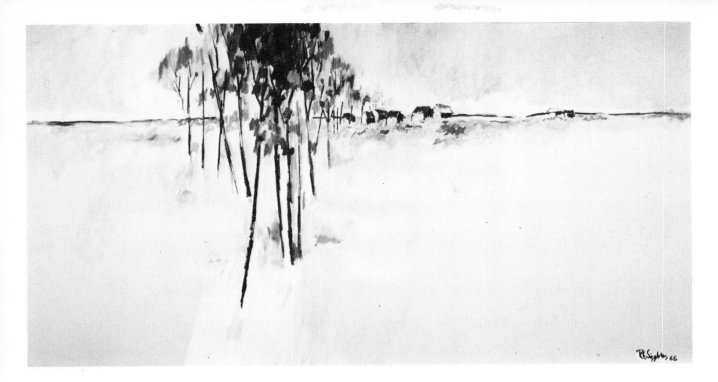

Opposite page: *Dunes II,* 1966, oil, 60 x 28. Collection Mr. and Mrs. L. P. Urback. In his early work, in 1963, Singleton had executed a series of paintings of a single subject, the Seattle fishing fleet. When he began to paint full-time in 1965, it was from this point and in the following manner; in series (always named and sometimes numbered), in evolving compositional cycles, using recurrent imagery, and with a limited palette.

"For the first time my ability to use the tools had caught up with my ideas," recalls the artist. "I had reached a happy plateau where I could direct my energy to what I wanted to say without stumbling over technique."

He was concerned with the nature of simplicity and the simplicity of nature. The first painting was a single dune on a high horizon, an image drawn from memories of Outer Banks, North Carolina, and St. Augustine, Florida. Some element of that painting led him to *Dunes II,* inviting him to explore the subject more fully. A new technical discovery on Singleton's part would evoke a desire to try the method on another subject, and a new series would begin.

At that time and for the next few years Singleton began with pre-primed cotton or linen canvas, giving it a coat of gesso, grayed slightly with black pigment. Then he would wash the broad area of focal interest with pigment in turpentine, creating the general composition and determining the limits of his palette. Next, using a prepared medium, he laid on colors, often only two or three, such as the Prussian blue and burnt umber in *Dunes II* (the darker patches), the brushes getting smaller as detail increased. Titanium white was used to highlight, reading bright white against the grayed gesso.

Above: *Summerscape,* 1966, oil, 42 x 22. Collection Mrs. Robert Stoddard. All of the series of 1965 and 1966 were impressionistic landscapes, virtually sketched on a predominantly white canvas; the focal interest concentrated on a very high horizon.

This use of a high horizontal line to break the canvas into two unequal rectangles was the first of Singleton's compositional trademarks. He called this contrast in use of space "majority" and "minority." He concentrated subject matter in a small space and left the rest up to composition. Among these series were "Beach Shacks," tiny houses clustered on the horizon of an empty beach; "Cliff Dwellers," tiny houses perched atop or spilling down mountainsides; and "Midwest," the golden expanse of wheatfields with barns or a farmhouse on the distant horizon, often with angry clouds far beyond.

Right: *White Beach,* 1967, oil and modeling paste, 50 x 40. Collection Mr. and Mrs. L. P. Urback. The first of Singleton's transitional paintings.

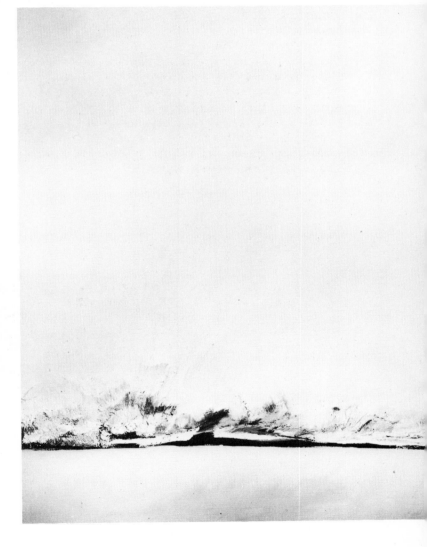

collections. Singleton has the rare quality of exciting critics and the public alike. As a very popular teacher at Loch Haven Art Center, Orlando, Florida, for many years, he displayed the also rare ability to impart his expertise to others, passing on each new idea and discovery to his students.

Today Singleton lives atop spectacular Screamer Mountain in Clayton, Georgia, with a view of several states. Nearby is the famed white-water Chatooga River, where the film *Deliverance* was made. The river is a powerful force in the lives of the residents of Clayton as well as all but the most casual visitor. Guests at Singleton's home, often the men and women who work on the river, are treated to a dramatic sound-and-light show, his own slides of the river in its most threatening role, punishing men, boats, and rocks in its path. Recent paintings are sometimes exhibited individually with special lighting and slected musical accompaniment.

Amid the dramatic appeal of "The View" and "The River," Singleton was forced to add a special studio to his home in order to work without distraction. One side opens onto two levels of the house; the remaining three walls are bare, white, and have no view. It is affectionately known as "the pit."

"I have always been a studio painter," he comments. "I retain images from the past, dim them, combine them, and brighten them for my paintings. Usually I remember the initial images, but not always. I painted a certain Victorian farmhouse for years before I remembered where it came from. The house was three blocks from my childhood home, a house that scared me to death: I was sure it was haunted."

The quality which makes him unique is the way in which his work is in a continual state of evolution, ever borrowing from past images and moving on to new forms of expression.

"I learn something from each painting I do to apply to the next, gain momentum, and teem on to the next," says Singleton. "I've made a commitment to continual seeking, in art and in life. I always want to be a student."

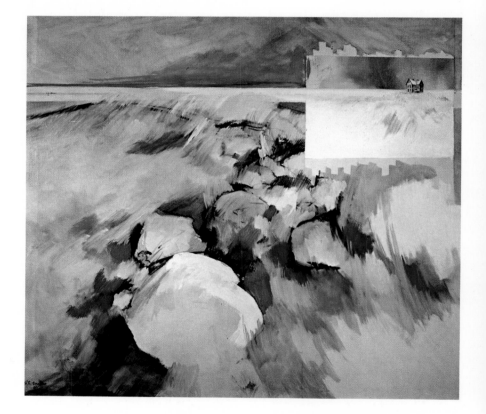

Double Entendre I, 1967, oil, 42 x 48. Collection Virginia Crenshaw Howard. From experimenting with the rock shapes, the block entered into Singleton's composition. An accidental extension of a series of Conté green and white hillside studies showed the way. Wanting to introduce a detailed sepia drawing of a farmhouse into a large version of the hillside, Singleton applied the sheet of drawing paper directly to the canvas rather than painting it over in oil. He gave both elements a common horizon and added sepia to the Conté and oil on the canvas.

The block became a distinct element: in this way Singleton formed a painting within a painting. A large, loose, organic field with a horizon in common with a controlled, detailed, small painting in a blocked-off area became *Double Entendre I.*

After a series of these, and several paintings which were partitioned with thin, colorful stripes converging on the now irregular block, Singleton departed to three transitional painting. All three were almost abstract landscapes, and all three had modeling paste under the oil for texture; the first was predominantly white the second gray, the third black.

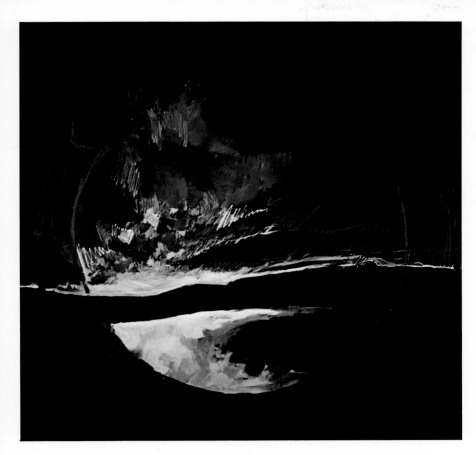

Left: *Focus,* 1967, oil and Conté, 50 x
50. Collection James G. Shepp. Singleton
started taking a camera with him everywhere
at the time he painted this. One slide from the
trip to Pennsylvania came back with a flaw. A
wheatfield with a dark mountain ridge beyond
was light struck, a diffused halo circling it.
The coincidental transition to a mostly black
canvas and the defective slide combined to
produce the 1967 "Focus" series. Here the
circle—another compositional element in Sin-
gleton's paintings—is seen.

Within the circle were the wheatfield and
the ridge, sometimes with a farmhouse,
sometimes with angry clouds reminiscent of
the earlier works, yet made more complex.
Often the black outside the circle was tex-
tured with modeling paste and loose sketch-
ing with Conté was emphasized to draw to-
gether areas inside and outside the circle.

"The 'Focus' series was a tremendous
turning point for me as an artist and as a
thinker," says Singleton. "I discovered that in
reality our vision literally focuses only a small
area. The rest, the peripheral [area], is dif-
fused, in most paintings, the entire surface is
in focus, actually a misunderstanding of vis-
ual perception as it really is. That realization,
combined with the circle as an exciting new
compositional vehicle, has influenced all of
my work since then."

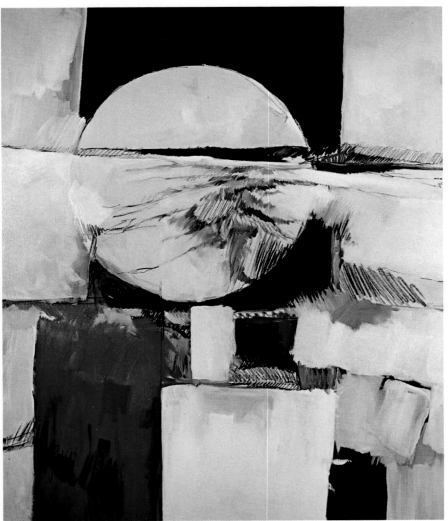

Left: *Prairie,* oil, Conté and charcoal
50 x 60. Collection Mr. and Mrs. Watson W
Dyer. Exploring one medium expands an-
other. The years 1968-69 were a time of ex-
perimentation with new materials and meth-
ods. Organic abstracts appeared on all sorts
of surfaces; extensions of the "Focus" series
appeared on three-dimensional canvases
and other materials.

Singleton became interested in aluminum
sculpture, rectangular reliefs or boxes; the
shapes within were circular, organic, and
linear. He also turned to printmaking in order
to explore all his familiar image themes in a
degree of detail he didn't feel possible in his
paintings.

The most important paintings of this period
were abstracts, large, loose studies in color
and composition, which he called "sensual,
emotional action paintings." The canvases
were mostly white with big, blocky areas of
black and brick red. A few, however, such as
Prairie, incorporated images.

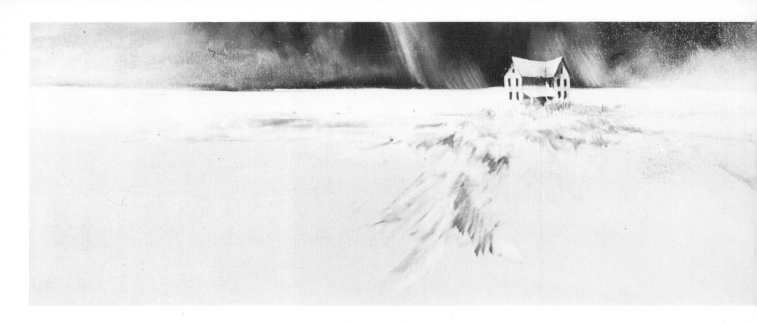

Opposite page, above: *Farmhouse,* 1966, oil, 12 x 30. Collection James G. Shepp. Here is an example from Singleton's "Midwest" series where the subject matter, the farmhouse, is concentrated in a small space. The wheatfields and cloud formations are then manipulated compositionally.

Opposite page, below: *Sprung Spring,* 1967, oil, Conté and charcoal, 36 x 50. Collection James G. Shepp. After a trip to the farmlands of Pennsylvania in late 1966, Singleton introduced several new elements to his work. One was technical: he often sketched his primary subject in Conté or charcoal and then blocked in areas over and around it in oil. The other was a new compositional element: organic or rock shapes in the foreground.

Singleton had expressed interest in these shapes at several other times, including a series of abstract oil sketches in 1965, which clustered them below a high horizontal line. Now they were used to draw interest to one of the image themes and often were obviously rocks. The slender trees in a frozen "winter" posture were first to be set in these shapes. As spring came to Florida, Singleton's palette thawed, and he executed, among others, *Sprung Spring.*

"I learned how shapes unrelated to the subject can be important in supporting the canvas as a whole," advises Singleton "Loose, unrelated lines also lend to movement and sweep. I discovered the positive use of negative space by giving that space organic form, activating that which was inactive before."

Above: *Nebraska,* 1971, oil and charcoal, 36 x 60. Collection Mr. and Mrs. Hamer Wilson. Singleton's constant changing is evident from a brief glance at the pictures on this spread. This work is out of sequence. It follows *Interaction.*

The following year at MacDowall, 1971, was the logical extension of the previous one. Most of the work was abstract, the palette was varied, and the block was the major element of composition. Loose Conté or charcoal lines gradually replaced loose brushwork. The contrast between the sensual component and the geometric became greater. The edges of the blocks became harder.

At the same time that he was experimenting with color and composition in his abstract work, he would return to one subject theme or another to develop it with new insight. The barren hills of Pennsylvania and the fields of the Midwest reappeared, the organic shapes smoothing out, the colors solidifying, the edges hardening here as well. The combined images and the new treatment are seen here.

Interaction, 1970, oil and charcoal, 68 x 72. Collection Koger Properties. In 1970 Singleton was accepted for the month of October at Mac-Dowall Colony, New Hampshire. Its impact on his work was immediate. The first paintings were in "fall in New England" colors. After the first snow they became icy blue on white. For the first time the structure was low instead of high, as can be seen here. And for the first time some of the works were visually or physically split directly down the middle.

The solitude of MacDowall made it possible for him to explore this phase of development in depth. It was rooted in Abstract Expressionism; the influences of the abstractionists Hans Hofmann, Franz Kline, and Mark Rothko were unmistakable.

"Painting, for me, is harder without a recognizable subject," admits Singleton. "Non-representation is making things work on the surface of the canvas; composition is purely composition, color is color, and technique is technique. It represents a synthesis of intellectual and emotional painting without the benefit of a subject vehicle."

Top left: *Window,* 1972, oil, 60 x 54. Collection Koger Properties. The "Window" series was a view of an obscure world through hard-edge borders. Charcoal sketching appeared below the horizon, a translucent haze above. In later works a thin pinstripe accentuated the window ledge.

Top right: *Eclipse,* 1973, oil, 84 x 68. Collection Mr. and Mrs. Charles D. Fratt. In the "Eclipse" series, Singleton's canvases were black in several tones. A single subject theme, the clouds, dominated Symmetrically placed blocks, circles, bars, or bands in brick, blue, or black obliterated and emphasized the image. Underscoring these elements was a new component of composition: the multi-hued pinstripe.

Singleton explored the series in both 1973 and 1974. He also painted several canvases, white this time, with whiter blocks and rainbow stripes as they only elements. He learned how to build blocks that appeared three-dimensional with solid-color striping. Several works were familiar subject themes, particularly the "Focus" images, with the new treatment.

Above: *First Light,* 1974, oil, 64 x 82. Collection Mr. and Mrs. L. P. Urback. In late 1974 Singleton executed what was to be the culmination of the "Eclipse" series. In a single painting, *First Light,* he brought the clouds to their fullest detail, pronounced the solidity of the earth below the horizon, and perfected the pinstriping technique, creating the effect of almost blinding light in the center of the canvas.

ERIC SLOANE

BY SUSAN E. MEYER

HIS NAME is the quintessence of America in more ways than one. Strip away the first two letters and the final "a" from "America," and you have "Eric." Take one of our great American painters—John Sloan—and you have a surname that would surely befit an artist who says that he paints "with a steadfast purpose of either reviving or retrieving certain worthwhile things of the American past."

The name originated from a luncheon some 50 years ago, during which time a young painter named Everard Jean Hinrichs was discussing the problems of public recognition with two already established painters, George Luks and John Sloan. The two older men mused about the plight of artists haunted by the inferior examples of their earlier work. Both agreed that it would be far better for an artist to work under an assumed name during the early years of experimentation and learning, and return to his real name only after perfection had been achieved. With this system, an artist need never fear seeing his real name attached to the embarrassing efforts of his youth.

This luncheon discussion made an impression on young Hinrichs, and he decided to adopt the name Eric Sloane—far simpler and more American-sounding—until the point when his work would satisfy him completely. Never having reached that point, Sloane never returned to his original name. By now, of course, Sloane has fully comprehended that no artist worth his salt is ever really content with his work. Retaining the name Eric Sloane is one way this artist has embraced the reality of "eternal studenthood."

In a real sense, every detail of Eric Sloane—like the name itself—is an extension of his art. It's quite impossible to distinguish his painting from whatever else he is or does in his life. They are all part of an unbroken whole.

"A painting an artist chooses to make is less a design or a picture than it is a piece of his own life or longing in his own heart. Painting to me is not a 'creative art' at all, but a recreative art or a 'mirror-art.' The so-called creative arts, it seems are all misnamed. He who invents, weaves, builds a house, or creates something new is the creative artist; music, dance, theater, writing, and painting involve not creation as much as reflection."

So says an artist whose paintings are simply one manifestation of a life consumed in creative exploration. He is also a writer, historian, meteorologist, collector, and designer, and all are linked by a connection which he describes in his notable book, *I Remember America* (Funk & Wagnalls, 1971, 1975). The following account of his early life is based on this colorful autobiography.

Sloane was born in New York City in 1904 into a family having no artistic taste whatsoever, a fact for which he is grateful, "because no one ever accused me of having talent; that sort of thing often frightens otherwise creative children into becoming business people. Discovering your own ability or reason for being is one of the rare and inspiring privileges of life, a deeply moving and a necessarily personal experience."

Sloane started his career as a sign painter, a skill acquired from his close association with a neighbor who happened to be one of the great typographic designers of all time, Fred Goudy. Taking this early training, Sloane became an itinerant sign painter, hitchhiking from coast to coast with a painting kit strapped to his shoulders: "Not the most dignified manner in which to begin an art career."

Through these travels Sloane acquired his first taste of this vast and picturesque country, an influence he carried with him for the years to come. He also developed a strong, sure stroke from painting signs under all different kinds of conditions, a free-swinging arm that still accounts for his confident manner of painting today. "After all," he says, "the making of an artist is far from being just the transferring of paint from a tube to a canvas. Instead, I am sure, it is being mechanic, traveler, laborer, researcher, historian, and, most of all, observer."

Sloane was hired as a painter in Coney Island to complete assorted assignments that included ten-foot letters on top of the Steeplechase Amusement Park roller coaster and a 1000-foot mural for the Luna Park Ballroom. Nearby was located the Floyd Bennett Field, an airfield famous for having the longest runway in the world. Soon Sloane was lettering and

Above: Every nook and cranny in Sloane's studio contains some evidence of the artist's passion for history. The view from each window resembles a Sloane painting

Left: Alongside his studio, Sloane has a new kitchen bedecked with bells and other artifacts from the past and present.

In the barn below his studio Sloane has installed a gallery for the viewing of his recent paintings.

numbering some of the great transoceanic planes headquartered there, and he became friendly with several of the spectacular aviators of the day, some of whom invited him to join their test flights high above the clouds. This was his first introduction to the mysteries of weather and to the majesty of clouds viewed from on high. The eminent transatlantic aviator Wiley Post suggested that Sloane paint clouds, so Sloane painted his first "cloudscape," which was purchased by none other than Amelia Earhart herself!

Sloane's enthusiasm for skies stimulated his curiosity about weather, so he studied meteorology at Massachusetts Institute of Technology. Soon he embarked upon his first book combining painting with research and writing. The book, *Clouds, Air and Wind,* was followed by five more on the same subject.

His absorption in meteorology also inspired him to conceive and execute a three-dimensional display of weather phenomena, which he called the "Hall of Atmosphere" and which can still be seen at the American Museum of Natural History in New York City. Small wonder, then, that Sloane even has the distinction of being the first weatherman to appear on a nightly broadcast for television!

Sloane's knack for combining his art with his other passions has led him into many equally diverse directions. He began to collect early American diaries and almanacs for their colorful accounts of daily weather conditions and sky descriptions. He also collected early American weather instruments, which led to still more marvelous discoveries that inspired him to collect other early American artifacts. His fascination with Americana soon began to express itself in his paintings. "Before long my paintings were depicting more Americana and less meteorology. Whereas I used to add a tiny barn or farm building to give further identity to a cloudscape, I was now using

a touch of sky merely to enhance more elaborate farm scenes."

He painted and collected everything that interested him and wrote about everything he collected and painted. He even purchased one of the last known examples of a New England connecting barn and acquired a cast-off church steeple because he considered it beautiful! Many books emerged from these researches—*An Age of Barns, American Barns and Covered Bridges* . . . the list goes on to over 30 titles—and so grew his reputation for being a "barn painter." Both in his art and in his writing, he communicated the heritage that is distinctly ours: "Old farm buildings are monuments to a dead and vanished America . . . they speak more truthfully of the past than most architectural monuments."

His collection of early farm implements and woodworking tools became so vast and cumbersome that he collaborated with the Stanley Works in creating a museum to house the items. The Sloane-Stanley Museum in Kent, Connecticut—a permanent collection of early American tools and implements—is a unique contribution to our American heritage, as original as the founder himself.

Sloane's intense feelings about Americans are hardly restricted to New England barns and tools. He has painted and written about nearly every facet of our early culture: the pueblos, church bells, windmills, railroad stations, even outhouses, each subject carefully researched and documented in his pen and ink drawings and oil paintings. Yet the subjects themselves are not what inspire him; they are merely the vehicle through which he seeks to capture the spirit of an agrarian culture. Consequently, his paintings have as much impact in Russia as they do in

Opposite page: *Indian Paint Brushes,* 1977, oil on Masonite, 30 x 22. The American Artist Collection. © 1977 Billboard Publications Inc.

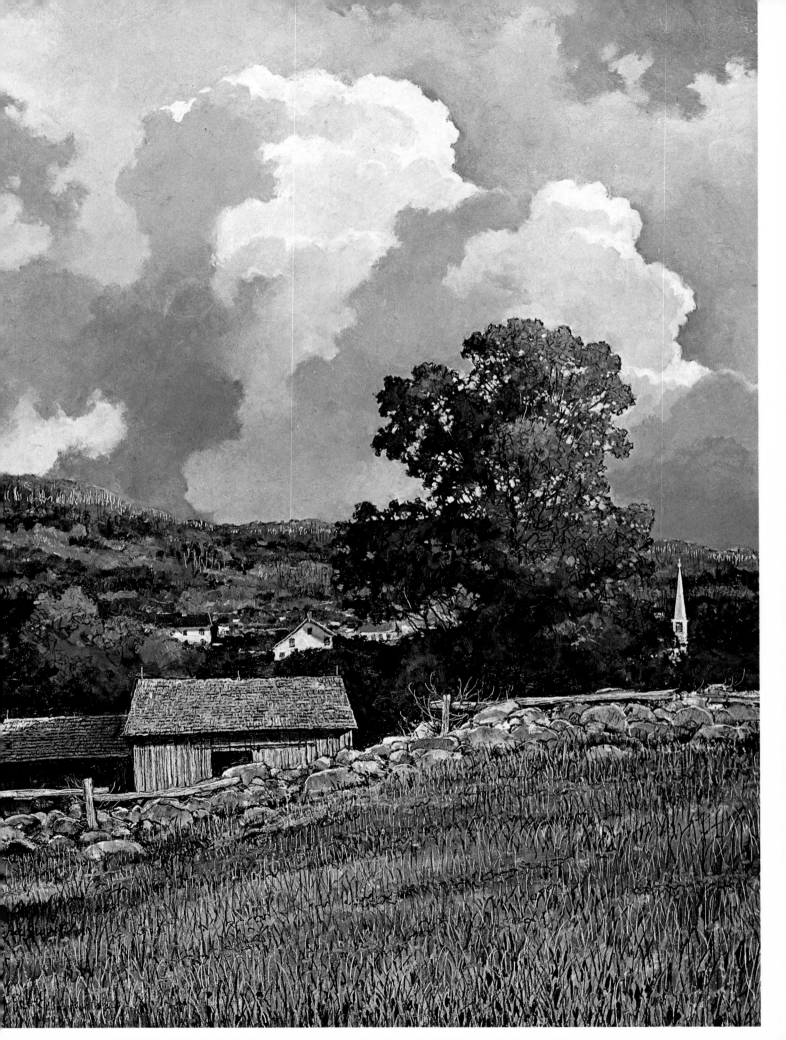

America, a universal theme that forms the spiritual basis upon which we all derive our heritage.

Spend ten minutes with Eric Sloane and you know you are in the presence of a man whose energy is inexhaustible. There is about him a sense of perpetual motion; several events seem to be happening simultaneously: he paints at the easel, swivels around in his chair and raps out a few paragraphs on the typewriter that is always at his side, swings back to the easel, reaches for the ringing wall phone that has been installed at knee level to his easel (this phone seems to ring incessantly), and hangs up the receiver abstractedly as he gets another idea for his painting or his book. (Callers seem accustomed to his abrupt termination of conversation. They simply call back later.)

At any moment he might pick up the Masonite on which he is working and set it aside for the next session, or he is just as likely to deposit it into the fireplace. ("Masonite makes excellent kindling," he muses.) With age, he admits, he can detect the quality of his painting more rapidly—after working only a couple of hours. If the painting passes his initial scrutiny, he completes it; if not, he pitches it, without any additional effort to salvage it. "A painting," he says, "is like a wife. You can get rid of it, but you can't change it!" (Sloane's analogy comes from experience on both fronts; he has been married several times.)

Sloane is always on the go. He commutes between his home in New Mexico and his home in Connecticut, the two regions that have provided him the fundamental sources for his painting and writing over the years. He finds dramatic skies in the high Southwestern altitude and violent weather changes in New England. Each is attractive to him, the one because it inspires his cloudscapes, the other because it kindles his continuing interest in man's enduring struggle against the elements.

When in Connecticut, Sloane drives to New York City each Tuesday to attend the weekly luncheons at the Dutch Treat Club, a private men's club. He is also a familiar sight in the small town of Kent, Connecticut, eight miles from his home, where he is welcomed warmly by the neighborhood restaurant, The Fife and Drum. Sloane has taken an almost proprietary interest in this restaurant, a characteristic example of his affection for the community. During lunch one day he commented on the decor, remarking that the

1. Sloane scrubs-in a rough compositional idea onto his Masonite.

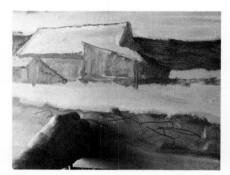

2. He draws with an Ebony pencil directly into the wet paint.

6. Returning to the building, Sloane draws in details with the Ebony pencil.

7. Sloane turns the painting upside down and sideways as he works, getting a new perspective each time. By now he knows if he has a flop.

restaurant needed some improvement. Now, everyone who knows Sloane is familiar with his great liking for barn red—the true barn red, that is; a deep and ruddy hue. Sloane paints everything barn red: Walls, telephones, cabinets; an entire bathroom in his studio—fixtures and all—is painted barn red. Even the cushions on his kitchen bench have been dipped into a can of barn red paint! So it was no surprise that Sloane happened to have a few cans in his car that day. After finishing his lunch, he brought in his supply of barn red and painted the entire restaurant. He continued his interest in the restaurant's decor by creating a collection of Americana for the walls. Each visit he adds another early American leaflet to the collection, and he nails it to the walls with the tools he brings with him for the purpose.

The restaurant is not displeased with this arrangement. Among Sloane's other talents is his impeccable taste and thorough knowledge of interior design. His own home and studio are evidence of his gifts as architect and designer, where he has interwoven authentic Americana with what he calls "instant old." Every week, he turns away numerous requests for his services as interior designer or architect.

Sloane's casual attitude toward hard work is most clearly exemplified by the way he approaches a painting. There is nothing precious or pristine about his method: he just digs in and attacks the painting headlong. He paints rapidly because he feels speed and authenticity are related: "A painter's stroke is his signature. You don't sign your name slowly, so why paint slowly?" In his vigor he tends to wear down his materials rapidly: he scrubs and scrapes, wipes and scratches with alacrity, a kind of intense enthusiasm that characterizes much of everything he does.

Since the '20s Sloane has painted on untempered Masonite—a hardboard that he impregnates with gesso on both sides—and is convinced that he was the first American artist to recognize it as a desirable painting support. He prefers the Masonite because he can crop his painting "like a photograph," easily cutting away unwanted portions with an ordinary hand saw. He has many amusing anecdotes about paintings he has cut down for very odd reasons. In one instance he cut down a panel in order to get the painting through a doorway into an art show. (It won a Gold Medal anyway.) In another case he reduced the size of a painting by half to lower the price to a level a

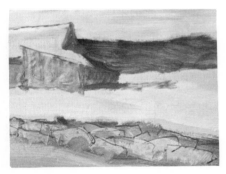

3. With the flat side of a razor, he scrapes wet paint for texture in the rocks.

4. With his brush handle, he scratches the trees into the wet paint.

5. Using a brush dipped into damar varnish, he smooths out the paint texture.

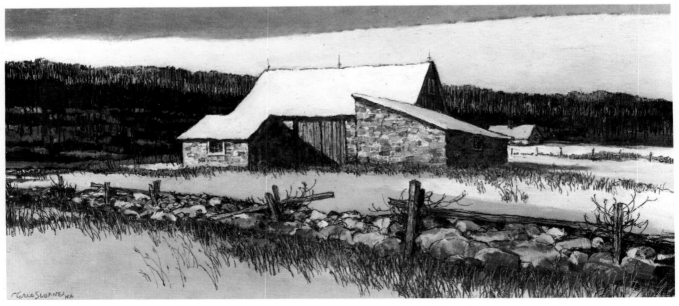

8. The completed painting is slightly more refined, but the essential ingredients were established at the first session.

client could afford. (He sold the other half of the painting elsewhere.)

Sloane's method of painting is very idiosyncratic. He squeezes out a few dabs of oil paint onto a scrap piece of Masonite, refusing to use a palette because he would rather throw away the mess after his painting session is over. Taking his idea from a sketch or from a photograph or from memory, Sloane swiftly brushes in a general composition onto the Masonite. ("I don't paint on location but from memory," he says. "The best way to capture the mood of a scene is to regard it as an echo in the mind.") He knows architecture so well that even his historical paintings—which demand total accuracy—can be worked entirely from imagination.

After he sketches in this approximate idea of a composition, he works back and forth with an odd assortment of materials. He draws into the wet paint with an ebony pencil (Eberhard Faber) and then paints over the pencil marks—or in between them—perhaps returning with the pencil, reworking, and then overpainting again. Into the wet paint he also presses the flat edge of a razor blade, scraping away the paint and piling up ridges along the surface of the painting: "The artist who paints rocks and stone walls derives real pleasure from seeing their textures appear on his canvas. When working on solid Masonite, I find that scraping my painted rocks with a razor blade will often produce accidental textures that are better than anything that could be achieved purposely with only the brush. By overpainting and scraping time and time again, remarkable effects are obtained. I guess I've used as many razor blades on my paintings as I've used brushes."

Periodically he dips his brush into gasoline and wipes it with a rag. He prefers gasoline to turpentine because it evaporates so quickly that he can work with the dry brush immediately, without depositing oily residue on the surface of the Masonite. Using a nearly dry brush—a technique he learned from the painter Reginald Marsh—means that he wears out a great many brushes and requires a tremendous number of rags. (His friends, knowing his penchant for rags, save them for him, and recently, on an "Eric Sloane Day" in Warren, the community presented him with an enormous red bag of rags.)

He continues to scrape the wet paint with his razor blade, scratches in trees with the handle of his brush, dabs with his fingers, smoothes out the surface with his palms, and turns the painting every which way as he works. Out of this deceptive jumble he magically extracts a very convincing painting. Finally he stops, when he's "tired of painting," knowing that he is no longer able to perceive his mistakes. He studies his day's work within a frame, decides if it is destined for completion or for the fireplace. By now he has paint stains all over his hands—and most likely over his face, too—all of which he removes easily with a special lanoline hand cleanser that he orders by the caseload.

We watched over Eric Sloane's shoulder as he painted, conscious of the skill and perception so easily camouflaged by his casual air. On the table nearby lay a manuscript written only hours before, an essay he had written on what constitutes an artist: "The onlooker sees only an artist's hand and brush operating, but it is the eye and the mind really doing the work. 'In art,' said Emerson, 'the hand can never execute anything higher than the heart can inspire.' The artisan's tool is the extension of his hand, but his hand is the extension of his mind."

The Sloane barn, converted into a studio and kitchen.

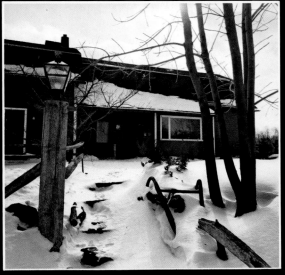

The details around the barn are early American.

Indoors the studio contains artifacts from early American history.

Sloane's easel is placed alongside a large picture window. Notice radio and shelf painted barn red.

On "Eric Sloane Day" the citizens of Warren presented Sloane with a rag bag.

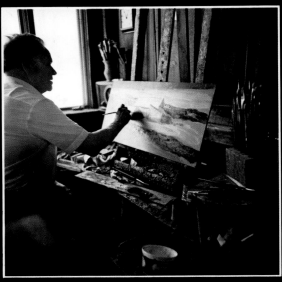

Sloane prefers to use a scrap piece of Masonite for a palette, disposing it after the painting session.

Edited by Susan E. Meyer
Designed by Bob Fillie
Composed in 10 point Medallion by Publishers Graphics, Inc.
Manufactured in Japan by Dai Nippon Printing Co.